NEVER ALONE, EXCEPT FOR NOW

Never Alone, Except for Now

ART, NETWORKS, POPULATIONS

KRIS COHEN

Duke University Press Durham and London 2017

Printed in the United States of America on acid-free paper ∞
Interior designed by Heather Hensley
Cover designed by Matthew Tauch
Typeset in Scala by Tseng Information Systems, Inc.

Library of Congress Cataloging-in-Publication Data
Names: Cohen, Kris, [date–] author.
Title: Never alone, except for now : art, networks, populations /
Kris Cohen.
Description: Durham : Duke University Press, 2017. | Includes
bibliographical references and index. | Description based on print
version record and CIP data provided by publisher; resource not
viewed.
Identifiers: LCCN 2017015435 (print) | LCCN 2017018551 (ebook)
ISBN 9780822372509 (ebook)
ISBN 9780822369257 (hardcover : alk. paper)
ISBN 9780822369400 (pbk. : alk. paper)
Subjects: LCSH: Art and the Internet. | Art and society.
Classification: LCC NX180.I57 (ebook) | LCC NX180.I57 C64 2017
(print) | DDC 701/.03—dc23
LC record available at https://lccn.loc.gov/2017015435

Cover art: Thomson & Craighead, *The First Person*, 2013,
generative digital montage. Installation view, *Maps DNA and Spam*
(solo exhibition), Carroll/Fletcher, London. Photo by Ruth Clark.

*Duke University Press gratefully acknowledges the support of the Dean
of the Faculty's Summer Fund and the Stillman Drake Award, Reed
College, which provided funds toward the publication of this book.*

CONTENTS

ACKNOWLEDGMENTS

As this book argues, finding language for collective form isn't just secondary to the labor of forming collectives, groups, communities, publics, counterpublics, mobs, gangs, marches, subcultures, cliques, bands, masses, listservs, fan cultures, groupies, gaggles, audiences, troops, comment sections—it is part of the work of collectivity itself. This means that gratitude expressed in an acknowledgments section is a group form. First thanks go to my teachers: Lauren Berlant, Darby English, and W. J. T. Mitchell. Even now, many years later, you make it impossible to feel as though I'm doing any of this on my own.

To Scott Richmond, Jim Hodge, and Damon Young: in the long interregnum between the first version of this project and the last, those long dark fallow days, you were my fans when I could not do that labor myself. Sometimes that was all that kept me going.

To Christa Robbins: anyone who has read every single word I've ever written deserves not just her own paragraph, but her own acknowledgments section. Every strained sentence I've ever written thanks you with all of the grandiose verbosity that you've been so good at taming in my work. My gift to you is that I did not make you edit this paragraph.

Talks, whether to small audiences in the context of a conference or larger audiences in the context of an invited talk, have offered life-sustaining opportunities to remind myself of the collectivity of thought: its liveness, its necessary awkwardness, and its belated right-on-time-ness. Thank you to Zirwat Chowdhury and your students at Bennington College for letting me try out a version of chapter 5. Thank you to Christa Robbins and Matt

Hunter, who each in different years invited me to the California Institute of Technology to think, out loud, about how my work does and doesn't address the question of networks. And thank you to Abigail Susik, my friend and colleague at Willamette University, who invited me to present chapter 4 to her students.

I've been extremely lucky to have Elizabeth Ault and Ken Wissoker as my editors at Duke. Thank you both for shepherding me, always with optimism for the project, through a protracted review process. And thank you to my anonymous reviewers. At some point, improvement becomes impossible without someone or something forcing one out of the abject position of staying attached to one's own project, and into a better or different form of attachment. You affirmed my project while showing me how to make it better—a magic simultaneity—which made it possible to detach and really start writing again.

I've also been grateful throughout this project to have known Sharon Hayes and Thomson & Craighead, artists whose work I discuss in the book. Thank you, first, for your astonishing work, the resonance and resourcefulness of which far exceeds the idiosyncratic account given of it here. And thank you as well for your unstinting support of my version of your work. Additional thanks go to Patrick Armstrong and the staff at Tanya Leighton, Sharon Hayes's gallery, for accommodating my late requests for images.

I'm also grateful to the journal *Afterall* for allowing me to reprint a much earlier version of chapter 3.

Finally, I want to thank Laura Heit and Leo Cohen, who are so close to home that the addressee and the addressor of this note feel almost the same. Almost, but not quite, and much of my gratitude is precisely for the differences you both continue to invent and insist upon. This project, as you know, has often made me moody. You've leavened many of those moods and patiently withstood the rest. For that I can't thank you enough.

I dedicate this book to all of you. It describes one possible outcome of our group form and so it is, itself, that form. This project was always easier, and better, when I remembered that strange fact.

INTRODUCTION

It is often said, in both popular and academic contexts, that neoliberalism, or whatever it is we call the present tense, has ushered in the age of the individual: the narcissist, the independent contractor, the temporary laborer, the web surfer, the entrepreneur. But this is only part of the story of contemporary life, which I refer to here as networked life. To speak, in periodizing terms, about the rise of individualism makes it sound as though the problem is a paucity, a dearth of viable models for conceptualizing and inhabiting the social. But if anything, there are too many competing social models for people to sort out, let alone inhabit or organize. Too many, too inchoate, too volatile, all underdescribed. This book takes up two in particular that are especially prevalent and that come into tense alignment to complexly overdetermine the spaces and atmospheres of networked life: one I call the "population form"; the other takes the more familiar, idealized form of a public, or public sphere. Individuality and other forms of personhood that feel solitary aren't just caught in the space between publics and populations. They are actively constituted by the logics of those forms as well as people's attempts to adapt to them. In other words, individuality is itself a form of collectivity. This book began with an interest in the forms of collectivity being imposed and invented in networked life and in the art of networked life. Because all vocabularies of collectivity are freighted (not least "collectivity" itself), I will conceptualize this problem, more generally and encompassingly, as one of *group form*. This is a story, then, of the forms of relation and personhood that emerge when social encounter is routed through circuits of technological

mediation but it is no longer clear which is the social portion and which the technological portion of the encounter.

Because this book locates itself primarily in the United States—where social invention, whatever else it becomes, often just *is* commodity invention—this is not a new but an ongoing story of the routing of relation and personhood through the commodity form. This history does not simply reside in or on the World Wide Web, although particular group forms of networked relation such as trolling, emoticons, and search queries are what I will ultimately be concerned to describe and will form the foundation for the more overarching account of networked life offered here. Nor for that matter does this history reside in the art world, as style or trend or movement, although Sharon Hayes's "love addresses" (2007–9), Felix Gonzalez-Torres's candy works (1990–93), William Gibson's novel *Pattern Recognition* (2003), and Thomson & Craighead's BEACON (2005–) will provide some of my key historical cases. *Networked life* is meant to signal that media and medium in what follows will be understood primarily as questions of personhood, whatever their extensions in and through specific materialities. In this framing, neither the individual on one side nor the collective on the other can be privileged or primary. One way to characterize networked life is that it fundamentally rewires the relationship between the individual and the group, the person and the collective, the one and the many or just the two. But this means that networked life is constantly rewiring this relation—this constancy is key, because what new media hasn't rewired this relation? In a Web 2.0 milieu, the invention of new commodities has become coextensive with, practically the same as rewiring the social itself. The syllogism "social media" hints at this conflation or collapse. This is why I will refer to *group form*, a placeholder phrase meant to be neutral while suggesting that the aesthetics of collectivity as constituted in the space between populations and publics is key to understanding the logics of networked life. It will be the task of the next chapter to more fully describe *group form* as an analytic term. The book's title, *Never Alone, Except for Now*, begins to suggest the affectively and technically contorted relationships between individual personhood and group life that obtain in networked contexts. These contortions are my subject.

My study, in other words, is contiguous with and extends out of the period in the United States and its spheres of influence in which many forms of collectivity have been lived to a great, and so far only ever increasing, extent in and through mediating technologies: the period, in other

words, wherein the interactions that constitute groups that are both idealized (e.g., liberal publics) and occasional (e.g., ham radio networks) are not primarily face-to-face and synchronous but are rather lived through a screen or mediator of one sort or another, one that fragments and rearranges both the space and time of encounter, and concomitantly, the fantasies, norms, and forms of belonging that structure encounter.

This, of course, is one way of telling the story of the public sphere, which was always a strictly mediated relationality and which is a key point of departure for this study (see chapter 2). In this sense, my interests are premodern. But think too of the U.S. postal network, radio, television, network news, presidential addresses, pulp fiction, a particular brand of clothing (see the section on William Gibson's novel *Pattern Recognition* in chapter 4), or any market for a particular commodity—including, not coincidentally, artworks. These, too, are mediated relationalities, though they do not bear the usual markers of technological mediation (or collectivity for that matter).

I don't depart much from standard accounts of modernity, then, if I understand it as the period in which group life has been lived in and through media, lived therefore to greater and lesser degrees representationally, even while the technologies that now undergird those mediations rarely operate on a representational logic (I take up this question of representation in chapter 5). Over the course of this period, as we approach the real-time connections of electronic networks, the time between the creation and the reception of a re-presentation (e.g., of oneself) dwindles to nothing, the "re-" eventually etiolating in favor of something thereafter more easily called life itself, something felt in its liveness and immediacy rather than in its mediations and lags.[1] In other words, the setting for some of the most significant changes to the form of collective life, ones that are closely and importantly associated with the history of modernist art and art making—providing their primary materials, their logics and codes, their drive to transformation—has been mass market capitalism and its demographic clusters of goods and services in and through which people come into, and fall out of, relation.[2] I expect this claim to be neither surprising nor controversial. The history of the mediation of social relation through commodity forms is (unfortunately) what predicates and motivates the conversation, for me, about group form and aesthetics in the context of networked life.[3]

In all of the artistic cases I will assemble here—including the ones that

seem, by the logic of artistic intention or manifest content, to reside far outside electronic networks—the form of the artwork embodies the collectivizing logics of the distributed network. In those logics, group form is constituted, but also riven by parallel processes: one predominantly liberal in spirit, based on an idealized form of reciprocal exchange, the other predominantly algorithmic (affectively illiberal, technically nonliberal), an automatic protocol that is indifferent to all content and all ideals, that simply tracks and aggregates. Group form in distributed networks, my argument runs, gets assembled in the space between automatic data production and self-conscious group production. In this space, the feeling of sovereignty, of surfing and connecting and networking, produces, *but in a parallel realm of activity*, data aggregates, or in the language I will be adapting, populations. This idea of parallelism is a pervasive theme of the chapters that follow and a structuring claim of the entire book. It is as close as the book comes to an overarching periodizing claim. In this sense, the idea of parallelism as a structure and the population form as a determinant of that particular structure works with but also against some of critical theory's existing roster of structural relations, each of which is, in its own way, a recondite thought about group form. I refer primarily to Debord's spectacle and its extension into various theorizations of "the image" and image culture, which continue to be so useful to art histories trying to come to grips with the influence of networks on contemporary conditions of art production;[4] co-optation and appropriation in all of their recuperative guises;[5] as well as to virality, parasitism, and the metaphorics of infection.[6] All of these figurations rely on a language of contact which is pessimistic while setting the terms for what will become legible as redemptive or subversive accounts: the image blinds; the spectacle deceives; the virus infects; the market appropriates. I don't deny that such processes continue into the present day (and are even amplified and accelerated). But the geometry of group form in electronic networks— which is predicated on nothing so stable as an image, so totalizing as the spectacle, nor so discretized as what David Joselit calls a "population of images"—is not that of the intersecting line but of the parallel, that which proceeds together but does not touch.[7] Chapter 5, the final chapter, contains the most concerted discussion of parallelism, a discussion which tries to gather together threads of a thought that builds from chapter to chapter. There I make the claim that the parallelism of the population form estranges us from representational politics. It makes a certain kind

of compensatory sense, then, that questions of representation and identity are so prevalent, even dominant, in both ordinary and specialized discussions of the Internet.

As the language of populations is meant to suggest, with its references to the longer twentieth-century trajectory of economic and informatic management, such logics were in formation long before there was a thing we could confidently single out as *the* web. This is the primary reason that not all of my artistic cases deal explicitly with the Internet or electronic networks or even technology, and why my artists aren't all Internet or new media artists. Neither Sharon Hayes nor Felix Gonzalez-Torres likely thinks of today's Internet as one of their express subjects or interests.[8] This would, in fact, be perfectly in keeping with what I believe networks are, as subjects of study: that is, not literal things to which we can confidently point, and in pointing hope to contain, but an expanse or net of virtual relationality with extensions in technical invention but also in far more distributed and amorphous social, cultural, and economic adaptation.[9] One thought that consequently guided my selection of artworks was to assemble cases that worked across a wide range of media and materializations—performance, media art, installation.

"Never alone, except for now," the phrase that stands as the book's title, describes the contorted form of togetherness being sketched here, one whose always-conditional absolute (never . . . except) registers the basic, but jarring fact that togetherness in electronic networks can never simply be the effect of willed acts of world building. It is built through parallelism rather than just through contact, impact, or intention. It also gestures toward the set of technical constraints innate to the network form itself, the way that networks connect while being indifferent to what happens in and through those connections. The title's phrasing tries to place those constraints in contact with the affects of their habitation. Once one is working in a distributed network, this form of togetherness—automatic not willed, indifferent not motivated—cannot be unchosen. On a network, one is, in a technical sense, never alone, even while in an affective sense there is often no lonelier place. At the same time, what happens at individual computers is, in an affective sense, isolated even while in a spatial sense, that anonymous troll in a chatroom might well be one's neighbor. In any case, the most important point is probably that one never knows, so both togetherness and aloneness exist in a permanently snarled and bewildering temporality: never but always. Every utopian dream undercut

by a dystopian nightmare; every act of unexpected kindness dogged by a seemingly random and senseless act of cruelty; every important political invention online attached, in a parallel but extremely lucrative relation, to a means of data accumulation, a relation that runs on an older logic of co-optation but where co-optation isn't hindered by the structurally and affectively parallel relation—by whatever distance there might be between, say, art and commodity—but is now constituted precisely in that parallelism.

The central argument in what follows is that much networked collectivity, in the most ordinary settings, messily and unpredictably cross-breeds the form of the public sphere (seen within its history of reconceptualizations and updatings) with the population as a collectivizing form endemic to the biopolitics of Internet data collection and informatic personhood. In short, we can say that in networked life populations crowd publics, creating a cramped and disorienting space in between that becomes a space of habitation, adaptation, and negotiation. This fact isn't insidious and secretive; it's the manifest structure of how networked sociality works.[10] I play out this argument by way of deaccelerated descriptions of the intimacies and forms of contact invented in the folds of the overlay, populations upon publics.

Many of my cases therefore emerge from these folds, from ordinary scenes of networked sociality that improvise modes of relationality in that space. Specifically, I take up emoticons and other invented diacritics, as well as trolling, and searching. All such improvisations (thus, proleptic) are also artifacts (thus, retrospective) of attempts to adapt to the space between populations and publics. But the three artworks and one novel that comprise my central aesthetic cases also inhabit, self-consciously or not, the same historical conjunction. Being scenes of mediated collectivity that are in retreat from commodity form while always being dogged by that form—now parallelistically rather than appropriatively—these works share and reveal (as bruises reveal other forms of violence) various facets of this layered structure, of its experiential nature, its logical structures or codes, its affects, its effects, its economies and technologies. In the present context, the works that I attend to closely have served as a way of sounding out the processes, residing far outside the Internet (or so deeply inside it that there can be no effective distinction), by which populations came into such close proximity to the structure and affect of publics, creating a distinctive space of mediated encounter. This has eventuated in a great diversity of group forms and styles of coming to that encounter that

can be seen as responses, as reactions to this graft and the work of living inside of it.

To say "group form" is to invite, even require, further elaboration. But the problem can't simply be solved by good, clear explication. The problem of vocabulary and description is contiguous with the problem of group form itself in networked contexts, as it is whenever rapidly changing technological and economic conditions force improvisation in the folds of new or new-ish conjunctures. We find this thought in Fredric Jameson's work on the political unconscious of postmodernity, in Ulysse Dutoit's and Leo Bersani's work on queer relationality and what they have called the "correspondence of forms," and in Lauren Berlant's work on the intimate public sphere.[11] I discuss these three references at length in the following chapter. In the meantime, we see description and life come into conjunction relentlessly, even desperately in the following kinds of questions, each indexing a vexed debate in and about web cultures: is Facebook a commodity or a social forum? Is file sharing theft or the free use of common resources? Is networked life virtual and supplemental to life, or do we just call it all life? Is political debate online public discourse 2.0, or is it trolling interrupted by a few calm, on-topic responses? All of these questions have a moralistic, even a polemical dimension. But the answers they invite also actively and literally set the social as well as, in many cases, the legal terms and conditions under which people come to encounter one another online. For this reason, the method by which I pursue these questions might be called ekphrastic.[12] Ekphrasis, in its variable relations to the scene it narrates, generates a vocabulary of experience or encounter. It builds slowly but always asymptotically to its objects rather than presuming their coherence. *Ek-*: out. *-phrasis*: to speak. To speak out. The tense here is key. Ekphrasis, as a critical methodology, generates a present tense, a tense in its ongoingness. Ekphrasis is a way to situate our histories with and thereby within the problem at hand, rather than pretending to get out in front of it with a name we hope the events in question come to inherit, as if it were their destiny to do so, as if History seen by the Historian should run in reverse, in synoptic retrospect.

If one feels that the problem characterizing the period I call networked life is, in some fashion, the simulacrum, the spectacle, a flood of virtual images drowning the world, then one might well worry about an aesthetic ploy like ekphrasis that is itself imitative, rendering an image in speech. But what if we admit we don't really know the problem from the start, that

we haven't seen or can't see its full image but only some of its symptoms, and so must grope our way toward it? In that scenario, where not even the ekphrast knows or has *direct* experience of the originating image, ekphrasis would be less an imitative art than a descriptive one.[13] Ekphrasis then *could* not totalize or simulate, categorize or otherwise situate the thing that it takes as its goad.[14] Instead, it would inscribe itself alongside, and in that untouching adjacency, we might imagine any form of transaction between the two: collusion, parasitism, interference, or hardly any relation at all.[15] There's no reason to presume, in other words, the form that the ekphrastic relation will take before the fact. The ekphrasis itself—in its particularities, its style, its obstacles and stutterings—brings that form into being, both its own description as well as, concurrently, the relationship it has with its inciting object or event. Its attempts to conceptualize its objects are therefore partial, haltingly iterative, experimental, improvisatory. Ekphrasis is, in Eve Sedgwick's sense, a weak theory: driven by curiosity rather than an aversion to surprise; moving along with its objects rather than encompassing them; open to incoherence as a form of knowledge and not just knowledge's obstacle or absence; moving at the pace of groping adaptation rather than confident, expeditious critique; affectively varied rather than oriented around monolithic affects like anger, trauma, crisis, and anxiety.[16] I don't mean, as indeed Sedgwick didn't mean, that the paranoid structure of what she called "strong theory" (critique, totalization), is wrong or misplaced.[17] I mean there are distinctive qualities of networked life—its pace, its recalcitrance to knowledge-gathering procedures, its ambition to remake the forms of personhood that would be our foundation for gathering knowledge about the world, the way networks alter the world as an artifact of people's movements through the world—that need the slower, iterative, exploratory nature of weak theory. In Internet research, strong theory abounds.[18] Before we need new names, new brandings of group life (a task we might leave to the Facebooks of the world), we need descriptions of the actions, gestures, words, events, and affects that are constituting, but never from scratch, the new forms of group life, of sociality invented in relation to networks.[19]

So the chapters that follow each started with an instinct about the particular pressures brought to bear in a networked milieu on the aesthetic interface as a medium of intimacy, affiliation, and belonging. In this vein, each chapter explores a particular aspect of the warped space between publics and populations and tries to be attentive to the invention of group

form within that conjunctive space. The first chapter proposes *group form* as the placeholder rubric under which to explore questions of networked life, where the individual and the group are both isolated and bound together within what I call a parallelistic relation. And it is precisely in that configuration—that of the distributed network that is now monetized and made possible by converting loves, likes, labor, life into a parallel stream of data—that individuals and publics or self-conscious collectives are made to effect the building of populations. Populations themselves then become deeply constitutive of personhood in both its actualities and its potentials. Which is to say, the group forms I explore will not always be heroic or revolutionary, even if they are inventive and resourceful; mostly they are bargainings with newly reconfigured conditions for collectivity and belonging. The second chapter historicizes and conceptualizes the disorienting overlay of populations upon publics as the scene for ordinary exchange as well as the remediation of such scenes in and through artworks.[20] The three succeeding chapters then describe three specific aspects or qualities of life as lived between publics and populations. Taken together, these constitute places to start an investigation, not a field totalized metonymically.

Central to each of the final three chapters are artworks that inhabit, present, and perform scenes of mediated collectivity. The third chapter considers violent or violating behavior online, exemplified by trolls and trolling, modes of encounter that limn liberal speech but without the reciprocity idealistically presumed to constitute scenes of liberal deliberation and debate. Such actions reveal one of the most disorienting affective structures of communication and politics in the populations of electronic networks. This I call the "broken genre." Sharon Hayes's performance *I March in the Parade of Liberty, but as Long as I Love You I'm Not Free* (2007–8), from which I learned so much about broken genres of speech and politics, is the central aesthetic case in this chapter. Chapter 4 then addresses affective diacritics such as emoticons and "LOL" (laughing out loud) that compensate for and adapt to this broken genre by asserting or curating the affective tone of interactions in populations. Such affective diacritics are adaptations to, and so are acknowledgments of, a particular feature of networked life, lived between populations and publics: a pervasive tonelessness. Here, Felix Gonzalez-Torres's candy works (1990–93) are central, as they have much to say about tone, tonelessness, and diacritics in relation to the politics of participation in networked life. Finally,

chapter 5 looks to the search engine industry and the ways that people search for something in order to orient themselves in the space between publics and populations. From within this broad activity of orientation—the search and that relatively new form of inquiry, the ordinary language search query—the question of personhood again emerges. Thomson & Craighead's multisited, multiplatform work BEACON (2005, ongoing), unlike the previous two chapters, explicitly thematizes its subject, namely search engines and specifically search queries. It allows us to see how personhood can be a distillate, an effect of the kinds of queries people formulate online. Search queries, which is what BEACON presents to us, are violently partial, a slight and exceedingly weird thing to know about someone, while also being emblematic of new forms of knowing and sensing others. Sometimes the radically partial is all we get in a networked environment and so might be best described as not partial at all. In this, search engines are part of an array of technologies and practices, evident in all of the proceeding chapters, that force group form into a parallelistic relation with the activities that might seek to learn about it, intervene in it, change it. The book ends, then, with a discussion of the difficult terrain on which we come to confront problems of networked life, something I refer to as parallelistic aesthetics.

Through all of these studies, I engage with the question of relationality and aesthetic form that has been so important in recent art history and art criticism. In a networked milieu, almost any object of study entails a problem of group form. And so each chapter also stands as an experiment in how to describe modes of relationality in light of the disorienting conjuncture of forces that now intersect at the site of the group: networked publicity and the metastasis of the population form, liberal and nonliberal forms of relation, ordinary intimate social life and the massive forms of data collection and commodification that are the technical and financial concomitant of lives lived online. The elements of the problem are familiar; their particular configuration presents challenges to analysis, to intervention, and to aesthetics, but first of all to description and so to life's habitability.

In a sense, what's being staged across all of the chapters is a particular arrangement of media theory with queer theory, all within a broadly art historical theater in which artworks and commodities, aesthetic form and commodity form, face each other not as enemies and not as opposites, but as anamorphic distortions of one another (more on anamorpho-

sis below). These fields of inquiry meet when mediation is understood not as a middle, and not as a distantiation, and not as technology, but as an organization of life in proximity to fantasies of belonging and togetherness. This understanding results from my attempt to hold together a number of discrete, disciplinary ways of defining mediation. Cybernetics would describe mediation, dryly but not misleadingly in the current context, as communication. Media theory would, perhaps, describe it as an interface. Queer theory has taught us to understand mediation as a variant of desire, a conventionalized or generic form of encounter that might always become more queer. Critical theory would probably have us simply call it commodity form, the ongoing subsumption of life as labor and then as value always for someone else. And art history has often subsumed broader questions of mediation under the more delimited rubric of medium specificity, the material and/or phenomenological specificity of an aesthetic encounter that might, under certain conditions, become self-reflexive (might, that is, become a site of pedagogy about the material bases of encounter, their arrangements, and the conditions under which one might come to encounter them).[21] But art history might equally refer, especially now, to various forms of participatory practice within the art world. I refer here to an accumulation of disciplinary discourse that in many ways only now discovers an explicit vocabulary for the questions of group form that have long concerned modernism and modernist art practice (and before).[22] The trick today is not to choose among these resources, as so many sites of disciplinary expertise which might then, later, be connected via collaboration, outreach, multi- and transdisciplinarity. To study forms of togetherness and belonging now—that is, to study mediation—is to study a commodity form that is a scene of (often frustrated) desire and fantasy that must operate in proximity to, if not be entirely encompassed by, various technologized interfaces that are themselves always changing according to the relentless progressivist logics of the commodity market. For such problems, the art world is not context enough; but neither are scenes of ordinary exchange and mediation, taken on their own terms (whatever those terms might be) adequate to the questions being asked.[23]

I said previously that in this book art and commodity face each other as anamorphic distortions of one another. In anamorphosis (Greek for "re-formation"), distortion occurs because one format is given within the delineations of another. Commodity form and aesthetic form are not equivalents, but are often forced to take one another's shape, most ag-

gressively within an economic discourse.[24] Instead of continually decrying this structural condition of capitalist circuits, I try to learn from those distortions while forcing my own bad fits in the pacing and arrangements of my descriptions. Bersani and Dutoit, in a different context, might call this a "correspondence of forms," where analysis need not privilege autonomous units (persons, artworks, objects) and distortion might more neutrally be called "difference."[25] The first chapter will elaborate this conjunction of media theory with queer theory in the context of what I call "group form."

The disciplinary implications of this thought partially informed the selection of my artistic cases: it was important to me to try to expand what art history on the one hand and media theory on the other consider to be their purview, especially with regard to technologies of social mediation. In this light, the inclusion of Thomson & Craighead—who are most often labeled, when a label is needed, as new media artists—is not because new technology is self-evidently *in* their work, but because in their work media and technology are deliteralized in pursuit of larger questions of personhood and encounter. Stated in those terms, where technology is deliteralized and we are much less sure about the boundaries of the term let alone the objects of inquiry, I could and do say the very same thing about the work of Sharon Hayes and Felix Gonzalez-Torres. In this more atmospheric or disbursed understanding of technology (a weak theory of technology), Hayes's and Gonzalez-Torres's works are just as much about technological mediation as Thomson & Craighead's.

The inclusion of Felix Gonzalez-Torres in a book about networked life might make some worry that we're proceeding ahistorically. But to start with an open analytical category (not new, but open), to accumulate formal detail ekphrastically toward better descriptions of networked group form, doesn't preclude historical thinking. Rather, it requires that historical thinking begin with formal descriptions that do not take as their presumptive model the familiar relational forms and discrete technological commodities that already so dominate thought as to make improvised, nonce, and queer forms either invisible or forever the bad example that bolsters, *a contrario*, the legitimacy of the existing vocabulary.[26] In other words, in what follows, ordinary life—the sites and scenes in which networked life is materialized—isn't the debased, lifeless site of expropriation against which critically resistant art stands out, and in relation to which it asserts a redemptive ethics. Ordinary life, like art, is a site for the

negotiation of historical forces in and as the development of new skills, new anxieties, new optimisms.[27] So, while the ultimately and immanently capitalist logics of networked life being explored here are increasingly totalizing, dire, and hopeless, life is not fully subsumed or determined or for that matter best or only described by those logics. *Never Alone, Except for Now*, in other words, aspires to be not a description of the inescapability of those logics so much as a description of how people negotiate with them. The tone of the book therefore is not hopeless, but neither is it optimistic or redemptive. It tries, more simply, to be curious, to assume that we don't know what a radical or critical aesthetics looks like in the folds of networked life.[28]

So my chapters move between specific artworks and specific cases of Internet sociality, accumulating evidence toward the description of group forms that, because of their dense intercalations of technology, economy, personhood, and collectivity, are fully experienced neither in artworks nor in ordinary life. The gambit is that perhaps such group forms can be sensed and described formally by attending to the anamorphic distortions involved when one realm is read in light of the other. In other words, for the cases assembled here, aesthetic form *is* a site of ordinary life, and ordinary life *is* a site of dense aesthetic mediation.[29] This is especially the case at the sites or scenes where someone comes into contact—through willful acts of world building, but more often within my cases, through automatic technical procedures or protocols—with the edges, the boundaries, blurrings, and expansions of one's own individuality.

If the previous discussion has seemed purely methodological, we will begin to see in the next chapter that it is also a nascent description of the practical problem of inhabiting group form in networked life.[30] There is, in other words, an ekphrastic aspect to networked life itself when worldbuilding actions, consciously undertaken in ordinary and minor settings, are returned by way of a population logic. When the data of our own ordinary lives are returned to us as suggestion, as personalization, as self-elaboration, the network can be said to speak *us* out. In the space between populations and publics, personhood itself becomes the ekphrastic quotient of networked life. We should therefore ask about the group form not just of populations and not just of publics, but of the individual in networked life.

GROUP FORM

Congregated on its blankness stood
An unintelligible multitude.
—W. H. AUDEN, *The Shield of Achilles*

We have not inherited a very supple vocabulary for group form, for the ways that individual subjectivity gets collected up into sometimes comforting and sometimes discomfiting little clots of sociality that, very often, we do not get to choose (witness: the "we" that begins this sentence). This paucity of terms is an odd fact given that capitalism has relentlessly transformed the economic, social, and political bases of belonging and collective life over the course of the nineteenth, twentieth, and twenty-first centuries.[1] The Internet, for all of its potential to diversify and proliferate forms of collective life, has not much alleviated this conceptual lack, in which vocabulary and life's means come into such close conjunction, in which inventing a grammar of connection is often concomitant to inventing collectivity itself. That paucity is the first, the inciting symptom of this book.

I choose "group" here over all of the other possibilities because I take it to be the most discursively neutral of our concepts for collective forms of life. "Mob" and "mass" all bespeak a formlessness that becomes, in the argot of modernism, strongly determinative of the form itself, but also drag around with them a great deal of overdeterminative baggage—most pointedly, an accusative tone that too often blames individuals for the violence done to collective life by capitalism and its own grammars of connection

(demographics, markets, styles, types, etc.). Both "mob" and "mass" assume that incoherence is politically bankrupt, even destructive, rather than forms that have not yet come into legibility. "Community" and "public" both have their own formative periods, as I will discuss below, but both are also now marked as much if not more by the connotative metastasis that makes of their definitions a kind of blur or data scatter (but if the form of that blur could be read, it would map attempts to reinvent our vocabulary in order to catch up to the ways that capitalism has transformed group life). There are more, of course: collective, nation, polity, citizenry, country; ethnicity, race, gender, class. As well as: friends, lovers, couple, fuck buddy, family. Or, sweeping heedlessly and determinedly across all: generation, demographic, market, consumer. All name something. But they also all name the desire to give a name to something that is, by its very nature, recalcitrant to naming: because mobile, because labile, because the noise generated in and around each group form exceeds the formative powers of the name. To be literal about it for a second, no one can name all the activities, persons, objects, histories, or events that make up, that quite literally constitute, even the smallest, most wieldy group. Think of a couple on a first date, a small knitting circle, friends joining a protest march or signing an online petition. This resistance to description, to naming, isn't always a problem for the participants. It is, however, always a problem for the analysts of group form (disciplinarily speaking, these have tended to be sociologists, anthropologists, and market researchers). One claim here will be that it has increasingly become a problem for participants, as existing vocabularies underdescribe both the innovations and impingements of electronic networks, and therefore underdescribe what has become of life itself in those networks.[2]

This is one reason why Leo Bersani's work, and especially his collaboration with Ulysse Dutoit, has been so important, and is so formative in what follows. Their work has been uniquely attuned to inchoate forms of relationality, nonce forms, wanting to generate a nonossifying vocabulary for those forms that barely hold *as* forms, that therefore resist exemplification, representation, and other accounting procedures while still meriting description.[3] And so their work has necessarily been critical of our existing vocabularies for group life—especially the languages of sexuality—seeing them as so many attempts to limit our imagination to whatever in the social does not conform to the idealistically unified One of the heterosexual couple, but seeing them also as always-failed attempts to prettify

social and sexual relation, to bracket its inherent awkwardness, incoherence, even violence. Dutoit and Bersani have been most attentive to the ways that sexuality determines and overdetermines scenes of collectivity, the coming into being of group form. But the careful attention they pay to incoherence, to awkwardness, to the tension between invention and negotiation, to the formative power of language and naming, to the desires and abreactions provoked in proximity to destabilizing encounters with others . . . all of these aspects of their work on group form make their work a powerful resource for thinking about how commodities have determined and overdetermined scenes of collectivity. The Internet and its various networked groups only extend and complicate the problems that have arisen in the long era of mass markets, during which group form has been variously and complexly mediated by a long history of commodities. Interaction through electronic networks, in other words, however materially specific, is just one moment, one point of inflection, in a long history of virtualized togetherness. If the focus in what follows is on electronic networks, it is on *the* age of electronic networks not as a break or crisis of group form but as an inflection of a longer history of commodity form which has constantly, relentlessly forced people in both analytical and ordinary circumstances to modify existing vocabularies of contact on the way to inventing new ones.

What, then, of the word I pair with *group* to complete the phrase that generalizes this book's cases: *form?* Its uses are often historically precise but, taken together, can seem impossibly diverse, dissolute, and irreconcilable. For this reason, *form* can appear to be meaningless, the kind of abstruse formulation that, for people who conflate clarity with meaning or, worse, with truth, can seem to be empty pretention. But the word's plight asserts its necessity. In Fredric Jameson's work, a significant influence on my own, a form is a conjunction, a coalescence of elements from disparate realms of meaning that results in a sometimes momentary, sometimes immaterial, sometimes more obdurate coherence.[4] This does not exclude a lot; but neither is it a description of everything. And in fact, far from being a sign of the term's uselessness, the tendency of such a definition to spread outward, encompassing more and more objects, is part of its analytical potential, its necessity. The more we see *as* form, as in-formed, as entities in conjunction, the more incitements we have toward critical, analytical, or historical thinking about those objects, about the processes that inform them, about the connections between them, about the forma-

tions they create in the wake of their formulation. Many things, too many, seem to exist in their individuality and autonomy, not least persons in contemporary political contexts.[5]

A form, in this conjunctive sense, is true to both the hermeneutic literary tradition vectored through a Jamesonian Marxism, and, maybe more surprisingly, to a modernist art historical tradition in which the notion of form bears and so transmits the imprint of a history of making, of formal problems and solutions to those problems.[6] A typical Jamesonian conjunction is that of superstructure and base, where form, for Jameson— for example, literary form or genre—is often what sparks between those conceptual registers, registering their deep interconnections in practice. A typical art historical conjunction, this one Michael Fried's and unique to late modernist painting, is that of optical and literal supports, a painting's appearance to vision and its appearance within a physical frame on a cloth canvas (as in Kenneth Noland and Jules Olitski's paintings).[7] For Rosalind Krauss, the relevant conjunction would be between medium and the specific social and economic conditions under which the salient features of that medium become perspicuous.[8] In media theory (turning now away from debates within medium theory), a common conjunction—although the way it is configured varies, and emerges in its variance as a kind of authorial style—is between immateriality (e.g., computer code; the ideologies of television programming) and materiality or material practice (e.g., software platforms and the use of social media; the television set and the practice of watching television). In these conjunctions, seen formally, the two terms inform each other in the context of a situation or scene. And in both explicitly aesthetic and ordinary cases alike, such scenes tend to be animated by people's attempts to reconcile the improvised nature of their actions (which might feel like agency or might feel like being out of control) and the historical sedimentations that come to bear in any particular moment of conjunction (the norms and other pressures of repetition).

But in another sense, when I say "form," I am also thinking about formlessness and its art historical lineage dating from Bataille, and more proximately, from disciplinary debates in the 1980s in North America about the significance of form and the procedures of formalism.[9] For Yve-Alain Bois and Rosalind Krauss in their exhibition *Formless: A User's Guide* (1996)— an attempt to disorganize the art history of modernism through a recuperation of Bataille's work—form in the late twentieth century must be seen as existing under an institutional imperative, always made to con-

form to certain precodifications that secure the work's value in advance.[10] Form, in their view, gathers things together into false unities, so Bataille's formlessness becomes attractive insofar as it undermines the confidence that undergirds such disciplinary procedures.[11]

In debt to a great deal of research on twenty-first-century capitalism, my starting assumption here is that we can no longer so easily assume that the formless contains a radicalizing potential while the formal, that which assumes form, is repressive, dominant, normative . . . in short, ideological.[12] As we'll see in the next chapter, if the capitalism of the twenty-first century has reorganized itself around flexibility, around diversity, around an endlessly attunable personalization of all things, around precisely these new kinds of formlessness, then maybe, in the kind of polarized view that Bois and Krauss were trying to eliminate, form—that which holds, which coheres, which stabilizes, however provisionally—comes into new oppositional importance.[13] A few restrictive norms might not look so oppressive in the context of the kinds of precarious lives, lives of constant hustle and self-invention, of constant adaptation and catching up that so many people are now forced to live. But the real lesson is probably that the politicization of form can't work through simple reversals anymore.

If the formless is the base, the low, and more specifically, that which brings low, then far from being an outlier in networked cultures, it might be seen as precisely formative, even marketable. As often as the Internet has been seen as a site of democratic reparation, of freedom from constraint, it has also been seen as that which demeans culture and politics: its unraveling of the rationality of language in various slangs and shorthands (see chapters 3 and 4); its sleazy anonymity and the Internet trolls said to be bred, as though bacterially, by that namelessness (chapter 3); its repetitive memes and irrational, noxious comment spaces (chapter 3); its open disregard for the law in the illicit sharing of music, movies, porn, and so on (chapter 2, chapter 3) . . . all the waste materials of culture that are so easy to see as debasing even while they are also clearly a product of the very democratic freedoms these practices are said to demean, to bring low, to deform.[14]

So, networked group form is formless not as in immaterial, but as in lowly, as in debasing, or, even better, deflating. This means not that it lacks form so much as it resists any single affectively or politically oriented analytical register: it can never simply be redemptive or debased, formal or formless. Rather, as an analytical object, networked group form

is that which thwarts attempts to place it definitively here or there: for the public or against it, for democracy or against it, for culture or against it, for revolution or against it. This is part of the blank but powerful potentiality of the distributed network form and of the commodity markets it has spawned, part of their own form and formlessness: the network connects, and considered on its own terms, that is all that it does. But that is already a lot. Paradigmatic here is the financial market's obscenely high valuation of websites long before they have proven to be able to earn any actual money. Merely the potential to connect people via a network, to produce a new and exciting group form, is enough to produce value (chapter 3 takes up this question of potentiality).[15] But also, more prosaically, something as annoying and humble as email spam manifests the network's power to connect and only connect, to connect without purpose or constraints but only with potentiality—an infinitely adaptable, infinitely exploitable potentiality. Thus, the groups that assume form in and around electronic networks must deal with a lot of noise around the signals they self-consciously generate to galvanize their membership; every intentional act gets bombarded or muffled by a host of unintended actions, events so random they can't even be called consequences: trolls, errant comments, data aggregation, spam.[16] We will see the effects of this noise, this formlessness, in all of the chapters that follow. In short, I might instead have used the phrase *group formlessness*, and there will be instances when that will be the more apt formulation. But I don't think that difference is self-evident or decidable a priori—especially because a structure we might like to call formless can produce affects of habitation that feel tightly, even restrictively formed. It is more often the case in what follows that we witness an oscillation, almost too rapid to consider, between form and formlessness, between coming together and being undone.

In this book, I focus as much as possible on the specificities of group form in and across such oscillations.[17] By *group form*, then, I mean to point to both the nonce and improvised, fleeting, and hypostatized shape of the group itself, as well as the materials (habits, mediums, conventions) out of which and in which such a group assembles itself, or gets assembled. Usually, in this book, they're assembled from the inside—through will or agency or self-conscious action—and the outside—through external determination that floats free of intention. And this happens at the same time and in parallel, meaning that subjectivity in those scenes can be thought of as, at best, a destabilizing quasi sovereignty. I mean, in other

words, to describe belonging *and* its mediations, collectivity *and* its interfaces. The phrase *group form* is vague because it means to be little more than a placeholder—at its best, an incitement to precise, situational description.

The art history of group form has been pursued intermittently and around the edges, although various recent typologizing literatures on "relational aesthetics," "dialogic art," "cooperative art," and "participatory art" have been trying to better understand some facets of the topic.[18] There are of course innumerable studies of various artist collectives and art movements—groups of artists who are given collective names, or assume them. But these studies tend to presume rather than theorize or historicize the *form* of the collective itself, and rarely are such group forms understood in and of themselves as a form of aesthetic labor. Rather, the stable presence and coherence of that form is presumed from the start; it predicates the writing, even in cases where the group form is known to be extremely fractious and instable, as with both the Surrealists and the Situationists.[19] More relevant to the present discussion, recent studies of relationality in contemporary art begin by noticing, each with their own preferences and attunements, a shift in the art world, a movement in need of a name, a clustering of artworks that their accounts want to explain: why has this cluster appeared, and what does that appearance mean? Thus, given the unwieldy diversity of ways to group the works that one might want to call relational or participatory, the list of possible designations for what is in almost all cases assumed to be primarily an art movement grows and grows, at worst proliferating like brand differentiations, at best intimating some conceptual and practical distinctions. As a consequence, the debates around relational aesthetics (to take only one art historical thought about group form, one that has perhaps sparked the most debate) have tended toward typologizing quibbles and, at worst, ad hominem attacks.[20] The have tended *not* to push the incipient conversation in the direction of greater specificity—neither specificity about the ordinary forms of relation *on and against* which the artworks in question build a critical aesthetics (that would be the true formal claim in a Jamesonian schema) nor much interest in discerning whether those works (everyone seems to have their own privileged set), taken together, add up to an art movement, a periodization, or some other kind of historical clustering.[21]

But the very fact of this burgeoning interest in aesthetic relationality and participation must itself be an outgrowth of a longer history of the

technological mediation of life, sociality, and citizenship. Claims about the power of presence or the face-to-face, be they Bourriaud's, Bishop's, or Baudrillard's, only really have force when seen in opposition to what must therefore be understood as a looming and ever-present threat posed by life's mediation.[22] I don't think the distinction between the face-to-face or embodied and the mediated is substantiated by much more than the power of fantasy (which is not nothing), but the shifting topology of opposition between the live and the mediated does have the value, taken all together and seen formally (conjunctively), of beginning to diagram the longer history of sociocultural mediation. To the extent that the art of modernity and modernism has been about commodities and their markets, or at least made in the long shadow they cast, it has traced an outline, as if in weak light against a vast darkness, of a history of group form. A history, in other words, of the aesthetic forms in which individuals have found themselves, if only for a moment, caught up in some larger belonging, one that might be thought to assemble individuals into something else, something bigger if not better, or to obviate the individual form altogether in the interest of some other organization of life. I take it as a starting assumption that the artworks of this period, including (but not limited to) the ones under consideration here, have addressed themselves, seriously and not accidentally, to the question of group form, and that, taken together, these constitute a still-latent aesthetics, a critical theory of group form waiting in the shadows. In other words, the overarching art historical question being pursued here is how artworks of this period have addressed changes to group form and have themselves been addressed by it. But of course it will take more than a single book to write that history. The present book picks up the story near the end, which is to say, more or less in the long present, with the advent of electronic networks as the site of contestation over the commodification of relationality itself.

Part of this book's project, telegraphed in the title, is to suggest that the recent critical theory of the present has perhaps overfocused, although for some good reasons, on the figure of the individual. This is most obviously the case in the literature on neoliberalism.[23] Here the story goes that a particular form of personhood has, in the last few decades, come to bear more and more of the burden of sustaining citizenship, belonging, sociality itself. The supercharged notion of "responsibility" means to name an ideal of self-ballasting, as if individuals were now little states, or better, little corporations. But individuality in the forms it is given today only

works when it is undergirded, at times even determined, by the population form. The following chapter will lay out this argument in detail. The phrase *never alone, except for now* suggests that individuality itself should be seen as a group form, where political atomization (one form of assemblage, specific if dispersed) is felt by some as abandonment or impoverishment and by others, mostly in principle it seems, as freedom to go it alone, to vote and shop as one likes.[24] This contorted process, both affective and technical, which makes individuality the most lonely and most crowded place on earth, is called "personalization" by Web 2.0. And Web 2.0 is itself propped up by a set of technologies and an ethos that together come to bear much of the responsibility for transforming mass atomization into a social form that is structural and structuring—functional, reproducible, and monetizable—even if it rarely offers much stability.

Here is where this research comes closest to recent work on data, now usually referred to as "Big Data," a phrasing that both inflates and hypostatizes what makes data so lucrative when it scales up—and it only ever scales up; Big Data doesn't have a scale so much as a trajectory. Big Data, for all of its technocratic implications, is a thought about group form. As Melissa Gregg summarizes: "An important area of attention in the emerging data economy is to assess exactly how users' online activity involves them in profitable transactions, often without their knowledge."[25] This Gregg names *data sweat*, referring to sweat as evidence of the body's porosity, of its capacity to "affect and be affected," and thus the insufficiency of an autonomous thought about individuality. The labors of love that populate, even generate networked life themselves produce, as byproduct rather than intended effect, a kind of sweat that pours out of us as data.[26] If in their instrumentalizing zeal the discourses of Big Data bracket the forms of life from which data gets extracted, this is only more evidence of the strong relation, albeit a parallelistic and so immanently bracketable relation, between that life and the data it generates.[27]

Historically, critically, and formally, the most challenging aspect of group form, whether we name it from one side as Big Data, or from the other as online dating or tweeting or blogging or surfing or searching, is that data isn't something that gets generated by technocrats in a space far removed and abstracted from ordinary life, data experts who, from that position outside and above, want to intersect and impact life while appearing not to do so. Things would be easier if that were the case. Then we could update, again, our idea of ideology or spectacle or advertising

and proceed with critique.[28] But the production of data depends on the realm of ordinary life proceeding fully according to its own whims, desires, curiosities, ambitions, and hang-ups. Data and life don't need to intersect, by way of a malicious or scheming consciousness, to come into direct contact, for data to be generated; data is generated automatically, and achieves its best form when people live full, variegated, and autonomous lives, at least within their own experience and sense of self. The two realms, ordinary life and data, proceed together but apart; their structure is parallel. If these realms are barely distinguishable (e.g., in a Marxist analysis of networked life), this is less because they are the same and more because, precisely in their affective and structural differences, they proceed together, near but untouching, each growing and improving as the other does, but with no necessary consciousness of each other (although, neither does our consciousness of data production change or disturb anything, which is why it's not properly an ideology).

It was in my attempt to develop a vocabulary adequate to forms of relation that are always adjacent and always untouching, and that in networked milieux are profoundly nonrepresentational, that Bersani and Dutoit's work on the "correspondence of forms" became indispensable.[29] Their own project has been to acknowledge, while also inventing, vocabularies for forms of relation that are not predicated on what psychoanalysis recognizes as our fundamentally violent relation to the world, a relation that must eradicate difference in order to stabilize the self. This project has been, then, and in my terms, fundamentally and even radically ekphrastic: a "communication of forms," in Dutoit and Bersani's alternative formulation. Often, bringing a form of relation, a correspondence, into language is a way to bring that form into being. If this marks a postpsychoanalytic phase in Bersani's own long career, it does not imply that he now rejects the psychoanalytic account of subjectivity and its modes of relation. Rather, Bersani and Dutoit recognize the brutal truth of this account. It is precisely this truth, its ineluctability, its deep intractability, its wildly variegated forms of violence and compensation, that drives their study of other modes of relationality, a study which is by turns a discovery and an invention—itself, that is, based in a correspondence, or a formal conjunction.

Their starting point is a desire *not* to predicate social relations as such on interpersonal or intersubjective relational forms. This means that intimacy and relationality, as experienced or figured through aesthetic

form—through an interface that is also, for my purposes, a commodity—are not conceptually beholden to pre-scripted sociological or political categories. Instead, Bersani and Dutoit take people's relationships with one another and people's relationships with—or within the situational scope of—artworks to be a subset of some relational category *X*, where *X* is the locus of analysis, the question mark. This reduces or dedramatizes the difference between art and life while, more importantly, leaving an opening in thought for relational forms that could only be underdescribed by our familiar vocabularies of group form: the heterosexual lover, the spouse, the friend, the stranger, the citizen. This is why their work is not about the homosexual as a person or particular practice, but about the homosexual as a category—as, that is, a potential for discovery, an experiment in relationality. Bersani and Dutoit's method is shaped by their aim: to produce knowledge and tools for remaking the social, for reconceptualizing relationality beyond, as they say, bodies and psyches. My project, not so different as it may seem, is to study informatic correspondence, something that is already remaking the social in excess of a vocabulary, beyond language and representation, which means I'm usually dealing not with relational forms ex nihilo, but with rhetorical and practical adaptations, repurposings, transformations, deformations. If I seem to have lost track of Bersani and Dutoit's political, even their utopian aims, it is only because I have found in their work a vocabulary for describing both the world-building activities of networked life *as well as* that which monetizes those worlds without much impacting what it feels like to inhabit them.

So I do not deny or bracket the ideological, pre-scripted aspects of networked life. I want to see them, rather, as part of a dense, complex negotiation that happens in the field of a technological form that is also a commodity form. Here Lauren Berlant's work on intimate publics in the nineteenth and twentieth centuries has also been formative.[30] In her work on early women's cultures, Berlant shows that the invention of spaces of solidarity, belonging, and intimacy for women in the American context have often and powerfully, if ambivalently, occurred within mass markets—for example, in novels or films marketed to women. In this, Berlant carries forward a line of thought found in Jürgen Habermas, where the criticality of early publics was potentialized once a private market for goods and services opened up a space of discourse, of life between the state and the home. For Habermas, of course, the internal logics and historical imperatives of such a market were also critical thought's undoing.

But Berlant joins this line of thought with a Jamesonian theme, one that understands form seen together with our resources for sensing and describing form—aesthetic and ordinary form, the conventional and that which would disturb the conventional—as a way of registering the violence of history.[31] Paying attention to form in this sense is not tantamount to critical reflection, or critique, or subversion, but is a way of sensing a kind of emanation from or manifestation of alienation and structural inequality, which become perceivable in the way, for instance, language systems come into conflict within novels, or historical styles come into conflict in postmodern architecture and film, or modern and postmodern conceptualizations of the self come into conflict in painting.

The mediations involved in group forms such as an intimate public— or in the neighborhood of any market for commodities—are dense and complex, sometimes opening onto scenes of intense intimacy, at other times, and within those same circuits, producing estrangement and depression. But for all of their mediatory intensity, group forms such as intimate publics are not often thought of as technological. If, however, we don't think of technology as discrete or fully equivalent to the commodities that are marketed *as* technological, as advanced, as forever new, then such intimate publics, as we'll see in the next chapter, are technologies in all but name (technologies of intimacy, of distance, of togetherness, of criticality and complaint). Of course, sometimes they also appear as technologies in name—for example, radio, cinema, or any of the channels of connection and distribution invented to disseminate cultural goods.

Key for me, in this project, is the particular way that Bersani, Berlant, and Jameson, when read together, dissolve the boundary separating art from ordinary life, but likewise, art from technology or art from commodity—not as in *art into life* or any such slogan whose prepositions always end up preserving the boundary they want to undo, but as in a Bersanian correspondence or the Jamesonian "political unconscious." In both concepts, the problem being confronted is precisely that representation fails and other modes of aesthetic thought must be conjured into being. Representational thinking is often the exclusive mode of art historical engagement with technology or media, as in art that represents technological change or art that represents forms of collectivity. Such representational logics are also what tend to make categories such as media art or net art or, for that matter, participatory art legible, even self-evident.[32] All other ways of thinking technology and mediation, when weighed against

the blunt clarity, the literalness of representational thinking, come to seem whimsical, merely idiosyncratic, or worse, ahistorical. But if the problem to be confronted is that certain modes of being together must not be represented (as in Bersani's work) or won't be represented (as in Fred Moten's),[33] or that certain techno-economic formations can't be represented (as in Jameson's work), or that the representational logics of advertising and mass markets can only underdescribe the lives of the marginalized populations to whom they nevertheless need to peddle goods (as in Berlant's work), then in those understandings of the problem, art that is thought in some literal sense to be *about* technological mediation can only presuppose what those technologies are, how they work, where they begin and end.[34] In an ekphrastic mode, where we don't presume to know everything about the ordinary commodities and interactions that are art's anamorphic other, Sharon Hayes and Felix Gonzalez-Torres (neither known as a media artist in any sense) can both teach us something about networked life. But before being able to see that, we need to be able to see how distributed networks have forced the genealogies, ideals, and practices of two group forms—the public and the population—into an extremely cramped, destabilizing conjunction that becomes the scene for networked life. That is the work of chapter 2.

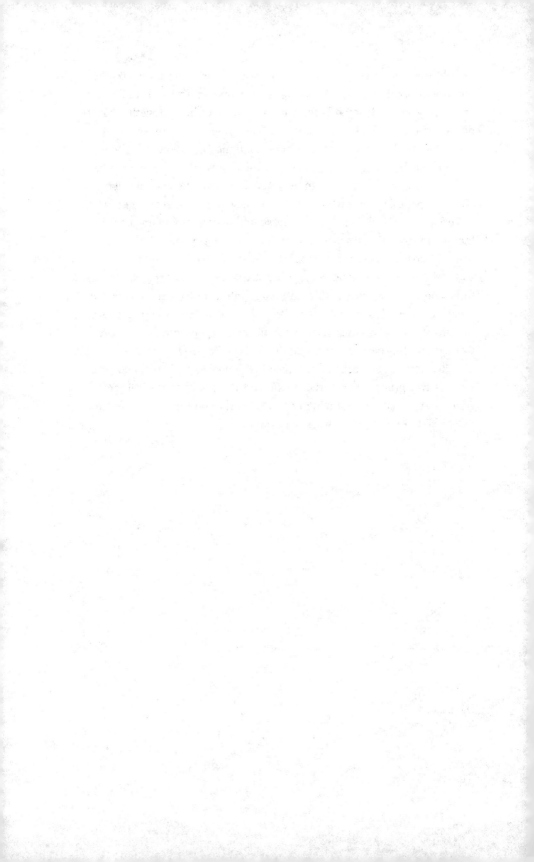

BETWEEN POPULATIONS AND PUBLICS

An unfortunate elision is permitted when, in writing on art and aesthetics, technology is made to be iconic of an age: the computer age, networked society, the industrial age. In these formulations, taken on their own, technology's influence is assumed to be so pervasive as to be atmospheric, so obvious as to be venal, or so homogeneous that it doesn't merit much specific critical commentary. There's a name for histories of art that pay too much attention to the technological quotient of their analysis: visual studies. It is in support of such prophylactic disciplinarity that Technology has become iconic of historical transformation tout court (e.g., a figure of progress). Technology has often been jettisoned into a rarefied realm where being an icon abstracts it away from anyone's responsibility to reckon with either its formal specificity or its specific forms of dissemination.[1]

Anthropologist Christopher Kelty, paraphrasing philosopher of science Paul Feyerabend, puts the point this way: "There is no single method by which technology works its magic."[2] By "magic" here, we might understand capitalist domination, technological progress understood as a humanist endeavor, or any super-iconicized account of technology. Science studies makes the key correlative point that a specific technology is not just the discrete device: it is the device, the aesthetics of its interface, the modes of interaction it invites as well as those it obstructs, the logics of production that have made the device possible, the economies of its production and distribution, and so on, on down the line from discursive formation to experience.[3] Taking such accounts to heart, we might be sus-

picious of the very attempt to carve out, isolate, and name the technological portion of any encounter.[4]

Fredric Jameson puts the point this way: "But technology is little more than the outer emblem or symptom by which a systemic variety of concrete situations expresses itself in a specific variety of forms and form-problems."[5] Or, discussing the importance of allegorical thinking to postmodernity, Jameson speaks even more to the point I want to make here: "If everything means something else, then so does technology."[6] So I'm suggesting something that sounds paradoxical but isn't: that we address technology (as intimately bound up with personhood, with sociality, with group form, with governmentality . . .) by not addressing Technology (as icon, as figure of totalization, or as its literal commodity form), by not, that is, isolating technology as a discrete portion of the social and political realms one might think of as one's real subject.

Guy Debord's epistemic notion that images are the commodity form of the twentieth century, which lends its authority and messianic perspicacity[7] to so many subsequent art historical accounts, tends to homogenize all image technologies (although it is not necessarily incompatible with a more materialist account of technology, so long as one attends to the protean historical form of commodities and, a fortiori, of images).[8] But Debord's account of a spectacularized world has often been extended into the present by way of a literalizing and intensifying logic: more spectacle, more images, more homogenization in the guise of diversification, as the world goes. Deriving their energy from Debord as well as from Jean Baudrillard and Susan Sontag, art historical accounts return, in their distinctive ways, to the image of a world overrun by images, overrun by a glut that exceeds our capacity to particularize, to learn, to differ.[9] In this, a Frankfurt School anxiety about capitalism and the particular group form of the mass is rejoined, even intensified.

The image of a mass of images has, unsurprisingly, become a common way to characterize the problem of electronic networks. The suggestion seems to be that the material and technical particularities of the Internet are invisible or immaterial (or unimportant) and can only therefore be examined by way of the barium swallow of a mass of circulating images. This is David Joselit's tactic in his 2007 book *Feedback*. The impetus for his project is the saturation of society and politics by the image and by technologies of the image, all of which he calls "the televisual world."[10] Importantly, Joselit locates his cases inside what he calls an image ecology

or "eco-formalism," where artworks represent only one part of a complex system of images, technologies, audiences, laws, and norms.[11] In a later book, *After Art*, he comes to call these "populations of images."[12] For Joselit, the idea of a population of images privileges circulation and aggregation over the singular image, the artwork or icon. The population is a mass in motion.

But if an image for Debord was always a relation, then we also need an account, at once critical and historical, of the specific *forms* of that relation, where commodities and commodity atmospheres encounter various kinds of practices, both ordinary and professionally artistic.[13] The world overrun by images still must be one part of a periodizing description; it continues to gesture importantly, for instance, to the ordinary labor, both practical and affective, of selection, filtering, and bracketing that are such exhausting parts of paying attention to or just living within contemporary culture. But, beyond the broader point I've been making about the importance of deliteralizing our accounts of technology, there is a new historical reason for being suspicious of this way of figuring the problem critical theory wants to encounter. The Platonic figure of a world drowned in images, in its unavoidable insinuation that all of those images are the same structurally or in effect (gesturing at them in toto relies on being able to bracket their specificity), belies a counterveiling, if complementary, cultural strain that moves in the direction of personalization, of disaggregation, of heterogeneity positioned not against mass culture but now resident inside of it, where it literally props up new economies of attention and circulation.[14]

In one of the most surprising aspects of his late lectures on neoliberalism, Michel Foucault describes how German neoliberal theorists (or ordoliberals) understood mass society, a world subjected to a homogenizing regime of images, as evidence of a failure of democratic politics (as though Debord himself had participated in their think tanks).[15] This is roughly the same critique being voiced at the same time by the Frankfurt School, not to mention by much postwar art history. For their part, ordoliberals attributed the problem of social and economic inequality to liberal theory itself rather than to the market, and so proposed, as cure, a purer strain of liberalism. They viewed statism itself as the problem because they believed that it was the state that generated the stifling homogeneity of mass societies. Fearing homogeneity as market stasis, neoliberal theory desired heterogeneity.

Foucault describes the practical consequences of this idea in some detail. Important here is the idea that neoliberalism, in both its theory and its implementations, has wanted not to create but to critique and correct a world homogenized by images, taking that particular image of the world to be its point of departure, even its condition of possibility.[16] The neoliberal solution, in brief, was to reconceive of people as hyperindividualized entrepreneurs, almost infinitely diverse and all in productive competition with one another, competing precisely on the basis of their productive diversity, where diversity becomes therefore a kind of branding. The individual person form, accommodated in all of its idealized diversity, thus stands as the bulwark against the state's influence on society, and more generally, as a defense against any (other) form of organized collective life.

This is why the population form is a central technology of neoliberalism in Foucault's analysis: it is a form of collectivity that accommodates both diversity and individuality, that doesn't require homogenization or seek to produce it. The population generates governmental policies automatically (algorithmically we could say now, with only a little bit of hindsight). By siphoning off the labor of the entrepreneurial individual, the population form shunts what might seem dangerously agential and self-reflexive about other forms of collectivity. Stuart Elden puts it this way: "Populations are not simply the 'sum of individuals inhabiting a territory,' but subject to variance on a number of factors including climate, materials, commerce and circulation of wealth."[17] Populations are not individuals amassed so much as the effect and source of variance. Individuals, in all of their variety, are thus one of many possible sources of variation that allow the generation and manipulation of populations. As we will see, and as many have argued, the Internet and the specific social media of the web capitalize on this especially productive relationship between the individual and the population.[18]

To acknowledge the influence of neoliberal theory on our world, as much art history has started to do, requires that we reckon with the present tense not primarily or only as a culture dominated and homogenized by images, but as a distributed network whose technologies and economies of privatization work to overorganize life around the individual on the one hand and the population on the other. One consequence has been that critical, liberal publics come under new pressures of fantasy and idealization, adaptation and recuperation while being fundamentally rewired. By organizing my study around such a configuration of public

and population rather than the figure of the world overrun by images, I want to conceptualize a mode of analysis, of art history but also of media theory, that takes as its condition of possibility and its historical basis not mass culture understood as a homogenizing force, but neoliberal culture understood as an engine of personalization and as a population form through which feelings of publicity circulate.

One important entailment of neoliberal theory, then, involves the uneasy graft of those two group forms: populations and publics. I say "entailment" because I make no claims that the contemporary world is or should be understood as a fully neoliberal one. As many have begun to speculate, perhaps that time has ended, although certainly its technologies of implementation as well as its rhetorics have continued to thrive. I merely claim that certain tenets of neoliberal theory have significantly shaped specific aspects of networked life, particularly the idea of a population as a group form that abets an antisocial logic of governmentality, combined with the implementation of networked technologies which by and large share that same logic while catering to an intensely personalized experience of individuality. In other words, I don't need to overdramatize the importance of this particular analytical line. Neoliberalism itself sits quite comfortably amid competing, even contradictory modes of governmentality, including contemporary manifestations of the spectacularized, homogenized world of mass culture. My interest is not in the overthrow of one analytical register by another, but in an accumulation of resources.

The multivalent term *neoliberalism* is a shorthand that, on its own, leaves many questions unanswered. It describes at once a period, that period's dominant governmental and economic technologies, and the immensely varied range of its impacts on people.[19] These loci of description are historically related, but not isomorphic or lockstep. One objective of this book is to give further definition to the impacts of neoliberalism rather than to assume its coherence (which is why the term *neoliberalism* won't come up much from now on)—to more precisely define what happens to group form in the there and then, here and now of a time in which individuality (overtly) and populations (behind the scenes) are privileged relational forms. I address these two forms theoretically and historically in the remainder of this chapter, and explore the space of their overlap throughout the rest of the book.

Vestigial Publics

The story of the public sphere has, from the start, been a story of decline. Habermas's titular "structural transformation" already telegraphs a turn for the worse. And subsequent additions and updates to the conceptualization and history of the public sphere either have been rescue missions, or have updated the instruments and effects of the public sphere's decline.[20] Nancy Fraser, Negt and Kluge, and Michael Warner are well-known exemplars of the former tendency, describing subaltern, proletarian, and counterpublic spheres.[21] Jodi Dean and Slavoj Žižek both exemplify the latter tendency.[22] Lauren Berlant's concept of the intimate public sphere requires both tendencies to operate together, or, one could say, is interested far less in recuperation or decline than in negotiation, bargaining, and ambivalence. It tells a story of how women's cultures in the United States have, since the late nineteenth century, built up political solidarities in the margins of proper politics, forging important life-sustaining connections and solidarities within the very commodity cultures that have facilitated women's political marginalization.[23]

Scholarship on the Internet and new media has reached no consensus over whether the classic public sphere of politics has been revived in the guise of the World Wide Web, but the question recurs incessantly—structural similarities, nostalgia, and an acutely felt need make the comparison irresistible.[24] At a first glance, the Internet complicates the problem of prophylaxis that Habermas describes. The Internet and its web cultures seem only to have intensified the collapse of the civil sphere into the market sphere, the intermedia condition of almost everything, the obviation of all autonomy.[25] On the other hand, the web does offer a space for endless debate, debate that circulates and persists, producing a space for chat and a diffuse space of belonging that exists mainly as an effect of the endless talk happening across multiple platforms—a space of belonging that exists, in other words, not as an effect of *explicit* membership policies but as an open invitation (often operating, as in Habermas's original public sphere, with a tacit membership policy).[26] But one might well be leery of a public structure where much of the work of producing a public—circulation, archiving, punctuality, and, in some cases, even debate itself[27]—is done by automatic procedures of software or marketing programs. Nevertheless, in theory (and the public sphere is theory made habitable), anyone with a computer or access to a public library with com-

puters can join in the conversation, and that's already more inclusive than many public forums.

The optimistic idea that the Internet is resuscitating the public sphere often seems born of desperation, despair over how few options for solidarity exist that are not centered on either the isolated genetic family or the workplace. In a situation where most instances of powerfully public speech emanate either from churches or from the marketing departments of corporations, a vast, albeit increasingly privatized technological network where people seem, for now, in some places, to be able to speak to each other about more or less whatever they want might well seem better than nothing.[28]

As anthropologist Christopher Kelty notices in his book *Two Bits*, most of these studies have been concerned to test whether or not Habermas's theory of the public sphere is suited *to* the present historical moment and to the Internet as its technological determinant.[29] Kelty's own study of the Free Software movement tries instead to build *on* the idea of a public sphere, to base a reconceptualization of that notion around the specific conditions that the Internet and the web offer for political engagement, or more precisely, for engagement with the very terms and conditions of public engagement itself. His concept of a "recursive public sphere" is built up from ethnographic descriptions of the Free Software movement, a loose affiliation of computer programmers committed (in a variety of ways) to the idea of free and/or open source software. A recursive public takes on its distinctive character because computer programmers are in the unique position of engaging in public discourse while building the very media and platforms of that discourse: that is, the web itself. This specific recursive structure, Kelty argues, is what makes it both properly public and therefore political.

An important implication of Kelty's study is that not all web cultures replicate this precise structure, rhetorics of participation notwithstanding—not everyone is a computer programmer or wants to be one. I will be mainly concerned with the people whose participation, whether in relation to art or the Internet, is often more about showing up than building, coding, or hacking. However productive or autonomous, this form of ordinary participation in web cultures is always laminated to a marketing scheme (now or in the future), always made to figure as a data point in a larger population. And this data is generated by the very technologies that make electronic networks possible. Far from optional or something

that one could oppose in thought or action, the lamination of data and life is all but ineluctable. This points to a unique feature of the web, and especially Web 2.0, a feature that Kelty's work helps to see: everyone's online activity *is* responsible, to a certain extent (with massive variations in know-how and access and self-consciousness) for building that world, a world that simply wouldn't exist without the activities that constitute it, activities that range from simply paying attention, surfing, and lurking to hacking, coding, and raising venture capital. Data accumulation makes all web cultures, not just the cultures of computer programmers, into recursive publics.

For my purposes, the very fact of this resurgence of debate about possible public spheres indexes not just the need to work in extension of the original concept, as Kelty recommends, but the way that so much contemporary life is lived in proximity to the thought or fantasy or floated possibility of a public even while that fantasy is always and everywhere threatened by the dominant counterveiling force that I will be concerned to track throughout the book: that of the population. If people are searching for the means, including the vocabularies, with which to again inhabit a critical public sphere, a space where their words might come to matter as actions, it is because there is at least an ambient, if not yet a practical, awareness that the collectivity of the population form works against these desires personally, structurally, and technically.

A Group Form Built Not through Will or Even Consciousness

Here Foucault's Collège de France lectures on neoliberalism, delivered in the late 1970s, again become important.[30] Biopolitics, the concept around which Foucault framed the lectures, takes the management of life as its primary task, and management requires knowledge. This link between management and knowledge is a defining feature of Foucault's late work on neoliberalism. It's not that politics hasn't always, in one form or another, been concerned with the management of life. What is distinctive about the biopolitics of neoliberalism (aside from its particular definition of life)[31] are the technologies it employs to make lives produce knowledge. Key here is that these technologies produce knowledge without the active or direct involvement of the people who go on living those lives. Examples would include: actuarial sciences, epidemiology, the consumer spending index, immigration statistics, and demographics of all sorts. The non- or

quasi-participant status of the subjects of such populations has been immensely complicated by the technologies that have succeeded those of Foucault's archive. Social media, for instance, solder a hypertrophic fantasy of sovereignty (freedom from gender, from bodies, from repressive Big Media) to a notionally resuscitated democratic public sphere while undergirding both of those fantasies with automatic data-gathering technologies that generate a group form that can be neither chosen nor unchosen. The recent National Security Administration scandal brought to light by Edward Snowden spectacularizes this process by fluorescing each of its constituent parts, its overlay of populations upon publics. In fact, one of Snowden's accomplishments was to transform the affect of that relation into something more paranoid, more insidious—to wrench it away from the ordinary facticity, the matter-of-fact technological rationality which it had achieved.

In other words, the counterpoint and ballast to neoliberalism's faith in the individual as the zero degree of society—part of what allows this model to work so well for a small fraction of people—are the technologies of the population form. A population is a form of affiliation, but significantly, one that is *not* built through acts of will, choice, solidarity, coalition building, or the "stranger intimacy" of a public sphere.[32] Neither is it recursive in Kelty's sense or autopoetic in Michael Warner's sense, where autopoesis describes the bootstrapping nature of publics, the way a public needs little more than the talk that constitutes it in order to persist.[33] A population, as I'll elaborate throughout the book, is more structurally analogous to what Alexander Galloway, speaking about biopolitics in the context of networked technologies, calls a "protocol."[34] "Protocols refer specifically to standards governing the implementation of specific technologies. . . . Computer protocols are vetted out between negotiating parties and then materialized in the real world by large populations of participants (in one case citizens, and in the other computer users)."[35] A protocol is a governmental process, meaning not necessarily a procedure of any actual government, but a procedure that may gather itself anywhere—government, corporation, software, hardware, the informal etiquette of a chat room or art gallery—toward the organization of life (I use the generalized term *life* because the coherence of the individual subject with a distinct subjectivity can't be presumed in this context).[36] Such organization might look like domination or coercion; more likely, it will look like group behavior or even the self-organization of a fan site

(see chapter 4). Such an affiliation, accordingly, would be one that is exfoliated from the experiential surface of other processes, processes that *do* tend to be understood as subject to individual sovereignty, choice, decision, or agency.[37]

I refer to this structure—between the public and the population, between subjectivity and forms of life that aren't predicated on the coherence or will or self-consciousness of a subject—as parallelism. It is a key component of the aesthetics of contemporary group form and will recur as a persistent theme throughout this book. For example, when I make a purchase from Amazon.com, my choice is logged, as is the search that led to the purchase, and the details of this entire shopping process are archived in a database.[38] A database is itself a form of grouping—it contains populations in potentia, while it generates the personalized modes of address that in part prop up a feeling of individuality. My personal choice of product, aggregated with other people's personal choices, generates a great deal of valuable information for Amazon and its affiliates: sales data, of course, but also buying and browsing patterns, all valuable sources of information that can be sold to advertisers. In other words, the choice to buy a particular book generates various groupings of people— demographics, marketing categories, potential users of a related service— that can be described as populations. These are collectives of protocol and algorithm rather than of autopoesis or recursivity or conscious action. One might very clearly understand that these are the stakes of participation while still recognizing the recommended books as close to one's own interests, as remarkably, even mystically related to the version of self that one had carried into the encounter, or that one would like to see spooling out into the future. What makes this process distinct from any advertising anywhere, which of course all aspires to produce such forms of lucrative knowledge about its customers, is its automaticity. And this automaticity is what, in turn, makes the information gathered from consumer behavior—which is to say, now, pretty much any social behavior—accurate, a quantitative rather than a qualitative knowledge. Populations, unlike markets, are not best guesses; they are accumulations of facts.[39]

The automatic or protocological affiliations described here may sound like a paranoid structure in Eve Sedgwick's sense—a "hermeneutics of suspicion," a big, encompassing, self-perpetuating idea about the hidden, motive forces of the world—but they are not.[40] The processes that produce populations are not hidden. There is a great deal known about them,

a great deal that can be learned about them, and their ongoing research and development is closely covered by all variety of press, from the smallest blogs to the largest newspapers. Rather, they are parallel to ordinary experience. The drama of these processes isn't about whether or not they exist; it's about how little our awareness of them (or our lack of awareness) seems to matter.

This parallelism is what allows populations and the subject fantasized as hyperagential to endure as a productive, even a structuring contradiction: people make choices, make friends, buy stuff or wish they could, have at their fingertips more resources for connection than ever before, and at the same time, in a separate sphere, related but not via sovereignty or self-consciousness, populations get compiled, organized, and mobilized. A rhetoric and a felt reality of individualism exists, thrives, and is catered to on many levels, from the commercial to the political.[41] When I discuss the individual and individual will or choice, it is not to resuscitate or reclaim those terms, but rather to track the sources of their historical reemergence and amplification in the context of networked life. Meanwhile, populations get generated as a central if not dominant form of collectivity in networks. But the connection between the two spheres isn't necessarily the effect of any one person's or any one organization's intention. The connection in the majority of my cases is algorithmic, automatic, a feature of the very mediums through and in which personal transactions take place. This is another reason why the language of individual will (or collective will for that matter) belies the historical conditions under which those terms are today so often and so vigorously rearticulated (as part of the democratic claims of early Internet users or the marketing claims of a company like LinkedIn). The automaticity and parallelism of the population form is a key characteristic of web-based collectivity, and of networked technologies more broadly—media, in other words, in which the aesthetic interface is isomorphic to the social interface. And they are a feature of networked mediation that the artworks I consider in the following chapters take up explicitly, if partially and obliquely.

And so I argue that many of the forms of intimacy that have been invented in the vicinity of electronic networks—centrally those predicated on nonreciprocity (chapter 3), on the most glancing and opaque kinds of tonal contact (chapter 4), and on radically partial forms of subjectivity (chapter 5)—are adaptations to living in the space between publics and populations. While appropriating elements of each, they are neither one

nor the other entirely: they embody fully neither the felt belonging of publics nor the algorithmic being of populations. When one forwards an email in order to share something funny or baffling or rancorous, that action participates, automatically, in several processes of population-formation: if identified as part of a viral movement, it might become a news story or the seed of a new web-based service; it might show up in a search engine's database or be mobilized as evidence for or against a particular political opinion. But, despite all this, the action of forwarding is not merely governmental. It is also the entrée to and the product of a felt connection; it is both the medium and the evidence of that connection, however fleeting, glib, or unmemorable. It might produce laughter, or discussion, or nothing at all, but it is still a vehicle of attachment and belonging to a vast field of nonce affiliation.[42] Potentially a public, affectively a public—and by "public" I mean here only the very low bar of a group who is conscious of their existence *as a group* in such a way as to spread the power of authorship around, to delink authorship from the individual. In Sharon Hayes's street-based performance *I March in the Parade of Liberty, but as Long as I Love You I'm Not Free* (2007–8), taken up in chapter 3, passersby might be galvanized into a public by Hayes's political speech, or by the conventions of the love letter she also mobilizes, but then again, the performance is addressed to an absent lover, and so, spoken in the street, its address calls out to the everyone and no one of the urban environment, where there are so many resources for not listening, for not belonging, for not completing the idealized liberal circuit of reciprocity and publicity.

These first two chapters have needed to be largely theoretical and over-arching, an attempt to conjure the historical setting for contemporary problems of group form and its key determinants within the awkward join of publics and populations. All of the remaining chapters attempt to describe life as it is lived between publics and populations. The next chapter considers one familiar ballast of group form that has been lost in this conjuncture: that is, familiarity itself in the form of convention, pattern, predictable response, or what liberalism has understood as reciprocity. The chapter sees this loss as dramatically evidenced and precipitated by one of the most oft-fretted features of life online: the prevalence of trolling and other forms of vitriolic or just random speech. Performance artist Sharon Hayes's "love addresses" teach us about this loss.

BROKEN GENRES

In the most optimistic of the literature on social media as well as some of the most pessimistic, the Internet's democratic promise appears as more than just a human potential. It is a kind of technological guarantee, almost a structural inevitability. This is why the public sphere concept has been so alluring in Internet studies. Like the original public sphere in Habermas's conception, social media can seem to combine private intimacy, public speech, and autonomous criticism in platforms with relatively low barriers to entry.[1] The fact that these barriers seem to be even lower than the one explicit property-owning requirement of Habermas's early public sphere makes it appear as if the Internet has practically automated the capacity for public critique and open exchange of ideas.[2] It is this thought that fuels the expressions of outrage that occur whenever these democratic ideals seem to be obstructed. And it is this thought that supercharges the resulting appeals to various forms of liberal humanism—ideals of generosity, reciprocity, and decency that the Internet has seemed to both guarantee and forever betray. If the technology makes democracy so easy, then it must be humans (again!) who are to blame.[3] From this perspective, bad online behaviors such as cyber-bullying, stalking, trolling, spam, even advertisements look like the betrayal of a live ideal, and are often responded to as such, with laments for what might have been, with accusations of deviance and attempts to purify the medium.[4] This exculpatory logic places its faith in identifying bad behavior, thinking that doing so makes the solution obvious. And this faith, in turn, as I discussed in the previous chapter, relies upon an assumption that humans and the networks they

foul are analytically separable, distinct.[5] Such a view leads commentators to overlook the possibility that the Internet and its social media might be immanently, technologically nonreciprocal and to overlook thereby the forms of intimacy people invent in acknowledgment (not disavowal) of this fact.[6]

This chapter considers the problem of trolls and other bad citizens of the Internet, but, unlike the reactions I've just sketched and that I'll address in more detail below, it does not start with the presumption that we know what proper interaction or proper personhood looks like in networked spaces. Specifically, unlike much of the most optimistic and pessimistic Internet literature, I do not presume that liberal personhood and the related ideal of intersubjective reciprocity are the standard by which we should describe and analyze networked life and the group forms that establish themselves there. Starting instead with an open category of sociality, one in which personhood, technology, and economy are deeply, inextricably intercalated from the start, the dominant structure of relation in encounters with bad actors comes to look not like antagonism or hostility or acrimony or even apathy, all of which are genres of liberal reciprocity (just not comfortable ones). Rather, the dominant structure is a kind of nonvolitional indifference where the outcomes can't be predicted and, even if they could, bear no necessary relation to one's own actions, to what we would otherwise think of as subjectivity and agency. In short, I read these encounters with the Internet's various befouling trolls not as betrayals of a liberal ideal, but as something structurally distinct: intimacy without reciprocity. Nevertheless, intimacy of whatever sort brings with it certain generic expectations—that intention will matter, that exchange will be reciprocal in some fashion. So I refer to the experience of intimacy without reciprocity, the experience of many forms of bad behavior online, as a broken genre. Both the performance art of Sharon Hayes and the actions of trolls, who have become avatars of all bad behavior online, teach us about intimacy without reciprocity: they each effect it while also being themselves one of the effects of the widespread distribution of intimacy without reciprocity as a new norm of sociality—the generalization, that is, of the population form.

To speculate that social networks are nonreciprocal, not an in-kind exchange and often directly antagonistic to in-kind exchange—a social platform that many others have generalized as one of an overreaching com-

petition—is to begin to speculate about the basis for an altered form of audience orientation.[7] This would be predicated on a different form of subjectivity, one that establishes itself not on the a priori imagination of a structurally (if not affectively) sympathetic hearing, but on the possibility of any-response-whatsoever, including no response. This chapter is about a structure of expectation that still floats and is felt in online spaces—an expectation for reciprocity, for exchange, for equal access, for listening— but that is everywhere flustered by the networked logics that make connection, speech, and listening into something with no guarantees: for audience, for listening, for response, for legibility. In place of a genre, we have what Jean-François Lyotard has called a differend; in place of connection, parallelism; in place of publics, populations; in place of reciprocity, asymmetry.

This might be expected from the social changes wrought by a new liberalism that has increasingly replaced an *ideal* of reciprocity guaranteed by property relations with a *rule* of competition that generalizes the logic of property.[8] Electronic networks might contain nodes of resistance to this situation, but they also have been the engine of these transformations and so, in many ways, embody their illiberal logics. That thought, specifically its torqued structure, will anchor my claims here. Sharon Hayes's performative remediation of the resulting conditions of collective life will give reason to think of those conditions, in a phrase taken from Hayes's "love addresses," the central cases in what follows, as a "broken echo of love." "Echo of love" is a metaphor for the conventional fantasy that love is a reciprocal relation: what gets given gets returned in kind, as though it were an echo. Sharon Hayes's *I March in the Parade of Liberty, but as Long as I Love You I'm Not Free* (2007–8), like all of her "love addresses," performs performance art itself, and, within that frame, love and protest, as broken structures of reciprocity. It thereby hints at an incipient social structure that rewrites the software of democratic social life in the code of competition. I thus read Sharon Hayes's performance as a transitional form within both a history of performance art and a history of liberal democratic speech. Many of the Internet's so-called bad actors, the most vilified members of the web—hackers, crackers, whistleblowers, and trolls, the figures I will take up most concertedly in what follows—embody an allied logic, and so my claim here is that both Hayes's "love addresses" and Internet trolls, each in their own ways, acknowledge (as a bruise acknowl-

edges a blow, or a mirror acknowledges a body) the jarring transition from intimacies governed by liberal genres of reciprocity to intimacies governed by the algorithmic logic of competition.

The confusion caused by such breaks in the circuitry of the social needn't be an effect of any particular technology. They could, instead, be an effect of the relentless pace of change, or, to say nearly the same thing, of product substitution.[9] People live constantly within the breakup of familiar forms: forms of speech, interaction, and encounter that no longer seem to work or that don't work in the same way. Products (experiences, services, objects) are purchased, lived with, then go out of date, leaving us amid the rubble of their broken remains—the residual habits and gestures that taken together constitute our attempts to inhabit those forms and turn them to account. But discrete commodities—say, iPods and photoblogs—are only the most obvious things to arrive and then be broken up on the rocks of the new.[10] Actual communities do too insofar as these rely on clusterings of discrete technologies, as well as more general forms of being together—social worlds and political worlds. But if media and associated forms of life, under the relentless pressure of capitalist innovation, can never quite congeal into habit, into something familiar and reliable, they are also never quite perfectly ephemeral. They leave residues on our bodies and in the culture: remainders of habit, gesture, and desire.

Drawing on the work of Fredric Jameson and Lauren Berlant, I will call this historical scene of everyday disorientation—our living amid the breakup and reconfiguration of commodity forms and the social practices they harbor—the "broken genre." Both Jameson and Berlant extend the concept of genre from the study of literature to the study of social life in order to refer to the vague but sensible shape of a floated promise, often violated or threatened with violation, that nonetheless structures expectations and sets the conditions for the habitation of ordinary life. Berlant builds on Jameson's conception of genre as a "tacit agreement or contract"[11] in order to think about how "people's ordinary perseverations fluctuate in patterns of undramatic attachment and identification."[12] Accordingly, Berlant understands genre as "a loose affectual contract that predicts the form that an aesthetic transaction will take."[13] In this sense, anything that appears as an "organised inevitability"—that is, anything that issues a kind of tacit contract for how an encounter will proceed—is operating as a genre.[14]

Because this conceptualization of genre deals with promises, and the fantasies and threats that circulate around them, it is especially good at describing forms of communication that are governed by an ideal of reciprocity: for example, gift giving, political speech, love talk, liberalism. And so it is also especially good at describing a historical moment when commodities (promises with price tags) are now the explicit scene for so much social and political life. I am thinking, of course, about social media such as Facebook, Twitter, and Instagram. But I am also thinking about the very structure of networked media that want to profit from democratic-sounding forms of speech and interaction (e.g., the idea of the web as a new public sphere, or of networks as spaces of equality) while at the same time being governed by a technological platform that is structurally indifferent to the content and form of speech.[15] Where the legacies of liberal speech and other genres of reciprocity meet up with the technical conditions of networks and networked social media seen as preobsolescent commodities, there we find the broken genre.[16]

If the concept of genre helps to describe this cycle of expectation, loss, and disorientation, then Lyotard's work on what he called the "differend" can help describe the topology of social encounter that people living between publics and populations are forced to navigate. It can also help us move between the kinds of competition meant by economists and the forms that competition takes in social media, which of course often feel (and are marketed as) collegial, chummy, collaborative. Lyotard invented the language of the differend to describe a kind of violence that occurs when one side of a dispute wins not by overpowering the other, but by refusing or failing to recognize the idiom of the other as one that is sensible or legible in the most basic sense.[17] From the perspective of the dominant argument, the other lacks validity, or merit, or even, in extreme instances, the most basic existence as speech. When the differend is operative, what occurs is not so much an argument or conversation as it is a disappearing act, a radically asymmetrical encounter that denies one party even the most schematic form of reciprocity. It was important for Lyotard's project, one that exposes the differend as a violent tactic, to describe the differend as an event, a dramatic rupture, because the operation of the differend requires misrecognition of its dramatic structure. To work effectively as a differend, as a form of domination, the differend must be seen simply and unobtrusively as something else: as pure or superior reason or, less obtrusively still, as language working just as it should to sort out the difference

between right and wrong, good and bad. The differend, in other words, is a radical nonreciprocity: it does not listen and it does not hear; it denies its opponents even the basic dignity of being called irrational or wrong.

In the forms of sociality I track in what follows, the differend becomes diffuse, less a tactic or act of violence than a kind of social platform, a social technology functioning in parallel to various economic technologies, and the basis for various forms of interaction on electronic networks (and beyond).[18] The differend's temporality becomes no longer that of the event but that of the ordinary, of everyday speech and intimacy. It makes ordinary group form into a broken genre.

Sharon Hayes's "Love Addresses"

Sharon Hayes is an artist of the broken genre. In her performance *In the Near Future* (2009, plate 1), the artist stands alone on city streets holding protest signs from other eras: "Ratify the ERA Now!," "I Am a Man," "Strike Today," "Actions Speak Louder Than Words." In this work, as collective history gets materialized as non sequitur, as the voice of collective protest is evoked and untethered from its audiences, as urgency gives way to a problem's ongoingness and diffusion, the genre of public speech breaks as a condition of its public performance. As an artist of the broken genre, Hayes indicates the ways in which the differend has become a determinative protocol of social life's mediation.

I focus here on *I March in the Parade of Liberty, but as Long as I Love You I'm Not Free* (2007–8) as exemplary of Hayes's "love addresses," a set of works that conjoin love talk and protest talk in the form of love letters spoken in the streets of a city.[19] A December 2007 performance of Sharon Hayes's *I March . . .* began with Hayes standing just to one side of the flashy glass and metal façade of the New Museum in Manhattan, as though sheepish or uncertain about her place there, despite the authority conferred on her by the megaphone she held (plate 2). Little else about her appearance stood out, or seemed intended to: brown coat, cold-weather hat, gloves, scarf, jeans, unscuffed work boots. Her clothes, neither ostentatiously feminine nor masculine, were too casual and too urban to betray any particular profession or special purpose. Standing in that place, dressed sensibly for a wet autumn day, she raised a megaphone to her mouth, and, to no especially large or well-organized group of people—a few museum folk, mostly people in the street who did not

stop long to listen—spoke in the genre of a love letter. But it was a love letter that was, from the start, intercut with the slogans and conventions of protest speech.[20]

At the beginning of the short speech, the layering of the genres, love and protest, is tidy and coherent—that is, organized into a coherent narrative—the love letter telling the story of a love that flowers in a time of passionate, optimistic protest. But this organized formal layering, in which the genres work together to make sense of each other, gradually erodes over the seven minutes of the speech, leaving one genre showing through holes in the other, each an interruption of the other's conventional legibility.

The short speech, repeated in its entirety three, and sometimes four times over the course of a single performance, tells a love story set in the first mass demonstrations in the United States against the Iraq War. As the optimism of protest dies and the war continues, love dies too. The disillusionment of failed protest reveals the liberal democratic promise of sympathetic listening—the idea that if a protest is allowed to happen as a privilege of democratic freedom then it will eventually come to matter—to be a sham, democracy's bad faith. This realization breaks the circuit of love for the lovers. Love and protest are thus conjoined in their faith and reliance on the promise of reciprocity. When each iteration of the speech ends, Hayes lowers the megaphone and walks quietly, purposefully, as though alone to a spot seemingly chosen in the moment, some other street corner in Manhattan three or four blocks away, and begins again, the same speech, varied only by the fallibility of her own memory—words dropped or added, remembered and forgotten, but otherwise the same speech.

The performance ends as informally as it begins, without apparent moment or gesture of finality. Hayes never emerges "afterward" to take a bow; in a sense, there can be no afterward to something that never really asserted itself as an event. It ends, in other words, as if it had no audience, or was heedless of whatever audience it had. This would be nothing more than a conventional "fourth wall" approach to theatrical spectacle except for the persistent ambience of people around the piece who weren't there to witness a performance, and to whom the piece was addressed every bit as much as it was directed at its art audience. That is, the performance was overheard as much as it was heard; heard fragmentarily and obliquely, if at all, by people who pass hurriedly, attending to the performance as much

as haste and urban propriety and the business of life allow. Few were arrested long enough to present for Hayes a stable site of address or reception.

In the December 2 performance (2007), Hayes started at the New Museum. After delivering the address there, she walked to three intersections, all on the Lower East Side of Manhattan, an area iconic for many reasons, all of which are now organized by the way the area stands as the icon of gentrification tout court.[21] Hayes first walked west to Prince and Elizabeth Streets, where she stopped and spoke across a four-way intersection; next she walked west and then north to Bleecker and Lafayette, where she spoke with her back to a hardware store; and finally walked north to Lafayette and Astor, where she spoke with her back to a prominent Starbucks coffee shop. At each stop, the few people who were following her, and whom, for that reason, I describe as a conventional albeit mobile audience, settled in desultory arrangements near Hayes, but never too near: close enough to hear, but not to interfere with the aura of the performer, as though there were a stage wherever Hayes decided to stand. But working against the stable group form of an audience, Hayes's self-containment throughout the performance, her lack of interaction or regard for either audience or passersby, generated an air of detachment. Her projection of the love address to no one in particular, combined with her efficient and private walks between speaking sites, gave the impression that a process was unfolding whose motives were not available to those who would witness it. One could watch, or not, but the choice was entirely one's own to make and, in any case, wouldn't affect the performance one way or the other. During Hayes's purposeful and unhesitating walks between sites, the audience followed, but not close enough that they appeared to be affiliated with the performer or with one another. For the first performance I attended, eight people assembled as an audience at the New Museum, and eight remained at the conclusion of the performance, confirming their status as an audience, with their cohesion as a group tied to the duration of the performance. Non–audience members—passersby, the momentarily curious, those constituting the noise of the street—were attentive only during the speaking parts of the love address, and I never saw anyone stay for an entire iteration of the letter. Most would arrest their walk for a few moments, possibly trying to assess the basic generic conventions of the speech, then move on. One such person approached me, sensing that I was present to the event in a particular way, different

from his own, and asked me if this was Art (the capitalization was audible). Not wanting to immediately close the case for him, I told him that I didn't know. For one final beat, he returned his attention to the *whatever* of the performance, then walked away.

As that passerby might have sensed, the opening sentences of the love address establish a generic ambiguity at the level of the speech's content — that is, as an expressly thematized aspect *of* the address, redoubling the more overarching confusion between love letter and protest speech established throughout the address. Those sentences begin: "My dear lover, I'm taking to the streets to talk to you because there doesn't seem to be any other way to get through. So that you have a picture of where I am, I'm standing on the street on the corner of Rivington and Orchard."[22] The failure of love letters to "get through" drives her into the street, and into another genre of speech, one that is more manifestly public, political, and therefore, diffuse in its mode of address. After stating the date, her location, the situation of her voice itself (a scene of perpetual liveness: "I'm speaking into a megaphone"), and situating the present tense for someone who will be hearing these words as something spoken in the past ("it's World AIDS day"), she continues the thought with which she began, describing a broken circuit of love: "You refuse to answer my messages, my letters, my phone calls. But I know that the ears are the only orifice that can't be closed, so I will speak to you from every street corner if I must."[23] This may seem to privilege manifest content too much over what would then appear, by contrast, as the form of the work. But in a performance constituted as a speech or address, the words of the address *are* the encompassing form as well as the medium of the work, producing the situation around or in which gesture, tone, affect, and extra-rhetorical meaning coalesce. Here, in the enmeshing of love letter and street protest, which become mutually constitutive and mutually interfering, genre fluoresces as a set of expectations and the reciprocating awareness of those expectations. Genre thereby becomes multistable, confused, and eventually, unworkable.

The farther Hayes traveled from the New Museum's façade and that institution's PR machinery, the less her performance constituted itself for an audience, per se: for, that is, an attentive group of watchers, united by their watching, their investment, their knowledge, their insider status as art consumer or Sharon Hayes fan or historian (plate 3). Increasingly, as Hayes iterated the love letter from one corner to another, the performance

simply occurred amid the street, amid a congeries of activities united not by a common focal point, but by their proximity in the total absence of a common focal point. Hayes, along with her small audience of followers, gets absorbed into the noise of the urban street.[24] Group form becomes ambient, no more or less distinct than anything else that occurs on busy streets. In this situation, Hayes's performance elicited the kinds of minor reactions provoked when someone on a city street talks loudly to themselves, or asks for money: a mix of aversion, timid curiosity, forceful resistance, and outright voyeurism. All of these nonreactions are part of the habitus of a crowded street, but also, responses to or even better, resonances with Hayes's own self-containment: her address that demands nothing from her (over)hearers, not eye contact, not attentiveness, not even listening. It seems clear from the narrative of the address that something about the public site of the performance is integral to the form (the speaker references her speaking situation in the letter), but not the possibility of interacting with passersby in a two-way exchange, not even the lopsided two-way exchange of performer and audience. Hayes seems to build the performance around an evasion of just such a form of exchange, moving ever farther from the New Museum until she decides, for reasons that are opaque to all but her, that the performance is complete—or, in any case, finished.

Hayes's performance takes its title from a Bob Dylan song called "Abandoned Love," a song that shows the love relation to be a training ground for the persistent ambivalence of attachment.[25] The song's wounded first person suffers under the somatic pull of attachment, his body "swoonin'" and "tellin'" him about the attractions of love, while "something else," some other part of himself, is telling him to abandon love. By the time we arrive at the line that gives Hayes's performance its name, it is already clear that the song's first person believes that the project of love makes "freedom" and "liberty" incompatible, makes, that is, the autonomy of the person form unworkable. Love teaches the singer about personhood more than coupling. But the song leaves the cause of the disillusionment ambiguous: is it the idiosyncratic fact that the absent lover is, as the song says, "strange," or the more impersonal claim that "the treasure can't be found by men who search / whose gods are dead and whose queens are in the church"? Is the problem love in general, or just that particular love? Love is in the song's past (it is an "Abandoned Love") while the verses of the song never stop returning to what's sticky about love. Love's reci-

procity here looks like a repeated pattern more than an exchange; a compulsion to travel and retravel the looped circuits of one's own ambivalence. When, in the lyrics, righteousness is revealed to be vanity, the reciprocating circuit of love is revealed to be, in fact, a one-way street. In the song, this is a source of persistent suffering that does not end when the song ends; its final line is "Let me feel your love one more time before I abandon it." Love spools forward, if only just beyond the bounds of the song. But love's one-way street is also the pain that generates the song as a form of speaking out. In Hayes's performance, this broken circuit is the starting point for public speech, for the speaker's reinvention of the parade of liberty as a march of one. The speaker's animating hope, bespeaking her self-containment, is "that some mere phrase, some single word, some broken echo of love might reach you, and find its way to bounce back to me." In that unlikely hope lies the premises of an intimacy without reciprocity, the empty "you" a relay that never completes its circuit, despite the very real desire to do so.

The tone of Hayes's performance, like that of the song from which it takes its title, is plaintive, modulating up to plangent when love's loss is the topic of speech, and down to a steely show of righteous indignation when the vocabulary shifts to what the speaker calls "movement talk." Hayes transmits affects ranging from desperate to disappointed to hopeful, but all weighted with the knowledge that the circuit of love has been broken and that that broken circuit itself is the medium of speech, the medium of the love address. The speaker of the letter implores her lover, diffusely articulated as "you," to submit to the imperatives of love's endurance. But affect here does not connect to outcome, it is not mimetic, not a prediction or even a hope in that sense. The address is not, in other words, sentimental, seeking to attune its hearer(s) to the right frequency of feeling.[26] Cultural geographer Nigel Thrift argues, relatedly, that urban streets can absorb a great deal of excess, dissonant affect, massing it together as a great noise the constancy of which can be taken for harmony, for people getting along.[27] In other words, affects should not be understood in this context as forms of address.

Even if she speaks on the street, Hayes doesn't exactly address the street as any kind of incipient public; her performance's polygeneric stance between love letter and street protest is evidence enough of that. It is as indifferent to the street as it is to its audience, its institutional patrons, its overhearers, and its passersby. It charts a trajectory away from all such

guarantors of generic legibility. It moves in space away from its institutional bases (the museum, the museum audience), it erodes narrative coherence, it speaks to someone who cannot answer, it entangles the expectations of a love story (that might, for instance, ask us to feel sentimental) with the expectations of a story about protest (that, for instance, asks us for solidarity or disagreement). Sitting between genres, therefore to the side of each, the performance produces innumerable responses, but—and this is really the key to its illiberal form—no formally predictable ones, and nothing that could be said to be addressed specifically to the performance as a form of response.[28] Being wayward, its replies can only be wayward; it addresses everyone and no one, indifferent to all particulars except a "you" that can only be a placeholder. Indifference here is both a differend and its own broken genre. As such, it is not the same as apathy, which is a kind of reciprocity or response, just not an affable or engaged one. It is simply not inclined in any particular direction, not toward an audience, not toward a lover, and not toward any specific effects or outcomes.

The potential to feel incidental to an artwork that is indifferent in this way blocks a participatory, dialogic, cooperative, or relational aesthetics of encounter, at least in the way those modes have been formulated to privilege conversational reciprocity, a two-way exchange that repairs a broken liberal-democratic circuit.[29] Hayes's address does not explicitly galvanize its listeners in its appeal, its politics, the issues it raises. It solicits neither identification nor sympathy. Rather, the speaker hopes her words travel from point to point, person to person—*through* people, not stopping to rest with them. Here, the rhetorical form of the speech matches its spatialization, its mode of circulation through the streets. The speaker of the love letter hopes that her message might be passed from one listener to another, circuitously, unpredictably, invisibly, to possibly reach the ears of its intended. Confronted with the failure of the voice to speak directly to its intended and elicit the desired reply, the reply that completes an intimate reciprocating circuit between two people, the speaker takes an action that in other contexts, including both political protest and the history of twentieth-century art, might sound radical: she "takes to the streets."[30]

RoseLee Goldberg, in her history of performance art, cites this desire for immediacy, for taking a message directly to a public, as a defining tendency in the long history of performance art.[31] But here, in Hayes's

street-corner response to the broken circuit of love, the voice's addressee, to the extent that it can be imagined to have one, is diffuse—comprising, hopefully, the mobile everyone and no one of a few street corners in Lower Manhattan.[32] This diffuse, attenuated scene of encounter takes its chances without the structural guarantees of a recognized genre, without the predicate promise of a future hearing. Hayes produces an address indifferent to reciprocity. It doesn't obstruct reciprocity so much as it simply exists without it, without even admitting the formal possibility of it.

As such, Hayes's performance lies at the extreme point of an anti-reciprocal trajectory in performance art which has established itself in parallel to, although not always in accord with, an antireciprocal trajectory in other media of intimacy, collectivity, and exchange.[33] In her description of Yvonne Rainer's role in early performance art, Carrie Lambert-Beatty emphasizes the status of spectatorship as an established, reliable circuit of perception between performer and watcher, and as a self-imposed formal constraint of Rainer's aesthetics.[34] Lambert-Beatty argues that Rainer's work, although often characterized as antispectacular for its seeming hostility to the conventions of dance, is in fact deeply spectacular, and therefore in dialogue with its audiences structurally and aesthetically, if not always affectively or tonally.[35] In other words, Rainer's performances were predicated on an understood circuit of reciprocity between performer and audience, a sympathetic awareness, even if audiences left feeling that their expectations had been snubbed or their desires ignored. To be snubbed, those desires had first to be recognized. Anticonventionality, in other words, is not unsympathetic or lacking reciprocity; its reciprocity lies precisely in its opposition. The sympathetic circuit with an audience, Lambert-Beatty argues, is never broken in Rainer's work. It is bent, provoked, threatened, and redirected, but always returned in some form, even if unrecognizable. Rainer, Lambert-Beatty says, is a sculptor of spectatorship.[36]

The same is true in effect, if not in intention, for any performance that situates itself in front of a group of people configured, thereby, as an audience. Such performances, following convention, predicate themselves—their issuance and their reception—on the spatial and phenomenal structure of performer–audience relations, even if the point of the performance (as was the case with Rainer's performances) was to disorganize these strictures of space and generic form. When Andrea Fraser addressed her audience as a museum tour guide in *Museum Highlights* (1989), the

address was an imposture, and the tour goers might have felt defrauded by the ruse, but Fraser left the circuit of communication intact. Indeed, the piece relies on the coherence and recognition of that circuit connecting performer to audience, tour guide to museum visitor. The defining feature of such a circuit is not the authenticity or duplicity of encounter, but the fact that it solicits its audience (configures people *as* audience) through those circuits, which makes the encounter feel like a two-way street, however rife with misrecognition, dissatisfaction, or cynicism. Dissatisfaction, in fact, travels backward along the same intact circuit; it occurs because the two-way street of communication was recognized to have been intact, but returned a disappointing response.[37]

These strictures are loosened in Happenings, for instance, or more relevantly for the present context, in performance art that moves into the street, not because the street is anti-institutional or antispectacular, but because in that setting there is more latitude for existing to the side of the various vectors of activity and address. All car horns might be warnings for someone else. This is why being hailed in the street can feel especially claustrophobic: it imposes the responsibility of a reciprocating circuit onto a space that formerly afforded more options for anonymity, evasion, and, in effect, privacy. Part of the city's famous anonymity is an immunity from conversational circuits, ordinary reciprocities of genre and convention. Described in the language of the marketplace, streets are rarely organized around or by a single product; rather, there are so many products on offer, from the wares of any particular store, to the ambiance that a city like New York has worked so hard to market and sell, that at best we can say that people are organized by the overabundance.[38] When performance configures spectators into an audience, the performance becomes the product that organizes attention—however complex and self-interfering that product is in an art context.

But not all performance art situated on the street, or outside a structured relation of audience/performer, wants to short-circuit reciprocity. Adrian Piper's *My Calling Card #1* (1986) begins: "Dear Friend, I am black. I am sure you did not realize this when you made/laughed at/agreed with that racist remark . . ." When Piper hands this card out, she initiates an act of reading that evicts someone from one conversational circuit but forces them to realize, presumably with some shock, their sudden presence in another, one that cannot presume racial indifference, one that can no longer rely on a privilege of unknowing and of being unknown.[39] In Vito

Acconci's *Seed Bed* (1972), the artist masturbates and fantasizes unquietly beneath a ramp that one must traverse to walk through the gallery. The absence of a visible source of sound (aside from the stereo speaker in the corner, a source of sound's reproduction or amplification), the relatively uncluttered installation, the fact that the sounds might be discovered to be self-pleasuring (masturbation is often ridiculed as the most pathetic of closed circuits), all seem to point to a work that wants to deny any sort of exchange with its visitors. But any sex in public is an address that is hard to ignore, or place oneself to the side of, and American culture is especially prone to taking public sex personally, as a personalized address, if not an affront demanding swift response.[40] Revulsion, fascination, ignorance, pleasure . . . all of these possible reactions are solicited, and perhaps even forced by the work and its installation—all, in other words, are forms of give-and-take made possible precisely by the work's masturbatory and occluded structure.

Fraser uses the conventions of museum tours as the medium of her conversation with an audience, leveraging a betrayal of that genre's pieties (to the museum, to a culture of art appreciation generally) to produce a conversation not about art but about art's institutions. Piper uses the calling card, the sudden shift in signifying system from speaking to reading, to erect an exchange about race on the site of a conversation that wants and needs to bracket race—to produce, in other words, an exchange about precisely that which the conversation she interrupts wishes to passively disavow. Acconci uses the fact that the ears cannot easily be shut, in conjunction with various precise phenomenal cues, to force people into an exchange, however unwanted, about sexuality, about Acconci's own sexual practices, or, more likely, one's response to being subjected to sex in public. This exchange might be uneven or unequal, but it invokes and participates in a long-running conversation about sex that is rarely indifferent and is hardly ever unconventional.[41]

In other words, antagonism and defamiliarization, those conventions of modernist aesthetics, are not equivalent to or synonymous with the aesthetics that enfold the broken genre and the differend that rends it, even if one feels antagonized by the nonreciprocity of Hayes's performances or, as I will discuss below, trolls. What provokes antagonism in modernist aesthetics, even in the starkest forms of negation, is a kind of recognition, reciprocity given as disappointment, as scandalization, as incomprehension, as radicalization. But in networked life, antagonism is just one kind

of noise, generated as though randomly, in the scene of an address that can have no formally predictable responses, whose genres of speech are constitutively broken—not a response at all, just a possibility. If Hayes's performances seem to straddle the line between one aesthetic modality and the other, then what makes them distinctive is the needling presence of the broken genre of networked life in the work's overall group form and the way that this presence distends to encompass a site people might once have blithely referred to as safely "offline."

Darby English describes an analogous dispersion of attention performed by William Pope.L's crawl pieces, performances that also instantiate themselves in the streets. English calls the crawl pieces not a "'signifying textual system'" but a "vaster phenomenon inscribed in its surround."[42] English relates this mode or spatiality of performance to Pope.L's own tactics of "apositionality," rooted not only in Pope.L's genealogical relationship to performance art (via Duchamp, Joseph Beuys, Vito Acconci, Allan Kaprow, Adrian Piper, and Geoffrey Hendricks), but also in his position with respect to a history of socioeconomic dispossession and race, which is always both too precisely inscribed and never precisely inscribed enough.[43] For Pope.L, the vaster phenomenon of a surround takes in an entire spectrum of engagement, from people who watch Pope.L's crawls, to people who try to intervene, to all the people who have to ignore his presence and his actions for the commerce of street and city to continue unobstructed or via the absorption of interruption. Pope.L relies on this majority middle ground to generate the apositionality of his performance. Pope.L's actions move his performance away from signifying systems, away from familiar genres whose expectations establish a reciprocating circuit, because they aren't themselves framed as a recognizable genre. They therefore cannot set out to thwart particular expectations, even while they all but force witnesses to guess at an appropriate genre of sociality and its concomitant modes of response. Hayes mobilizes performance similarly by employing two distinctive signifying systems that mutually interfere. The love letter privatizes an address that street protest, as a genre, endeavors to publicize, to open out to more capacious, more sympathetic hearings. The megaphone amplifies both genres, casting the voice over people who are not in fact the "you" of its address, but who are nevertheless addressed by that "you"—people from whom it seeks nothing and who could not respond in any case except to interrupt the piece, to speak across a "differend," across the gap between systems that are gov-

erned by different rules of engagement and judgment, by different circuits of reply and exchange.[44]

The differend that rends the overall form of Hayes's performance is echoed by the incommensurate genres within the story of broken love that the speaker tells—a mise-en-abyme of broken reciprocity. The particular antiwar protest that she describes ("Cheney's pompous warnings," "the hurried talk about Baghdad returning to normal") becomes the theater for the rise and fall of a love now lost to political depression, itself induced by the failure of protest to stop the war or even to produce the slightest murmur of commensurate response.[45] The speaker reminds her absent lover how deeply in love they were the day they marched together, with thousands of others, full of optimism about protest and love, the one propping up their optimism for the other. A week passes, the ecstasy of protest fades ("the ecstasy of being gay and angry"), her lover turns "despondent." A month passes, their protest produces no effects, not even the barest response, the world neither hears nor relays the claims of their protest, the war does not stop, no one's lives are interrupted, and her lover announces that she has booked a flight, that she is leaving the next day.

Her lover's departure begins the rift against which the speaker's voice is raised in protest the day she decides to take to the streets. The lover leaves the broken circuit of love and tries to assert herself back into an unbroken, sympathetic circuit of democratic protest in Iraq—as though refusing to return to love one last time might allow politics to be returned to her. By contrast, the speaker is content to speak unsympathetically, indifferently, as though for speaking's own sake, as though to herself and for herself alone. Rather than fleeing the nonreciprocating circuit of love and politics, she embraces it as her medium: "Oh my love, I feel that I could talk to you for hours and hours. I could stand here for days and days, longer even." Even while these words maintain a fidelity to love as a galvanizing force, the speaker projects herself more deeply into the mediations of voice, speaking outside the reliable structure of a speech convention (between protest and love), and cut off from faith in the possibility of unbroken hearing. She could stand there for days, animated only by the idea of a voice bouncing from point to point in a distended, impossible-to-visualize network of reception.

This deracination of speech, performance, protest, and love from reciprocity is replicated at a structural level in the slow deracination of love talk from protest speech over the course of the address. Hayes's speech is

perforated with conventional protest slogans that initially seem to arise from the *narrative* interweaving of a love story with a story of antiwar protest. Phrases make sense of each other, even across the gaps in conventional registers. But eventually the movement talk rises out of the speech without explanation, indifferent to the surrounding phrases: "Come out against war and oppression" is followed by "I love you." "Out of the closets and into the streets!" is followed by "We will not hide our love away." "Act up, fight back!" is followed by "I'm beginning to think we speak in different tongues." The historical protests referenced here—the protests against the Vietnam War, the Stonewall riots, post-Stonewall AIDS activism—stand apart from the increasingly epigrammatic, increasingly universalized slogans of love, producing a rapid oscillation between their circuits of hearing.

At its most extreme, this deracination produces bare schematism. Between the sentences "Nothing that has ever gone before was like this" and "Oh my love, I feel like I could talk to you for hours and hours" Hayes shouts the familiar protest chant "What do we want? . . . When do we want it?" In her performance of the lines, she leaves an interval for response, the rhythmic gap, familiar to protesters as well as to the objects and bystanders of protest, in which people respond with the what and when of protest's demand. But in the performances I witnessed, no one spoke in that interval (although they were free to) and Hayes quickly passed through it, rendering it a schematic beat—perfunctory, conventional, sounding alone but not necessarily lonely in the nonreciprocating interval of its moment. Loneliness is a structure of expectation, a thwarted one; Hayes's speech seems, decreasingly, to rely on such an expectation.

And this deracination of speech finds its spatial equivalent and amplifier in Hayes's movement from point to point in an urban grid, improvising a path whose shape and determinants were known only to her. This is one of the more opaque and interpretively recalcitrant features of the performance, the repetition of the love address on several street corners in succession, and then the sudden end—not even end, cessation. But the opacity of this feature is a symptom of its formal effect, which is to further widen the gaps between generic form and the form that reception takes, and to thereby impact the form of the group constituted by that broken receptivity. In distributing her address around a small section of a large urban grid, Hayes distributes reception around and between the genres that her performance confuses. Considered within the

genre of the love letter, movement around an urban grid looks most like searching: searching for one's lover, maximizing the chance that the address will reach its intended. But considered as a spatial concomitant of protest speech, movement around an urban grid looks more like an organized march: an orchestrated movement of bodies that gives an image to political solidarity and opposition. A march intends to take up physical space as a proxy for its desire to take up space in the public sphere of politics, while a search is the asking of the same question at various points in a grid, more or less systematically.[46] But Hayes doesn't adhere to either kind of movement, the march or the search; both are merely schematized, generic cues issued but not fulfilled. So the confusion of genre here extends to the performance's circulation and spatial distribution, accelerating its trajectory toward a breaking point of democratic, and aesthetic reciprocity. Hayes's mobility, considered as an address to the people who overhear rather than hear her speech, makes all attention to her work partial, perforates the performance itself with cross-currents of attention paid to something else, or nothing, or who knows. In other words, rather than galvanize the noise of the urban grid into a known form of receptive group, an audience or crowd or mob or otherwise responsive body, the performance mimics the city's noise, blending in by reproducing it, and so further constitutes itself as a form of intimacy that offers generic cues but no generic structure, no promise of in-kindness, no projected image of its future reception or judgment.

However unpromising this form of collectivity might sound, my central claim in this chapter, or the horizon of that claim, is that a great deal of intimacy, faith, optimism, and action survives today in just this form. Many people posting photographs or anecdotes to the Internet for the first time describe a similarly abstracted hope: they have no plans, they just want to see what happens; they hope that the schematism, the formalism of the project of posting stories or photos online will motivate them to write more or take more photographs, transforming a hobby into a project, transforming something solitary into something social.[47] In this, they understand the address of a blog, for instance, as basically indifferent to reciprocity: neither issued from someone whom anyone knows all that well, nor addressed to anyone in particular. Yet hope abounds, for hearing, for followers, for intimate publics at many different paces and scales. Such schematic optimism is mirrored by the speaker of *I March . . .* , who concludes more or less as she began, imploring the absent "you" of the

address, undaunted, as though her speech wasn't the product of a fail-
ure, wasn't the very voicing of an inability to connect, but was fully self-
adequate or was, anyway, all that one could hope to expect.

Many qualities are absented when the lover is addressed as "you"—most
conspicuously, perhaps, gender. And with gender is absented any pre-
conceived relationship of gender to sexuality in the love addresses. I've
gendered my pronouns female only because so far my account has under-
stood the love addresses as embodied performances, manifest on the
street, taking place in the noise generated when bodies come into contact
in a space that doesn't fully precode that contact as useful in any particu-
lar way. So in the encounter with the work, one is made to find one's way,
and that will include the usual assumptions about gendered embodiment.
But there are many reasons to be far less confident about the gender of
my pronouns. First, the gender of the speaker is less materialized than
it is neutralized: longer hair, but mostly covered; some femme features
but faintly butched by the unremarkable, boxy nature of the clothing that
dresses the body; the female complaint of being the one left behind, but
neutralized by the assertiveness of being the one who takes this complaint
to the streets.[48] One may well ascribe gender to the body of the presenter,
but the performance's own unmarked pronouns make it pretty clear that
those ascriptions are a need generated by the work of finding one's way
in the encounter with the performance rather than being manifest in and
by the performance itself. This becomes especially clear in the installed
version of the performance, where the speaker's voice is carried only by
a black speaker on a stand, raised to roughly head height. There our re-
sources for thinking gender are even more impoverished: just the sonics
of the voice alone, and, carried by that voice, statements about love that
trace a trajectory from the particularity of a single relationship to the uni-
versality of love clichés.

This strategy is striking given that, for women, there is no genre of lib-
eral speech that wasn't always a broken genre. Early twentieth-century
suffragists in England and the United States employed a technology of
street protest that they called the "voiceless speech." The voiceless speech
was a simple device: a large piece of cloth inscribed with a demand, held
up on street corners by women who always stood by but never spoke.
In its withholding of the voice in the vicinity of a sign that couldn't help
but be read as shouting its demands (as most newspaper reports at the
time remarked), the voiceless speech was an acknowledgment that gen-

dered speech was always subject to the operations of the differend masquerading as rationality and civility. If the differend screened women's voices from public discourse, from legibility in that context, then suffragists would withhold the voice while still continuing to speak, their ever-present bodies a silent reminder that gender marked the scene but would not be allowed to restrict its ambit.[49] If, for an unmarked audience, Hayes's performance manifests the promise of a genre only in order to break it, then for an audience that understands itself in solidarity with women, this simply describes the complexity of the world they have always inhabited, where all genres of public speech have been broken genres.

This fracturing of the world along liberalism's fault lines, dividing those who can inhabit the promise of reciprocity from those who are constitutively excluded from that promise, is precisely mirrored in the noxious speech of those we have learned to call trolls. Trolls, more than just reminding us of a fault line that has always structured experience, actually work to make that fault line the presiding social condition of the web. This fact is well known.[50] So ordinary, in fact, is the violence disproportionately enacted upon women online that it is hard to discern from the basic workings of the technologies that make the Internet functional in the first place. But if, as I've been arguing, the network technologies that make the web both communicatively and financially viable institute an illiberal non-reciprocity as the very condition for social encounter online, then trolls have worked to socialize that technical condition, forcing people to self-consciously inhabit it.

Trolls

Bad behavior online—in spam, hate mail, baiting, homophobic bashing, misogynistic stalking, racism, jingoism, and virulent tampering with conversational commerce everywhere—generates a distinctive opprobrium. How, in this newest and most promising of democratic media, commentators seem to ask, can such behaviors exist?[51] The despair assumes that the medium, being networked, and now more free and open than ever, is saturated by democratic potential, by potential to give everyone a voice, to make all politicians accountable, to replace all mediated, one-way, top-down representation with immediate give-and-take. People who are cast as deviants relative to this ideal are thought to be tainters of a public good that they devalue in defacing. Their actions, in refusing democracy's and

the Internet's supposedly inherent or hardwired reciprocity, are cast into another, deviant register of action, where they are meant to be kept as exceptions.

An Internet troll, or simply "troll" in web argot, is, in one definition: "someone who posts controversial, inflammatory, irrelevant or off-topic messages in an online community, such as an online discussion forum or chat room, with the intention of provoking other users into an emotional response or to generally disrupt normal on-topic discussion."[52] Or, more broadly defined by anthropologist Gabriella Coleman, a troll is "a class of geek whose raison d'être is to engage in acts of merciless mockery/ flaming or morally dicey pranking."[53] A troll—seen from a perspective that understands networks, democracy, commerce, and reciprocity all as basically synonymous and mutually sustaining—is a disruption, a kind of protest against the expectations for smooth commerce on a website. The trouble they create for chat rooms, virtual worlds, comments sections, reviews, and so on ranges widely in its intensity: from banal (being off-topic), to homophobic, racist, and misogynist. And crucially, symptomatically, their interruptions are almost always costly, requiring websites big and small, commercial and non-, to hire people or write software dedicated to both erasing and preventing their disruptions.[54] Their actions have very real financial consequences, maybe some of the only kinds that matter anymore.

In 2008, the *New York Times Magazine* ran a cover story by Mattathias Schwartz called "Malwebolence: The World of Web Trolling."[55] Taking the epithet *troll* to describe phenomena that the article fears are both spreading and diversifying over time, all linked semicausally to the growing popularity of the Internet, the article stretched trolling to cover everything from "innocuous" baiting in the late 1980s to the "vicious group hunt" today. The Japanese word for Internet troll, *arashi*, carries the broader sense of "laying waste," and so supports Schwartz's inflation of the term.[56] Schwartz gives the example of Jason Fortuny's "Craigslist Experiment," where Fortuny posed as a woman looking for a "str8 brutal dom muscular male" and then published on his popular blog the names and identifying information of all the men who responded. This act of trolling exemplifies, for Schwartz, the lawless conditions of the web, of human subjectivity released from civilizing constraints such as laws and proper names.

Trolls carefully guard their anonymity and most commentators, including Schwartz, agree that anonymity is an enabling condition of their viru-

lent actions.[57] Appropriately, then, "Anonymous" is the name for a loose affiliation of programmers and hackers known for their extreme trolling.[58] One of Anonymous's slogans is "Because none of us are as cruel as all of us." Through their frightening actions, they address the everyone and no one of mass remediation by spectacularly targeting specific people. They move between the particularity of ad hominem address and the universality of public speech by way of what Mark Seltzer calls the "pathological public sphere," a mass-mediated sphere of collectively experienced and perpetually recirculated trauma, where the repetition of the traumatic event is precisely what binds people into a collectivity, a public.[59] Stories about trolls and other online deviants repeat endlessly.[60]

While many of their actions are made to exist, for now, in a moral rather than a legal field of meaning and interpretation, Anonymous also perform actions that play at the edges of the law, especially the law as it is being newly applied to the web. For example, they have hacked websites in order to expose and publicize people's Social Security and bank account numbers (such exploits are called "doxing"), and have sometimes succeeded in shutting down websites entirely. Anonymous ran a now-famous "distributed denial-of-service" or DDoS attack[61] in early 2008 against the Church of Scientology, in response to the church's attempt to have a promotional video featuring Scientologist Tom Cruise taken down from YouTube.[62] A message released via YouTube from Anonymous specifically addresses the Church of Scientology: "Over the years, we have been watching you, your campaigns of misinformation, your suppression of dissent, your litigious nature. All of these things have caught our eye."[63] So while Anonymous frequently disavow any programmatic or political content to their activities, this campaign has been both organized around and motivated by what appears to be a liberal democratic ethics with a strong libertarian inflection—an ideal of equal access and free exchange. Here Anonymous act reparatively: they presume that the genre of exchange that governs the Internet is one of free, permanent informatic flow and punish people who block this ideal by literally (if temporarily) banishing them from the Internet and from whatever fantasized ideals of reciprocity might now more freely reign there.

Rereading the list of their "targets," one could generalize: Fox News, Bill O'Reilly, copyright laws, the Church of Scientology . . . Anonymous might start to look like an organized (albeit decentralized) libertarian or Radical Left protest group—or an art collective like the Yes Men, who work

in the medium of "hijinks" and public relations.[64] But to accept this description requires ignoring a lot that isn't congruent with that agenda, not least Anonymous's vigorous attempts to thwart generalizations about the group, as well as their more vicious statements (e.g., those that advocate rape in conjunction with severe strains of homophobia and misogyny).[65] While the Yes Men's hijinks are probably coherent and compelling to the broad anticorporate Left, they must seem nihilistic or simply puzzling to any of capitalism's strong defenders.[66] To some happy capitalists, picking on Dow Chemical might seem as much a civil rights issue as trolls targeting women bloggers. That is to say, some forms of protest are legible as such only inside a partisan public, and trolls' actions often have the effect of exacerbating those partisan divisions. But Anonymous, and trolls more broadly, have no coherent agenda in the sense that would appeal to any particular partisan audience. Their appeal to an anticorporate, art-friendly Left is probably made unpalatable by the overt misogyny and homophobia of some of their statements. Their appeal to a libertarian fringe is made at least ideologically incoherent for the same reason.[67] These facts index a more basic one: that the status of the group, group form itself, is one target of trolls' actions. Their own group form is precisely the dissolution of group form. It's an undoing. Lacking centrality, coherence, and consistency, but constantly associated with mass spectacles of targeted hatred and vicious randomness, Anonymous teasingly provoke a desire for exemplarity while thwarting the ways that an example adds up to something collective and generalizable. If they are made examples of, either to vilify or valorize their actions, that can't help but index the ongoing fantasy that things will add up, that patterns will eventually emerge, that we can identify and label those patterns, that moral and ethical stances can be built on those observations. Ascribing to the group a coherent group form is central to these desires. When this can't happen, we seem to be left with no basis from which to speak, to analyze, to respond, to complete the reciprocal circuit of public debate and criticism. This is why it can be productive to see trolling less as a behavior, with intentions we can attach to both individual and collective subjectivity, than as a technical feature of networks. I don't mean that trolling is guaranteed or that the Internet automatically produces the conditions that create such vicious people. I mean that what we call trolling expresses something fundamental, something technical about networked life.

In part, this is all attributable to what Coleman refers to as Anonymous's

deflationary agenda of taking nothing seriously, their anti-ideology. Which again raises the question of how to respond. From what basis or idiom or set of political conventions, from what signifying system, would a possible response be launched? In most cases, the law has not yet caught up to their actions, although as I will discuss below, this is beginning to change. When trolls interrupt a discussion board, we can easily imagine that they want a response—they want to bait people into angry replies, derail the conversation, disrupt the associated commerce. This is part of the original definition of *troll*, and they do in fact often accomplish these things. But the mistake is to think, even though they might speak in the same forum, use the same argot, log on to the site just like everyone else, that "they" want conversation.[68] Instead, they use the purportedly democratic forum—a place where everyone can speak because, as Habermas put it, "they preserved a kind of social intercourse that . . . disregarded status altogether"—in order to disrupt precisely the democratic operation of that forum, or, closer to my argument here, to show that it was disrupted from the start, that the democratic idealizations of the Internet may not be any part of the Internet's innate potential, but might instead be a fantasy that compensates for the absence of exactly that potential. Their actions thus mark the presence of another logic of sociality entirely, one that is less familiar and that grates against democratic expectations.[69]

In effect if not intention, trolls identify the ideal by which a site functions and to which it wishes to give form, and show that ideal to have been inoperable from the start, not least as an effect of their own actions, but *not only* as an effect of those actions. DDoS attacks are a technologized form of this procedure: they use software to automatically generate so many responses that the hardware hosting the conversation overloads and ceases to be available to others. DDoS attacks take advantage of the technological ideal of free speech to precisely target and disable that very ideal, and in doing so, they not only disable the give-and-take of one person's interaction with the targeted site, but remove that site from the social realm altogether, until the site recovers from the attack. Reciprocity in such situations becomes practically impossible. From one point of view, the exploit attacks an ideal through the circuits that sustain it. From another, it simply operationalizes (and spectacularizes) the techno-logic that had already made the democratic ideal inoperative.

Taken together in the pathological public sphere that actively imagines the various online threats to democracy, good citizenship, good com-

merce, and good fun, trolls and other bad actors protest not publicity or privacy or the perceived balance between them, but conversation itself— or, as Internet and art discourses have it, interactivity and participation. This is less protest as a program or an explicitly goal-oriented politics than it is an effect of actions possibly conceived for other reasons—in any case, the reasons are often opaque, and so unavailable for anything more than speculation. And such speculation would itself necessarily operate from across a differend, seeking, as it would, a purpose or program or pattern.

As we've seen in Hayes's love addresses, a telltale sign of the broken genre, of nonreciprocal contexts, is that in them the differend arrives less as an assertion of power than as an automatism, something that seems, via some opaque logic or process, to have always been there. This illiberal form of protest does not register a complaint against interactivity in the circuits of that interactivity; rather, it renders inoperative the commerce of interactivity, while revealing the expectations that make that commerce both attractive and familiar in the first place. It is a protest that acts locally on particular people or particular entities, trolls' various named targets, while acting globally via a pathological public sphere that amplifies and circulates their actions. It is no wonder trolls' actions are hard to classify. Straddling as they do vestigial liberal ideals and technical algorithms of competition, publics and populations that have, in tense interaction, become a new social fabric, they are recognizable by the conventions of neither while rendering both inoperable.

When a virulent, unpredictable form of seemingly antisocial behavior appears, people want to know why: what has changed to precipitate the change? What has come unhinged? Answers to these questions, it is hoped, if not the very posing of the questions themselves, will help put things right: will, for example, particularize and pathologize some person or group so they can be cast out.[70] Laws are often conceived in this way, reverse engineered from the deleterious effects they want to "chill," while attempting to nurture any part of the new behaviors that might positively impact society—a society that legal discourse often figures, in this rational logic of good versus bad, productive versus unproductive, as the free market of ideas. It shouldn't be surprising then that the moralizing language inspired by trolls, when rendered as laws, often masks corporate protectionism. Some trolls attack people violently and inspire lawyers to action; most just make websites less attractive (less marketable) from the point of view of the companies and people who run them. Trolls obstruct

traffic, and any law that makes trolls less able to do what they do is going to be a boon for companies who exist in the "conversation economy"[71]— so long as those laws don't hang the responsibility for bad behavior on the companies who host the conversations.[72] Trolls disrupt the socioeconomic logic of twenty-first-century America's claims to have realized a more perfect democracy on the Internet. They do so by toxically literalizing the rule of all against all, generalizing a feeling of competition as the basis for social cohesion, which, as Foucault pointed out some time ago, is less a social glue than a kind of centrifugal force, a disintegrative tendency.[73]

So the law's recent mobilizations in the face of trolls and the Internet's other bad actors should also come as no surprise. At a conference hosted in 2010 by the University of Chicago Law School called "Speech, Privacy, and the Internet: The University and Beyond," co-organized by Cass Sunstein[74] and Martha Nussbaum, lawyers gathered for two days to discuss how they should respond to the vicious, bigoted, antisocial forms of speech that everyone agreed had found an accommodating home on the web and that most agreed should be considered a form of action and not just speech.[75] Although there were sharp disagreements about the conceptual boundaries of free speech, the distinction between speech and action, the definitions of personhood at issue in harmful speech, and the reach of the law, most participants agreed that the Internet provided a relatively lawless harbor for weaponized speech, that this lawlessness at best allowed and at worst encouraged bad behavior, and that the law was therefore a promising if not inevitable source of social reparation.

Brian Leiter presented a paper titled "Cleaning Cyber Cesspools," whose scatology voiced a mixture of outrage and condescension, set righteously aglow by an intellectual's special incredulity that such scat could ever come to exist in the first place. The language of waste was echoed in Saul Levmore's characterization of the Internet as a technologized bathroom wall.[76] Leiter concluded that writing laws with the goal of removing these waste products of "proper" speech from the public realm of the Internet could not possibly "violate any morally viable conception of freedom of speech."[77] And while many members of the audience vigorously disputed his legal formulations, no one challenged his moralizing presupposition, namely, that unproductive forms of speech, first, are self-obvious, and, second, deserve to be cast out of the marketplace of ideas (aka society)—that such waste removal is desirable even if not yet possible. The very figuration of society as a marketplace of ideas inherently,

discursively supports this operation, if one believes that the law is the final arbiter of what gets to count as an idea in the first place. Leiter proposed holding search engines accountable for the circulation, archiving, and re-circulation of shitty speech, attempting thereby to bring the law to bear on the technologies of amplification until it became possible to directly prosecute the human waste that produces such speech (this being the ultimate goal). Others, like Frank Pasquale and Danielle Citron, attacked precisely the anonymity that makes direct prosecution impossible. Speaking as nominalists rather than moralists, they defined a category of "harmful" speech, and speculated that the enabling condition (if not the cause) of such tainted speech is the easy anonymity under which it is possible to speak on the Internet.[78] Solutions therefore include what they called "pseudonymity" and other forms of traceable, accountable personhood, including some scenarios in which, in order to use the Internet, people would be required to present a form of identification.[79]

While many of these proposed legal solutions cling to an ideal of universal personhood, so long as that ideal can be made accountable within new social networks (that is, given a name, a tag, the capacity to be located), Danielle Citron pointed out that many of the offending forms of speech target women specifically.[80] This pivot between universal personhood and particular personhood is one place where the pressure exerted by the Internet's bad actors is acute. Many of the infamous cases of online abuse, including that of Megan Meier and others addressed by the participants in the "Speech, Privacy and the Internet" conference, have women as targets.[81] Kathy Sierra, for instance, is a prominent technologist and games creator who was repeatedly threatened with both death and sexual violence in the comments section of her blog. As a result, Sierra retreated from public life for a time, and still mainly avoids public speaking appearances. Attacks against women are also at the heart of the more recent "Gamergate" controversy.[82] Citron argues that such targeted abuse amounts to a civil rights problem, that women's right to speech has been unfairly burdened by specific attacks and by the looming threat of attacks. If such attacks on women are part of an overall animus on the part of trolls toward all forms of particularized identity, this is only more evidence, as if we needed it, that the burden of particularity falls far more heavily on some populations than others.

But the civil rights conception of personhood as a locus of rights, where rights provide the metric for equality or equalization, is the very concep-

tion that is rendered problematic by the intrinsic (technical) asymmetry of the differend, by the way that networks tease with the offer of reciprocity as a genre of social interaction while disabling it or routing around it at a technical-economic level. The civil rights conception of personhood might represent a pragmatic attempt to protect the marginalized populations that continue to be marginalized in networked life. But we also need to recognize a shift in how gender is constructed and lived. In networked life, a population logic of data accumulation might occasionally generate gender as a productive class or market of people, but populations can always disintegrate and re-form around some other (more profitable, or potentializable) locus. They do all the time, in every instance, as a response to every one of our actions online. Donna Haraway puts it this way: "No objects, spaces or bodies are sacred in themselves; any component can be interfaced with any other if the proper standard, the proper code, can be constructed for processing signals in a common language."[83] Or, as Shaviro says, amplifying Haraway's darker implications: "If you're connected, you're fucked."

Noxious speech online may be a civil rights problem, then, but it is one that will force us to invent new genres and new numeracies of response. In relation to what appears to be gender discrimination, we have a problem with no ostensible or locatable or representable cause. An effect, but an effect as such. In order to criminalize that effect, the law needs not just a person, but a person with a name (thus the impulse to kill anonymity). To fight the effect, the law punishes the cause. In a civil rights context, the guiding principle is equity. But what's the cause of inequity here? Trolls? There is no such group, qua group, and my own references to them have had to be careful to describe trolls as a kind of effect, more a population than a self-conscious collective. Misogyny? Yes, but what individual holds the execrable viewpoint? Who holds it, when, and where? Would removing them from the Internet solve the problem? If which is vexed here is the relationship between a person and a class of people, trolls also resist the form of belonging by which, in being made into an example, they come to stand for something—be it the pathologization of the Internet or a politically progressive hacker function.[84] To put it another way, trolls resist genres of exemplification, a fact that is attested by the furiously compensatory attempts to make an example of them, to symptomatize, pathologize, and invent ways to eradicate them from the web.

Maybe, then, exemplarity is the wrong register in which to track their

meaning. Maybe rather than standing out as a revealing example, trolls blend in to the fabric of logics and meanings embodied by electronic networks. Rather than representing that logic—the logic of the differend, spread out to become a new social norm—they simply *are* that logic, one of its many automatic manifestations. We might see all of the compensatory action on social media sites and at law conferences as attempts to repair this fact and institute, in its place and as the Internet's retroactively natural birthright, a social web, a democratic web.[85] My argument, however, has suggested a different approach. I see responses to living awkwardly between populations and publics not as a form of misrecognition, but as themselves attempts to acknowledge and accommodate the broken genre, to adjust to it and improvise lives on that basis. From that point of view, trolls do not taint the logic of networks. And the women so often targeted for online attack are likewise not exceptions to the Internet's inherent democratic universalism, even if the violence exacted upon women and the burden of that awareness for any woman doing anything online is disproportionate. In a population, violence enacted upon a particular group is no more an exception than kindness, inclusion, or the privilege of unmarked personhood. Violence is still felt by some more than others, and presenting as male or white is still a privilege (whether understood as such or not). But the problem cannot be fixed by more and better equality. There is no equality in a population; just more data, more and more personalized forms of address, more deployments of that data. The cruelty here is that the Internet has so energetically revivified the idealism of the public sphere, the fantasy that everyone can show up as equals to scenes of collective life, the hope that showing up to a networked scene finally lets choice trump ascription in the realm of identification. So trolls are cruel in this sense. But they are also utterly ordinary.

Trolls, in other words, *are* misogynistic, but not only in the older structural sense.[86] They are also misogynistic in a technical sense, one connected as though via circuitry to the techno-economic protocols of the Internet: they target groups (women, queers, people of color, those with disabilities) that have a vexed relationship to a history of liberal politics and to the ideal of inclusion that has been the source of liberalism's hypocrisy as well as its capacity to reform that hypocrisy. It is not, then, primarily or most significantly hatred or fear or anxiety about women that drives the vitriol directed at people online who present as women. It is an antimony toward liberal models of inclusion. Trolls embody a different

logic of collectivity, a different group form. This, I stress, does not and will not make anything feel better for the people so targeted; if anything, it's worse, even more cruel. So this is far from a defense of the attacks, as though trolls were heroic for attacking liberalism (neoliberalism attacks liberalism too). Rather, I think it's important not to mistake the cause of what truly is, in effect and in affect, misogyny, homophobia, and racism in networked life. To do so can make it seem as though basic equality claims, for example, liberal assertions of civil rights, can fix the problem. They will fall short insofar as the problem isn't a lack of equality; it's the claim to equality itself that's at issue. In this sense, when genre breaks, so does gender. Thus, trans-genders, like trans-genres, would therefore need to point not only beyond gender, but beyond the kinds of equality claims that structure both radical and liberal politics of personhood.[87]

From Genre to Algorithm

In both cases I've considered here, familiar democratic forms, genres around which circulate ideals of reciprocity and sympathetic listening, establish a promised equality of liberal conversation, but one that operates without reciprocity, without the return on that promise. Here we see the confrontation, often violent and jarring, between the logic of populations and the logic of publics, and we see what happens when one is forced to inhabit the space between them.

My point is not the ideological one, that people are stuck in a bad relation to real conditions, where the injunction would then be to identify and broadcast those real conditions in the hope that something would change. It's that in a population logic, one just can't know about the "real conditions" because what there is to know is always being built, day after day, click after click, into something new based on the very actions — investigative, exploratory, analytic — one might have performed in order to get a sense of those real conditions in the first place. A distributed network creates (and is) a field of relations that is open rather than reciprocal or dialogic, a field that is, as Alexander Galloway says, a "proscription for structure whose form or appearance may be any number of different diagrams or shapes."[88] Accordingly, networks do not force people to mimic their structure or to become themselves illiberal. They do not create trolls. Better to say that trolls embody some of a distributed network's animating logics.

Still, the lack of structural reciprocity in the technologies of networked collectivity, when compared with cases such as trolls, or spam, or Anonymous—which appear to be practices more than technologies—is more than a suggestive coincidence. That is, people's relations to one another through any distributed network are governed by the same technical protocols that govern the so-called back end technologies of user experience. This is less a question of determination than one of colocation, or mutual implication. It's a parallelistic governance: untouching at the level of affect and intersubjective communication, of no necessary concern to web cultures, but parasitic upon just those cultures and their encounters (as we'll see in the next chapter). If networked sociality makes it possible, for example, to receive innumerable spam, to have one's computer hacked, to be the random or deliberate target of a troll, as well as to be contacted by an old high school friend, then networked life is galvanized less and less through structures of expectation and more and more through the instantiation of an automatic, algorithmic logic.[89] In other words, concepts like agency, will, sovereignty, and action are not enough to understand personhood in the context of networked life.

A historical transition from a social system predicated on genre to a social system predicated on algorithms would be necessarily messy: full of affective dissonance, feelings of betrayal, violence, moralization as part of an attempt to create stability, nostalgia for how things were, and conditions on the ground that make it impossible to distinguish nostalgia from coping. If networked life witnesses the installation of algorithms that generate populations in place of genres of in-kind exchange—and I should stress that this is probably unknowable because it is an experiment we are all living, an open case whose evidence is our very lives—then all points in a social grid would be potentially affected by the shift, while continually refracted through old habits. To speak outside of intact circuits of listening—as Hayes does in her love addresses, as people addressing the Internet often do—sometimes produces no response; other times, it produces a reply from another register of signification entirely, not a response so much as an errant effect, an indirect encounter that makes every speech and every speaker potentially not matter.[90]

Likewise, if Hayes's performance evinces the breaking of a structure of expectation, be that of performance art or public speech, making that structure legible but inoperative, then the performance itself would be subject, a priori, to being obstructed or broken. On one of the occasions

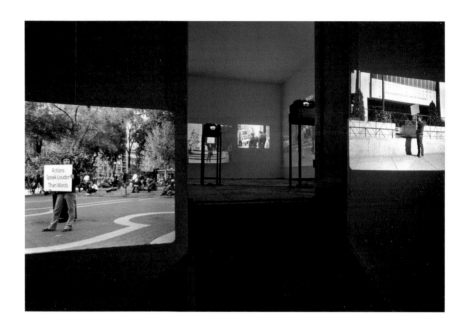

Plate 1 Sharon Hayes, *In the Near Future*, New York (2005). 35mm multiple-slide-projection installation, 9 actions, 9 projections, 223 original slides (729 in total). Projection dimensions variable. Edition of 1 + 1 AP. Courtesy of the artist and Tanya Leighton Gallery, Berlin.

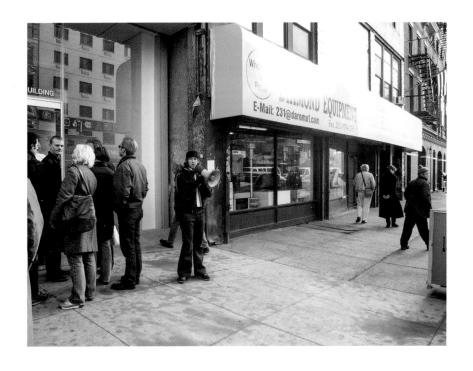

Plate 2 Sharon Hayes, *I March in the Parade of Liberty but as Long as I Love You I'm Not Free*, Performance view, New Museum, New York, NY, December 2007. Image courtesy of the artist. Photo by Kristine Woods.

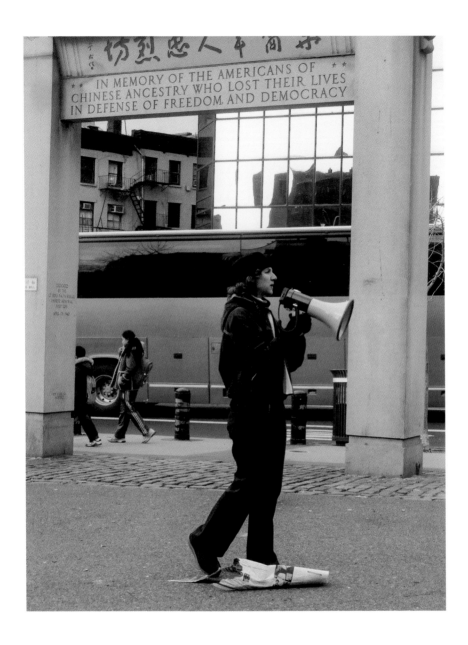

Plate 3 Sharon Hayes, *I March in the Parade of Liberty but as Long as I Love You I'm Not Free*, Performance view, New Museum, New York, NY, December 2007. Image courtesy of the artist. Photo by Kristine Woods.

Plate 4 Sharon Hayes, *I March in the Parade of Liberty but as Long as I Love You I'm Not Free*, Performance view, New Museum, New York, NY, December 2007. Image courtesy of the artist. Photo by Andrea Geyer.

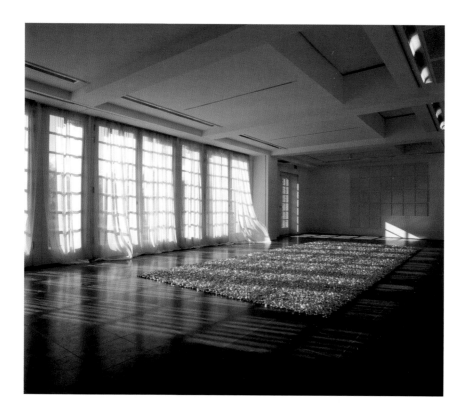

Plate 5 Felix Gonzalez-Torres, *"Untitled" (Placebo)* (1991), candies individually wrapped in silver cellophane, endless supply, overall dimensions vary with installation, ideal weight 1,000–1,200 lbs.; Felix Gonzalez-Torres, *"Untitled" (Loverboy)*, 1989, blue fabric and hanging device, dimensions vary with installation; Felix Gonzalez-Torres, *"Untitled" (31 Days of Bloodworks)* (1991), acrylic, gesso, graphite, photographs, and paper on canvas, overall dimensions vary with installation, thirty-one parts (20 × 16 in. each). Installation view, Serpentine Gallery, London, June 1–July 16, 2000, curated by Lisa G. Corrin. © The Felix Gonzalez-Torres Foundation. Courtesy of Andrea Rosen Gallery, New York. Photo by Stephen White.

Plate 6 Felix Gonzalez-Torres, *"Untitled" (Portrait of Ross in L.A.)* (1991), candies individually wrapped in multicolored cellophane, endless supply, overall dimensions vary with installation, ideal weight 175 lbs. Installation view, *Felix Gonzalez-Torres: Specific Objects without Specific Form*, Fondation Beyeler, Basel, Switzerland, May 21–July 25, 2010, curated by Elena Filipovic. © The Felix Gonzalez-Torres Foundation. Courtesy of Andrea Rosen Gallery, New York. Photo by Serge Hasenboehler.

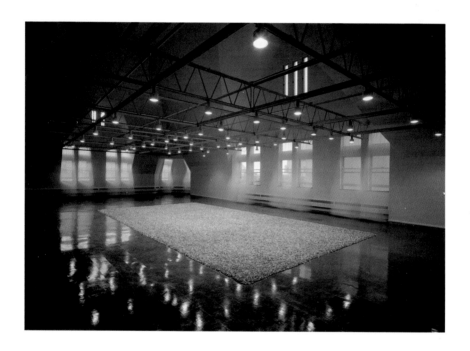

Plate 7 Felix Gonzalez-Torres, *"Untitled" (Revenge)* (1991), light blue candies individually wrapped in cellophane, endless supply, overall dimensions vary with installation, ideal weight 325 lbs.; Felix Gonzalez-Torres, *"Untitled" (Loverboy)*, 1989, blue fabric and hanging device, dimensions vary with installation. Installation view, *Felix Gonzalez-Torres: Traveling*, The Renaissance Society at the University of Chicago, IL, October 2–November 6, 1994, co-organized by Amada Cruz, Ann Goldstein, and Susanne Ghez. © The Felix Gonzalez-Torres Foundation. Courtesy of Andrea Rosen Gallery, New York. Photo by Tom Van Eynde.

Plate 8 A single search query streamed by Thomson & Craighead, BEACON (2005). Installation view, Moderna Museet, Stockholm. Courtesy of the artists and Carroll/Fletcher, London. Photo by the artists.

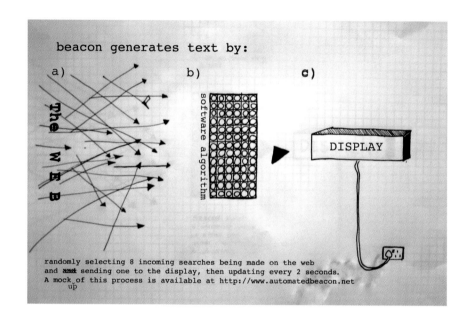

beacon generates text by:

a) The WEB

b) software algorithm

c) DISPLAY

randomly selecting 8 incoming searches being made on the web and sending one to the display, then updating every 2 seconds. A mock up of this process is available at http://www.automatedbeacon.net

Plate 9 Diagram of Thomson & Craighead, BEACON (2005). Courtesy of the artists and Carroll/Fletcher, London.

Plate 10 Thomson & Craighead, *The First Person*, 2013, generative digital montage. Installation view, *Maps DNA and Spam* (solo exhibition), Dundee Contemporary Arts. Photo by Ruth Clark.

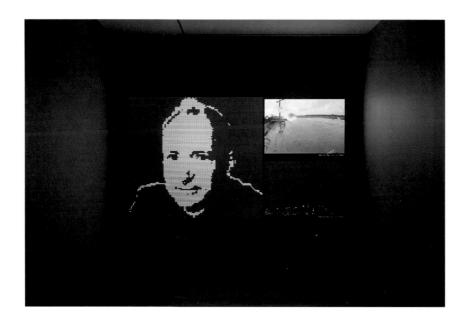

Plate 11 Thomson & Craighead, *A Live Portrait of Tim Berners-Lee (An Early-Warning System)*, 2012, digital projection from online sources. Installation view, *Never Odd or Even* (solo exhibition), Carroll/Fletcher, London. Courtesy of Carroll/Fletcher, London.

[] YOU HAVE REACHED AN AUTOMATED BEACON

christian chatroom

CURRENT TIME = WEDNESDAY, AUGUST 17 12:18 PM
FIRST STARTED = 00.00HRS GMT ON 01ST JANUARY 2005

ID = TC002\LIVE_RELAY\DOGPILESEARCHSPY_2005-2011
ALWAYS VISIBLE AT: HTTP://WWW.AUTOMATEDBEACON.NET

HTTP://WWW.THOMSON-CRAIGHEAD.NET

 READ_ME

Plate 12 Thomson & Craighead, *BEACON* (2005). Courtesy of the artists and Carroll/Fletcher, London.

Plate 13 Thomson & Craighead, *BEACON* (2007). Installation view, British Film Institute. Courtesy of the artists and Carroll/Fletcher, London.

Plate 14 Thomson & Craighead, *BEACON* (2007). Installation view, Dundee Contemporary Arts. Courtesy of the artists and Carroll/Fletcher, London.

Plate 15 Detail of Thomson & Craighead, BEACON (2007). Installation view, Watermael Station. Courtesy of the artists and Carroll/Fletcher, London.

Plate 16 Solari di Udini SpA, Split Flap Board Flight Information Display System (1996). Museum of Modern Art. Photo by Alex Liivet. Creative Commons Attribution 2.0 Generic.

I witnessed Hayes's performance, a woman, maybe in her fifties, apparently a tourist in New York City, walked confidently up to Hayes, mid-performance, with a map or bus schedule in her hand, and asked where to pick up a bus to somewhere (plate 4).[91] Hayes was then speaking in front of the New Museum, the first in a series of what were the four repetitions that made up that particular performance, and she was early in the love address. The moment was tense and form-breaking, but at the same time understandable. Hayes stood with a megaphone in front of a building whose spectacular façade, even if it was not specifically identifiable to the tourist, would have radiated some kind of recognizable institutionality, making Hayes look like an employee or representative of that institution and, as such, apparently available for questions. The assembled watchers of that first of four repetitions — many of whom had appeared, as I had, on time to see Hayes's performance, following the New Museum's publicized schedule of events for the weekend — thus functioned more as an audience than as a street crowd, rendering the speech, in that moment, more of a performance in a spectacular, generic sense. So this audience of insiders, aware of the aesthetic aspirations of the event, watched as Hayes took a moment to decide how to respond to the interruption: Ignore or engage? Continue the performance or respond to the woman's question? Either way, Hayes's decision to perform this piece on the street was a decision to potentialize just this kind of encounter, a kind of unintended and benign trolling (which was, after all, based on a perfectly accurate identification; Hayes, with her megaphone, did look like an employee of the New Museum, and in fact had been hired and paid by that institution).

In the context of the web, and especially the public remediation of its specific cultures, people often treat such wayward responses as pollutants. But such responses are always potentialized by intimate contact that operates far from an ideal of reciprocity. In fact, the abandoned lover of Hayes's performance hopes for just such a wayward response to her speech. She sees it as the last recourse to her lover's absence and continued indifference to the generic expectations of love. She hopes that some "broken echo" of love will return to her. People who post content to blogs and photography sites and open forums, people who experiment with intimacy online, often hope for little more than such "broken echoes." In the context of networked life, even a broken echo can feel like not being alone, for now.

In the performance in front of the New Museum, Hayes eventually

lowered her megaphone and gave directions as best she could. We in the audience could only see gestures, one body attempting to orient another. But we didn't need to hear the exchange in order to see in the moment all of its genre-breaking oddity. Once oriented, the woman walked off with her family, and Hayes raised the megaphone and resumed speaking more or less where she had left off.

Parallelism, Part I

This short-circuiting of reciprocity is characteristic of all of Hayes's love addresses.[92] *Everything Else Has Failed! Don't You Think It's Time for Love* (2007), for example, has Hayes emerging at lunchtime every day for a week to perform a love address in front of the United Bank of Switzerland (UBS) corporate building in Midtown Manhattan. Wearing clothing meant to evoke the precarious figure of the "temp," or temporary worker, Hayes here points directly to a variety of endemic breaks in the promise, the genre of a good or normal life: the imbrications of state, intimacy, and "financial services"; of public grievance and privatized space; of the American Dream and the lies of the mortgage-backed security scandal in which UBS was implicated around the time of the performance.[93] *Revolutionary Love: I Am Your Worst Fear, I Am Your Best Fantasy* (2008), on the other hand, adapts the formal and generic features of the love addresses but is voiced collectively, although never quite in unison, by an unruly crowd of hired performers whom Hayes asked to perform a "flamboyant queerness."[94] The disorientations and nonreciprocity of the broken genre are equally evident in other Hayes performances. *In the Near Future* (2009), discussed previously, finds Hayes standing conspicuously alone in once-famous protest sites around the world, carrying deracinated signs announcing slogans from protests either long past or speculatively fictional.[95] Limning the circuit of political speech, this performance also renders such speech inoperable, uninhabitable.

Connection in all of these performances, if one feels it or finds it at all, is largely technical—an effect of the impersonal fact that sound carries in the streets ("The ears are the only orifice that can't be closed" is a pronouncement that appears in many of Hayes's love addresses). That is, connection here is not necessarily the effect of desire or will or agency of any sort. This shift away from subjectivity as the basis for communication and action is a key feature of Hayes's performances and of the wider politi-

cal context in which they take place. Of course, people are present in the love addresses, and in familiar roles: artist and audience, speaker and receiver, lover and lost love. But the connections between them, and more specifically the genres of those connections, are attenuated to a breaking point, even while various genres of connection and reciprocity are in the air like promises that once meant something. It's not that the subject herself has withdrawn in these performances; it's that subjectivity no longer provides a secure basis for encounter, for collectivity, for action—political, aesthetic, amorous, or otherwise. The figure of the protester appears, for instance, but with a sign whose message can't be connected to the urgencies of the present tense. A noisy protest mob appears, but rather than, as we might expect, addressing a government in the voice of a public, it addresses an absent "you" in the voice of an unrequited "I." Love is in the air, but its addressees are all passersby. There is never hearing, only overhearing. We could say that the geometry of encounter in Hayes's performances is not the circle of participation, but two parallel lines. As such, Hayes's performances take their place among all of the other forms of nonreciprocity that exist in a period during which the reconstruction of liberalism has unplugged so many of the promises of return, of exchange, of public mattering.

I refer to the refashioning of the state as an adjunct to business, the dismantling of the welfare state, and all of the concomitant diminutions of citizenship effected through a redoubled investment in the figure of the individual as isolated and self-sufficient.[96] But I also refer to the closely affiliated technological imaginary of the present tense. The imperative of connectivity which many have said characterizes our contemporary moment, and which Steven Shaviro has importantly argued is now more a structural given than a privilege or a good, is likewise not predicated on reciprocity, even if it feels like a promise of closer connection.[97] It is, like the propagation of sound on a street, strictly technical, hardly subject to desire or any other willed impetus for interaction. In fact, connectivity in this sense is more like a demand, even a form of labor as many have argued.[98] As a result, many of the most iconic, most lavishly capitalized, most dominant new media of connectivity—now so synonymous with protest itself—operate in a parallel but constitutive relation to the stream of actions and events that we conduct, more or less self-consciously, on those very sites.

This is one reason that so many of today's mediated encounters, in-

cluding but not limited to so-called social media, are broken genres. They are familiar, extremely available to utopian fantasy, and have proven to be adaptable to a wide range of uses and appropriations. Yet, as those on both sides of the digital divide have now learned, they are also built on a connective circuitry that never ceases to surprise with the disorienting, even violent indifference of its sociality.[99] Such parallelism—near but not available, intimate but not touching, promised but not delivered—now often slides quietly into the place of, and so breaks, familiar genres of reciprocity.[100] It insinuates itself even while expectations for reciprocity persist in the breakup of old democratic and mediatic forms and people continue to try to find sources of optimism and intentional connection in the debris. Parallelism, in other words, *is* a form of relation, just not one that is much affected by self-conscious world-building activities like protest or love.

Hayes's response to this situation, as I have described it, might sound like perpetuation more than interruption. If various genres of social connection are broken or parallel when they appear to connect, why approach that situation homeopathically, through a kind of parallelistic aesthetics, as I have claimed that Hayes does? Homeopathy is, of course, only one mode of response to a situation whose wrenching effects have been sensed by many. Others have wanted to reparatively reinvent connection as participation, relational aesthetics, dialogue. How do we choose among such tactics when we can't really know what effects they will have, when part of the historical problem to be addressed is that effects are so often deracinated, technically rather than metaphysically, from intentions?

On the other hand, if the lived temporality of the present is deeply discontinuous, if people inhabit different temporalities in the commodity churn that is now synonymous with ordinary life for so many people, then Hayes's work should be seen not only as a self-conscious response to a situation she claims to know, but also as a kind of intensification of something that might be more sensed or enacted than known.[101] It is, in that sense, an experiment, an attempt to see what happens when one performs the new technical basis for encounter—one that is parallelistic by design, and so rarely sensed or performed as such—within the ordinary noise of city streets, and then later, as what Hayes calls a "nonevent," within the controlled environment of a museum or gallery.[102] Do we feel surprised, bored, indifferent? How do one's feelings track with and diverge from the formal qualities of the work? We won't, after all, necessarily feel unad-

dressed just because the work doesn't address us, just as we won't always feel alienated from the networks that make our connections and attentions into commodities. In that gap between affect and structure, feeling and form, populations and publics, lies not the pluralism of art but a kind of sound check for the media of our attachment to love, to protest, to the ordinary business of sociality.

We find another such sound check in the now-infamous, often slapstick difficulty of communicating tone in networked encounters. This, seen refracted through the candy works of Felix Gonzalez-Torres, will be the subject of the next chapter. Together, these two cases will let us look more closely at the population form. Emoticons and acronyms like LOL attempt to compensate for the tonelessness of networked life—attempt, that is, not to deny but to acknowledge and inhabit that tonelessness. Such compensations alert us to the fact that tone is one vexed feature of life lived in the broken genre, between populations and publics, and will give us a better sense of how group form in networked life is inextricably bound up with—and often just is—commodity form.

TONELESS

One cannot not exist in a population. Even those who don't count politically are counted, proleptically or algorithmically, in some accounting of bodies or the features of bodies.[1] Even the dead are counted, and the unborn. There are estimates that let us imagine populations of people who are living off the grid, in places without Internet access, without electricity. Populations, as a form, account for the possible as well as the actual; in doing so, they participate in actualizing the possible. Opting out of populations is either a futile gesture or a meaningless one. It might not be possible, but even if it were, what would it change? So we exist in populations, and far more and more diverse populations now than the familiar geographic and nationalist ones. But is it possible to say that one *lives* in a population? Are populations habitable? Is it possible to self-reflexively change the existence or smooth functioning of populations, or are our actions simply logged, whatever their content?[2] What if the population form were the last mode of collectivity on Earth?

Populations are data entities; their aesthetic is informatic even if their style is humanistic. They are derived, not created, with all of the massive changes that are entailed for authorship and analysis. Derived from statistics, their production can be automated: machines capture simple, often innocuous bits of data; that data can then be compiled, recompiled, conceptualized, and used, very flexibly, to allocate resources, suggestions from friends, advertisements . . . always advertisements (which look more and more like suggestions from a friend).[3] Populations assembled through

online data collection are an effect of a set of networked technologies that track and categorize life as that life is being lived, ordinarily. Michel Foucault's late work on biopolitics considered populations as part of an epidemiological discourse, but the implications of his thought are now far wider.[4] As we saw in the last chapter, populations are a central technology of the neoliberal political practice that Foucault was then studying, but their economic, political, and social valences have been both transformed and massively expanded by networked technologies.[5]

The Internet assembles a set of technologies that produce populations automatically.[6] Most of the major Internet service commodities, including Google and Facebook, keep data on users not just as a matter of course — that data collection is the only reason they are a business at all. The service they provide to users — providing a gateway to the web's vast resources, or a gateway to all or part of one's social life — is, in a certain sense, epiphenomenal. The data they keep on their users is what they sell to advertisers, and advertising accounts for the vast majority of both Google's and Facebook's total revenues.[7] This is the familiar part of the story.

In the language of group form that I've been developing, this data, the data that Internet companies carefully collect, aggregate, and sell, generates populations: collections of people who have no necessary self-consciousness of their participation in that group and whose life activities — tracked and aggregated — and not their intentional participation in critical discourse are the very substance of that group, the basis of its existence. Publics, the group form with which populations so often get hybridized in networked cultures, are contrastingly built up from some minima of participation. It might be an extremely undemanding form of participation with a low bar to entry — in Michael Warner's understanding of publics and counterpublics, simply paying attention counts. In any case, there is a minimal element of choice or self-conscious action.[8] These self-conscious activities, however intermittent or uncommitted, are what constitute belonging in the context of a public. In the context of a population, where belonging is parasitic on activities pursued in parallel realms of activity and whose content is not necessarily related to the production of the population, self-consciousness as a form of agency is more or less irrelevant.[9] One might be perfectly well aware that Google (or Target, or any consumer-facing corporation)[10] is collecting their data, but that awareness cannot change the terms of one's use of that service except to produce an atmosphere around that use, a feeling of being watched or tracked while

one is performing the actions whose population effects are unchanged by that feeling. One either uses the service, in which case one's life becomes the engine of population production, or one does not use the service. It is therefore one of the urgent political projects of the contemporary moment to invent ways of inhabiting populations that can be more than a stark choice between opting in or opting out, being on or off the grid. For that political project to be possible, we need to know more about the population form: what is its structure, its affective range, its mediating strategies; what does it feel like to live inside a population; what are its logics of display and obscurity; how is the population assembled; what kinds of actions affect its operations? Does it help, for instance, to know more, or is knowledge irrelevant to the smooth functioning of the population?

In this chapter, my interest is to describe some facets of the always-indirect experience of existing within a population; that is, the structure of that experience.[11] This will be a story, set within the long history of networked intimacies, about the ways that the negotiation of insiderness and outsiderness in the context of cultural participation generates the structural conditions under which populations can be built off the back of that participation—not through conscious acts on the parts of the participants, but by way of data aggregation as a kind of social siphoning. Passion, fandom, the experience of beauty or singularity, and the attempt to communicate something of those experiences: these personal investments—authentic, committed, or uncynical when viewed as affective events—induce the kinds of behaviors that, in the context of densely and complexly commodified environments like the web or the art market, can be tracked and logged as data and then manifest as populations that are themselves now highly, even immanently monetizable.

Forms of fandom are, of course, not the only generators of populations. Any old comment or click or poke will do. And the building and feeling of insiderness likewise need not be dramatic or countercultural. It can be perfectly ordinary. But passionate insiderness generates the most wrenching contrasts between self-conscious action and the automatic siphoning of the population form, and so are a useful heuristic. Navigating insiderness in networked environments frequently turns out to be about navigating the tone of networked encounters. And this is because in networked spaces of population building, the tone of an interaction, its affective atmosphere, is often obscured. This fact, although not necessarily sensed as such, induces people to invent a diacritics of tone. Such diacritics—the

acronym LOL and emoticons will be my primary cases, alongside Felix Gonzalez-Torres's tonal diacritics—are therefore important elements of people's attempts to make such populations habitable, even if they don't change the structure of that habitation. All of these cases, in other words, are engines of but also supplements to life lived in populations.

In short, populations manage life. This is true whether the populations are generated epidemiologically and used to (more literally or existentially) manage life through the distribution of medical resources, as in the AIDS crisis, or whether they are generated within a commodity market for goods and services, where the management of life looks like the organization and economization of preferences, likes, dislikes, identifications, disidentifications, friendings, defriendings, links, pokes, and forwards.[12]

I will consider two artworks of the population form: William Gibson's novel *Pattern Recognition* (2003) and Felix Gonzalez-Torres's candy works (1990–93). In both works, populations retain the biopolitical function that Foucault described in his later work, while also alluringly incorporating certain characteristics of intimate publics, where people can feel as though they control the terms of their participation.[13] The resulting collective form is a queasy amalgam whose disorientations are exemplified by an overarching tonelessness and the compensatory need on the part of inhabitants to invent ways to mark tone, to incessantly announce their loves, likes, hates, tepid investments, and boredoms as a (if not the) condition of their participation in this particular group form. Felix Gonzalez-Torres's candy works address populations, belonging, and tone broadly as well as in two particular contexts that the works put into tense dialogue: the AIDS crisis, where activism, including Gonzalez-Torres's own, has attempted to produce habitable, political publics and other forms of association out of biopolitical populations; and the contemporary art market, where Certificates of Authenticity or Certificates of Authenticity and Ownership[14] verify the uniqueness of the work and the ownership of the work. At the same time, through some of the certificates' descriptions of the original installation or manifestation, the certificates imagine (thereby giving form to) the population of people who might take a candy from the installed work, might eat those candies or pocket them and circulate them around and away from the works.

William Gibson's novel *Pattern Recognition* is a parable about the coupling of passionate engagement and property management, aesthetic singularity and commodification that—as in the coupling of imagined col-

lectivity and legal or property form in Gonzalez-Torres's candy works—is central to the production and smooth operation of the contemporary population form. It shows how populations are built off the back of people's attempts to navigate, by way of engagement and the tonal markers of that engagement, the insiderness (and outsiderness) of a certain scene. *Pattern Recognition* begins to tell the story of what happens when ordinary aesthetic experience generates populations. The candy works, made in the decade before the web but not before the Internet, telegraph this situation in their deployment of a range of tonal markers in the installed form of the works. They explicitly link tone to a commodity form in which value coalesces around an imagination of future interaction rather than to any interaction in present-tense time. If this telegraphing is critical, it is minimally so, a wink more than a sneer—a wink that Gonzalez-Torres delivers through the parenthetical portions of the titles, obscure references to ideal weights, and, most obliquely, through Certificates of Authenticity that imagine and in imagining instantiate the populations that constitute the key group form addressed by the works. The minimalism of the wink is a significant part of the candy works' pedagogy.

Patterns of Attention

At the obscured center of William Gibson's novel *Pattern Recognition* is an artwork that is simultaneously considered great art and the "most brilliant marketing ploy of this very young century."[15] The designations are not mutually exclusive. In fact, they are mutually dependent, and this dependence is both the novel's subject and its driving anxiety. The work in question is a film released in installments and distributed across the web, hidden beneath complex encryptions that only the most passionate and skilled acts of fandom, which always appear in the novel as a kind of unpaid labor, can locate and decode. Such labors of love are the basis for the passionate online fan communities that form around the film and that are as central to the novel as they are to the film itself. But these labors are also the basis for the increasingly valuable skill of discovering the next consumer trend. The novel calls this skill "pattern recognition" and defines it as the identification of "group behavior patterns around a particular class of objects" in preparation for commoditization and marketing (86). In a further significant condensation, both skills are embodied by the novel's protagonist, Cayce Pollard, a professional "coolhunter"—"a 'sensitive' of

some kind, a dowser in the world of global marketing" (2)—who is also an active member of one of the online fan sites that tracks and comments on the segments of film, the Fetish:Footage:Forum or F:F:F.[16]

But this film, described as surpassingly and timelessly beautiful, is never experienced as a commercial sellout, despite the pervasive commercial allure that drives the novel's plot. As though in opposition to such commercializing forces, the novel describes the film as having a radically styleless style, unnamable and uncharacterizable—singular. In the following passage, that description is focused around the film's only two characters: "They are dressed as they have always been dressed, in clothing Cayce has posted on extensively [in the F:F:F], fascinated by its timelessness, something she knows and understands. . . . There is a lack of evidence, an absence of stylistic cues, that Cayce understands to be utterly masterful" (23). A masterpiece of abstraction then, but one that directly abstracts the aggressively named and branded landscape of contemporary culture (names and brands are all but synonymous in the novel). The footage asserts its mastery in the rendition of an object world whose patterns do not cohere in a style, a brand, a copyrightable name.[17]

Significantly, fans refer to the film as "the footage," not "the film." "Footage" conflates that word's original filmic denotation, the length of film corresponding to the duration and depiction of an event in the world, with the historically posterior sense of whatever events are captured on film. It conflates a singular materiality, the number of feet corresponding to a particular shot, with the more general sense of any kind of shot whatsoever; conflates, in other words, the singular with the representational. The footage's genius is its capacity to reproduce the feeling of an event in the past while signaling that that event could not be known in any other way than through the footage itself. The footage is the event's only referent and thus its only instantiation. It seems to have no precedents and to have brooked no copies; it can hardly be called a re-presentation. Elsewhere, the novel describes this aspect of the film as its capacity to be assembled, but not reassembled (68). In other words, the footage coheres around the passionate viewing, discussion, and archiving that it motivates and by which it is assembled, but not at all around an artistic subject (in the sense of subject matter) that would sit in history such that it would be available for retrospective study, learning, adaptation . . . that is, reassembly. It is *merely* footage. Thus, it is a quite literal instance of consumption as production, but one that, unexpectedly, in what might once have been a para-

dox, makes its true producer—its "maker" as the novel reverently, even religiously refers to her—so much more the cipher and cynosure of the work (both novel and film).

Which is to say, *Pattern Recognition* is about a work of art that, in its distributions, invites intimate attachment that is itself distributed across actors who are isolated not only by space and historical time (post-Soviet Russia versus post-9/11 United States), but also by the form of their own individual subjectivity. Characters rarely worry about whether they are understanding one another—about whether they are trapped behind their own subjectivity, as Stanley Cavell articulates the modernist problem.[18] But they do often worry about whether or not people are who they say they are, whether online identity itself isn't some kind of malevolent sham. This is less a problem of intersubjective understanding than a problem of whether subjectivity is even a useful concept with which to navigate the kind of online social encounters that in many ways drive the novel's plot. For most of the novel, Cayce has never met her most intimate F:F:F confidant and eventual lover, Parkaboy, whose proper name, Peter Gilbert, she doesn't learn until late in the novel (39, 198). Moreover, Cayce spends much of the novel alone, and "perfectly" aware of her loneliness.[19] So when the novel ends with her and Parkaboy happily coupled, which is to say, physically together in bed in the relatively synchronized space-time of contemporary Paris, the last line of the novel arrives like a solution to a problem theretofore unstated: "She kissed his back and fell asleep" (356).

But for most of the novel, intimacy, contact with others effected through a network and often in the context of the fans who assemble together there, is a side effect of the way that the footage focuses the attentions of its disaggregate fans. Attention can be focused, like a lens. It can also be paid, like a currency. In the novel, it is both. People pay attention and this quickly, even immediately, makes them of professional interest to people who work in marketing. But this attention is also focused on the footage—its creation, consumption, and circulation. Attention is the measurable unit of what "footageheads" experience as passion, love, obsession, fandom. It is the building block of populations made by marketing, which the novel presents as the engine and heart of all networked economies.

The footage fascinates the novel's entrepreneurial hero, Hubertus Bigend, because it shows how popularity relies not on actual sales of some singular commodity, but on talk, passionate gathering, the idea and merely the idea that a certain object or event, whatever it is, has orga-

nized the attention of a large number of people.[20] Bigend heads a kind of avant-garde marketing firm called Blue Ant. Bigend understands that the footage has "focused" (his word) the attention of a body of people who are separated by distance, time, interests, and intersubjective ignorance of one another, but who are all riveted by the footage and by conversations about the footage—a potential population, which is really the same thing as a population, as populations monetize and so materialize potential. Bigend is often spoken of in the novel with a kind of hushed reverence, a deep though fearful respect that seems rooted in the fact that his attentions alone are enough to make a small fan event like the footage into the next big thing. His attention, in other words, makes fans into populations.

The conversations on which Bigend and his company are always eavesdropping are usually arguments, fractious infighting on the F:F:F (and presumably other places, although these don't make an appearance in the novel, except by implication) about the origin of the footage, the "maker," the provenance of certain articles of clothing visible in the footage, and so on. Connoisseurial questions, mostly. That company includes Cayce, whom Bigend eventually entices to be one of his consultants. She joins reluctantly. But Cayce's reluctance only serves to underscore the direct, ineluctable, almost hardwired link between passionate involvement and population building. If the book has a moral, it resides here. Reluctant or willing, it matters not at all in the context of populations built in parallel to realms of activity defined by choice, passionate involvement, self-conscious participation. It is as though the entire plot of the novel—the search for the maker, Cayce's conscientious attempts to not betray footageheads to the commodification machinery that her work aids inexorably—happens in parallel to the real action of the novel, the building of populations through the harnassing of attention, which always only proceeds so long as someone is passionate about something somewhere.

The aggregated and quantifiable attention of the individuals who participate in conversations about the footage are tracked in the novel by the mystical powers of Bigend and Blue Ant—mystical precisely because Bigend's tactics for monetizing attention don't seem to involve any of the traditional means for assembling markets: mapping, representing, surveying, interviewing, and so on. Those attentions, aggregated somehow, perform the labor of making a cultural product matter. Mattering here conflates economics and passionate engagement, production and consumption; the novel is really built around their commingling. While pris-

oners in a private prison in Russia sit in great cubicle farms painstakingly rendering the footage on personal computers in lives rendered isolated by their incarceration (they do so under the direction of the maker's producer, who is also the maker's sister), footageheads watch, analyze, and discuss the footage on personal computers, in lives rendered isolated by the form of the networked commodity culture in which they exist.[21] Spatially and socially, the labor of production and the labor of consumption look the same.[22] And while the prisoners produce the form of organized information known as the footage, footageheads, in their relative freedom, produce the buzz about the footage that makes it matter within an economy of organized attention.[23] In the one case, a Fordist labor of discrete actions and assembled parts; in the other, the labor of population management. Here, these modes of labor become extensions of one other, an object and its image touching at the surface of a mirror.

It is their organized attention that makes footageheads into a population for Bigend, into an opportunity. As such, they are evidence of the aesthetic/economic value of the footage. This is why Bigend has deemed the footage not a work of art, as most footageheads understand it, but the most brilliant marketing ploy of the century. The proposition is explicitly tautological: people pay attention to the footage, so the footage is worth paying attention to. Most of what footageheads know of each other, and all Bigend needs to know about footageheads, is the fact of their attention, trained on the same product. This syllogism of attention and life is literalized in the character of Nora, the maker. The creation of the footage literally preserves her life by holding her attention. Nora was badly injured by a bomb that lodged shrapnel in her brain. Inflicting a kind of existential drifting of attention, the injury seems fatal until a doctor notices that a monitor displaying a closed-captioned feed from a hospital security camera trained on the hospital's reception desk holds her attention and thus sustains her life. When that live video is fed into her computer, Nora begins the editing work that will become the footage. That work consists in stripping the feed of detail, qualities, particularities, working at the level of the pixel to produce a work of art that is neither universalized nor affectively flat, but radically unnamable (289). The footage she produces, although affectively rich by virtue of people's interest in it, is toneless by virtue of its capacity to thwart all attempts to name and thus categorize it. This labor, the work of producing the footage, focuses Nora's attention and thereby preserves her life. But it focuses her attention, in what once

might have been a paradox, by sending it through a live security feed, by distributing it.

If the F:F:F seems to exemplify the grassroots workings of the population form, viral marketing is its AstroTurf analogue. One of Bigend's holding companies has employed a small-scale artist (a fashion designer and hat maker), Magda, to virally market the footage—a product, it's worth noting, that the company does not own in any traditional legal sense. To do her job, Magda shows up at fashionable nightclubs and simply chats, strikes up conversations during which she casually mentions the footage. The interlocutor, thinking the conversation to be a social one, even a successful one (friendly or flirtatious), understands the enthusiasm for the footage as genuine and, ideally, passes along this cultural information to someone else, and so on (84–86). In this way, a pattern is established, but here programmatically. The ramifications for the artwork of the population form are significant, because while the first, paid reference to the artwork is cynical—Magda is paid to name-drop the footage; her enthusiasm is cynical in structure—subsequent references, passed along the viral chain, might approach the genuine, or anyway get assimilated to the normal, complicated, and familiar processes by which cultural capital is displayed, traded, and compared. As Magda herself articulates the stakes of the process whereby distributed intimacy is harnessed to the imperatives of marketing and cultural production: "I'm devaluing something. In others. In myself. And I'm starting to distrust the most casual exchange" (85). The population form thrives on life itself and not, precisely not, on the complex but familiar business of commodity markets (purchases, demographics, co-optation, the crucial distinction between small and large markets, the cynicism or idealism of small or indie commodities that seem to work against or outside mass markets, and so on).

As uncertain as these disseminations of information and passion are in terms of authenticity and affect, they are increasingly certain in empirical terms. In the novel, Cayce discovers that segments of the footage are watermarked, encoded with an encrypted unique number that allows them to be tracked by whoever possesses that number. The maker's sister and de facto producer, Stella, we learn, uses the watermarks to track the dissemination of the footage (81). But of course this process can also work in reverse, and Cayce uses the decrypted watermarks to track Stella and her sister Nora to Russia, effecting one kind of denouement in the novel.

Like Felix Gonzalez-Torres's Certificates of Authenticity (discussed in

the next section), the watermarks preimagine and so help organize the parameters of the work's circulation. But whereas watermarks allow the holder of the key to visualize and map the movement of segments of the footage through networked space, through the space of the future population form, Gonzalez-Torres's certificates allow one to visualize the dissemination of candies *in imagination only*. As the novel predicts, this turns out to be a far less meaningful difference than we might want or expect, especially in the context of a legal contract. Consequently, these two artworks of the population form, considered together, telegraph the way that populations siphon off of world-building spaces like fan sites. The result is that imagination and algorithm, passion and data, fandom and protocol become aggregated as engines of population production—but aggregated precisely in the parallelism of their relation.

Imagined Populations

Felix Gonzalez-Torres's candy works, or spills as they are sometimes called, array themselves on the floor, sometimes piled in corners, sometimes swept into great squares or rectangles in the middle of the floor. Because people are usually invited to take a candy, the candy works may change shape through the course of an exhibition, sometimes diminishing without being replenished, sometimes becoming disorganized as an index of the action of bodies on the work. In actual curatorial practice, museums and galleries often tidy the works regularly, even though the Gonzalez-Torres Foundation does not require or suggest any particular maintenance of the works. This impulse is born of a desire to replicate Gonzalez-Torres's own installations of the works, thereby securing the works' appearance and market value as a kind of radicalized postminimalism. Gonzalez-Torres has acknowledged the influence of minimalist sculpture and conceptualism on his works, practices rooted in the 1960s and 1970s.[24] Even if he hadn't, the comparison would suggest itself at the most simplistic formal level: the seemingly bare and unabashed objecthood; the laconic, even recondite appearance of the works; their abstention from expressive gesture and so from questions of subjectivity understood as an identity formation.[25]

Approached simply as a question of phenomenal form, the works are quite simple—a simplicity easily read as formal elegance, even beauty (plates 5–7).[26] There are the candies, the color of their sugar forms, the

color of their wrappers (which often mutes or obscures the color of the candy itself), their shapes individually, their amassed shape, their position on the floor (hard rectangle in the middle of the floor, soft pyramid in the corner of the room, thin strips that trace the line where wall and floor meet, loose scattering on a handkerchief), and a wall label that is sometimes supplemented by guards who are instructed to invite people to take a candy. The wrappers can be colored cellophane, clear cellophane, paper, metal foil, or waxed paper. On the wall label is a mysterious though precise specification of the "ideal weight" of the amassed candies, and a title. But that weight, seemingly so precise, is more a conceptual category and is not always reflected in the actuality of a particular manifestation of a work. The title, never quite securing the work in a name, is always fugitively the same: *"Untitled"*—although there is also always a qualification, an afterthought in parentheses that is also a part of the work's title. Grammatically, parentheses are winks: they tag something unsaid with an acknowledgment of the fact of the unsaid, at the same time hinting at the fullness of what has been omitted. The ideal weights mirror this strategy of indirection. As does the tension between the defined shape of the candy work and the cumulative effect, over time, of people taking candies. The overall impression is of quietude and intimation, a feeling that more is going on than is indicated by the ostensible form of the thing to be consumed.

Speaking from his experience of installing and maintaining *"Untitled" (Placebo)* (1991), Museum of Modern Art curator Robert Storr gave an apposite if tendentious name to the candy works: he called them eyecatchers. That name occurred to him during an interview in which he explained how difficult it is to enjoy the freedom conferred upon the curator by the Certificates of Authenticity when one is also an owner of the work (in this case, Storr is a kind of owner-proxy with responsibilities to the titled owner, the MoMA). As will be discussed in more detail below, the certificates act to verify the uniqueness of the work, while granting the owner some license over how the works are to be displayed and treated over the life of the work's installation. It's unclear, constitutively unclear, whether maintaining the works' original, pristine form is a refusal of this license or an extreme version of accepting it. Regardless, with this sentiment, Storr points out that the apparent incompatibility of his two roles— owner and curator, the one who possesses and the one who shares—is precisely at issue in the works themselves, even exacerbated by them.

This is apparent in the event that precipitated Storr's comments. Artist and critic Joe Scanlon describes how visitors to an exhibition curated by Storr had begun, en masse but asynchronously, to discard their candy wrappers around the work.[27] This does not always happen with the candy works. But in that particular installation, the idea to do so had spread virally through the distributed group of people who attended the show. In response, Storr instructed his staff to pick up the discarded candy wrappers at the end of each day rather than leave them as a visible trace of the process of distribution and disintegration that, in fact, at some scale and some pacing, occurs during every installation of the candy works. This was Storr's way of balancing what he took to be his own responsibilities, as owner and thus maintainer of value, with Gonzalez-Torres's request that the museum not interfere with the decay or aging of the works.[28] The installed work, Storr summarizes, should be an "eye-catcher," not an "eyesore." Storr's compromise protects what he, acting on behalf of the owner (his employer), takes to be an essential quality of the work, something that he feels discarded wrappers would obstruct or make less available. Storr here gives a PR spin, "eye-catching," to an aspect of the works that others might call beauty, and makes every effort to communicate that aspect of the works to museum visitors, to facilitate and unfetter that particular transaction.[29] Some photographic installation views of Gonzalez-Torres's candy works likewise attempt to communicate and thereby preserve the works' capacity to catch the eye. In the installation view of the Serpentine Gallery's exhibition of *"Untitled" (Placebo)* the silver candies reflect light and screen-blue shadow (plate 5). The shape of the pile is perfect; not a pile or a spill at all, but a perfectly sculpted rectangle. The ordinariness of the single silver candy, and the unruliness of the massing of candies, is thus smoothed over by the doubled formal assertion (work and reproduction) that this be seen as a minimalist sculptural object.

But Steven Shaviro reminds us that beauty, in Kant's sense anyway, cannot be directly communicated; its transmission is fettered from the start. One person's experience of beauty cannot be expressed to someone else; it can't even be adequately expressed to oneself. As a singularity, in other words, beauty is affectively but never conceptually available. If the defining paradox of beauty is that it communicates yet cannot be communicated, then this reaching for metaphors on the part of the stewards of Gonzalez-Torres's work (beds, bodies, sculptures) communicates more about the presumptive conditions of possibility *for* the communication of

affective impact—a kind of marketing that is at the same time an attempt to stoke passionate engagement—than about the confident communication *of* that impact.[30] The decision to tidy up the wrappers, while practical, erases the communicative disjuncture between the owners of the work and the particular audience instantiated by that exhibition, and effaces the ways that communication in that relationship and in many others is often not direct and transactional, but lateral and halting, delivered through asides, insider references, winks, parenthetical phrases. The oblique gesture of a discarded wrapper is just such a gesture.[31]

Gonzalez-Torres's works communicate parenthetically in just this way. In an interview with Robert Nickas first published in 1991, Gonzalez-Torres called his most recent candy work at the time, *"Untitled" (Placebo)*, a "mean" piece.[32] Seemingly no meaner or less mean than any of his candy works, the adjective *mean* finds one of its ostensible motivators when heard in relation to one of the most stark differences between the various candy works: the parenthetical portion of the titles. The parentheses make the information given in the parenthetical portion of the title into an aside rather than an assertive, confident communiqué, a tone of voice more than the content of that voicing. In this sense, the parentheses seem to disavow or undo the semantic clarity that the word inside the parentheses grants to the title and thereby to the work. With a wink, the open parenthesis lets us in on the open secret of the piece, the closed parenthesis seals off the space of insiderness to which that secret grants us access. As a member of that space, we seem to belong to the public galvanized by the circulation of the secret; as an outsider, the parentheses cordon off a space of privacy, of interiority. The title makes both subject positions available, if not equally available, and lets people step into those positions according to their own identifications with the content of the secret or the invitation of the wink. In other words, *Placebo*, the word inside the parentheses, is a title that does not confer a name.[33] Gonzalez-Torres's candy works are untitled, and so unnamed, with little to communicate the significant difference between one work and another, except the open secret inside the parentheses.[34] In this sense, *"Untitled"* could be the non-name for beauty, because it announces itself while resisting the communicative finality of a name.[35]

Corroboratively, *placebo* is not the kind of word that rewards a wish for representational clarity. From the Latin for "to please," *placebo* in contemporary medical discourse gives the impression of efficacy without the

effect. It is, in part, an epistemological term. For a placebo to function as such, someone needs to possess knowledge of the substitution, and someone else, the subject of medical discourse projected as a population of people, needs to be ignorant of it.[36] If the candy work is itself a placebo, if that is the referential inflection of the title, then some aspect of what is presented—its beauty, its expanse, its availability for consumption or collection—is mere appearance, hollowed out by someone else's (the artist's? the owner's?) knowledge of the truth, the lack of substance, the trick. Of course, seen in the context of Gonzalez-Torres's AIDS activism, the referent extends outside the immediate formal boundaries and into the broader resonance of AIDS politics, sexuality, care for others, loss, death, the management of death both personally and epidemiologically, and the role of the state in that matrix of vexed relations.

More specifically, the parenthetical title refers to the use of placebos in the earliest trials of the drug AZT (1986), during which people in the placebo groups died in far larger numbers than medical testing alone could have warranted, sparking a wave of AIDS activism that demanded, among other things, "drugs in bodies."[37] In this regard, the work points to a false appearance within a more expansive realm, making the beauty or affective impact of the work itself the placebo, thereby implicating art, galleries, museums, aesthetics, taste, social class, and all the parties that contribute to the mortal divide between mere appearances and the elusive fact of continuing death.[38] A "mean piece," then, toward its owners, toward an art establishment whose politics rarely change policy or save lives, toward a state whose stewardship is itself a placebo.

Rather than clarifying meaning, the parenthetical portion of the titles give a slant to meaning, a tone. It spreads out within the aesthetic expanse of the work. Touching on this diffusive aspect, Gonzalez-Torres often talks about his works as "viral."[39] The virus is a figure of movement, of a distribution that spreads outward and yet is always too close: a toxic intimacy.[40] For Gonzalez-Torres, the viral was a heuristic for understanding his works' relation to that which they reference and critique. In Gonzalez-Torres's self-presentation, his works do not undermine or reveal that which they reference. Rather, they infect, they taint, they inhabit and spread. He conceives of his impact as not, therefore, revolutionary or avant-garde, advancing beyond the previous generation or leading by example. It is, instead, a distribution, measurable not by the force of its singular impact but by its capacity to mutate and spread.[41]

In the twenty-first-century lexicon of networked culture, the viral refers less to the spread of illness than to the spread of little intensities — pleasure, hilarity, cuteness, incredulity, the passionate love of a particular film. Once disseminated across a number of people and aggregated, for instance, as a meme, these intensities are said to have become culturally significant, to have made an impact. The viral thus names a form of distribution that is driven by individualized practices, actions, and attentions that feel like choices, preferences, the practice of taste and discernment. But the viral is not a direct effect of individual actions. It is less a scaling up of individual actions into a kind of stochastic proliferation than a side effect that can exist at multiple scales. No one person or group of people could have intended it, although certainly there are entire industries whose business is to try to manufacture memes. The viral in this sense therefore shifts the register of personhood away from the individual understood as the agent of one's own personal history. The viral begins with the personal — our distinctive interests — but produces a population through the automatic aggregation of those interests *by* the media through which those interests are pursued and voiced. So while the practices that constitute the viral can be tracked back to the individual, the viral itself is a population effect. The individual might be aware of her participation in a viral trend, she might even intend to instigate a meme, but neither self-consciousness nor intention is required for the viral to work, even to work paradigmatically. A joke that goes viral is a joke that people like enough to forward to a few friends, each small intensity hopefully motivating another forward push. The viral, in this register, is no longer something that happens to us; the epidemiological register is exceeded in that sense. It is something we effect, a kind of group form, without intending or even being conscious of our participation in that form. The very feeling of individual *participation* is an image generated after the fact by the spectacular appearance — say, in the news — of the viral as a population effect. The sentiment "I loved X before X was popular" perfectly reflects the temporality in which individualized action, and by extension individualism itself, is a back-formation of a population effect.[42]

In conceiving a form that dissipates in time and space as a side effect of individual choices, of the pursuit of small intensities, the choice to take a candy or not, Gonzalez-Torres figures a dilemma of personhood that is now not just a state relation (this was Foucault's interest), but a dilemma posed by the consumer marketplace itself, the erstwhile site of Haber-

mas's critical publics.[43] This is a marketplace where consumer browsing (not just purchases) can be tracked and measured; where the consumption of advertisements is precisely observable; where what might feel like non- or anticommercial activities (making a friend in LiveJournal; recommending a book on Facebook; being a fan of the footage or anything) are actions that can be logged, and fed immediately back into research and development, product design and marketing.[44] The most intimate experiences of love, friendship, and care produce populations, as we saw in Gibson's *Pattern Recognition*. Many of the candy works can be understood in these terms, with their precise references to the weight of bodies pivoting ceaselessly between the personal and the biopolitical, the self experienced as an aesthetic and the self understood as a statistic. At the pivot point of this understanding sit the Certificates of Authenticity.

Most candy works and some paper stacks, when purchased, come with a Certificate of Authenticity or a Certificate of Authenticity and Ownership.[45] Like most documents in this genre, the certificates verify the works' uniqueness and ownership—that is, their status as property. As the certificates say: "The physical manifestation of this work in more than one place at a time does not threaten the work's uniqueness since its uniqueness is defined by ownership."[46] The certificates thus anchor the works' value as property, as a thing that can be owned, even while the certificates stipulate a set of possible practices that would stretch the boundaries of ownership. In other words, the certificates only become directly relevant to one's experience of the work *if* one owns a work (or *if* one is being told about the certificates, as is the case here but is rare in installations of the work). This is entailed in Gonzalez-Torres's position that the certificates are private documents, something that sits between the owner, the work, and, in a sense, Gonzalez-Torres himself. But indirectly, or precisely in this recessive privacy, the certificates have far wider ramifications.[47]

The certificates codify one of the central, most remarked-upon, and most marketable features of the works: the fact that people are allowed, and often encouraged, to take a candy from the work. The circulation of candies around and *away* from the work is thereby made an explicit and formal feature *of* the work—the certificates declare this circulation part of the work's "intention."[48] Whatever we make of the strange group form that results, the certificates make the figure of this form perfectly available to the imagination, even to a merely contractual imagination. This contractually stipulated group, the members of which have no *necessary*

self-consciousness of their participation in that group as the contracts imagine it, is the primary group form of Gonzalez-Torres's candy works. It barely matters whether people actually take candies from the works. Their groupness, seen in the ways the certificates imagine it, is less something that can be actively worked on than it is a cultural by-product of other parallel processes—here, the potential that one will take a candy as envisioned, contractually, by the certificates.

Some of the literature on Gonzalez-Torres has argued that the offer of candies produces a kind of participatory atmosphere around the works, and a debate has emerged over whether this gesture should be seen as radical (antagonistic, avant-garde) or part of a relational aesthetic which is assumed, by the opponents of that aesthetic, to merely replicate the participatory ideology of commodities such as the footage or social media.[49] In this debate, the certificates are usually ignored. This radically reduces the ambivalence of the gesture and obscures the way that Gonzalez-Torres's aesthetic tactics adapt themselves to a far more complex political environment than one in which generosity, the power of the single gesture, could simply overcome some inherent structural withholding.[50] Gonzalez-Torres's aesthetic procedures hinge neither on such forms of strong, subversive authorship, nor on the simple antinomy of calling an artwork generous rather than stingy or exclusive. A wink is only barely a form of authorship at all. Moreover, the certificates generatively imagine this "private" value as precisely the engine of the groups it assembles around itself. In the candy works, a diacritics of insiderness, winks, and parenthetical phrases produce not a space of avant-garde exceptionalism so much as an imaginable group form built through the curating of affect and the circulation of small intensities. In other words, the nexus of personhood in Gonzalez-Torres's work is not just a scene of endangered liberal privacy into which reciprocity, generosity, and exchange are reparative intrusions, but the algorithmic imaginary of the population.

This claim will sound inapt, even ahistorical, if network logics and their relationship to populations are understood as contemporary phenomena that came after Gonzalez-Torres's life and work and that therefore exceed the possible range of his work's interests. But if technologies are neither discrete nor synonymous with their commodity forms, as I argued in chapter 2, then the modes of sociality now endemic to networked spaces are not strictly or chronologically concomitant to Web 2.0. Both networks and the skills people learn to navigate them have a history that exceeds

the commercial popularity and globalization of the Internet. Gonzalez-Torres's own biography proves the point. His AIDS activism stands as an early exemplar of a political movement that had to confront, with the highest possible stakes riding on the outcome of that confrontation, the problem of making a population (of AIDS victims, of people actually and potentially infected) into an inhabitable world, not only for politics, but for life itself.[51]

Foucault prepares this line of thinking when, in an essay written early in 1981, he calls friendship a "way of life."[52] Friendship in Foucault's account is a way of inventing, of inflecting the conditions under which one lives one's life. It is not, that is, a mode in conflict with other modes (e.g., political v. apolitical; antagonistic v. relational). In the context of the AIDS crisis, this project of reinvention, of inflection, of the atmospheric politics of tone, had to assemble itself within the cramped social logics of what Foucault historicized as biopolitics, a central feature of which was the dominance of the population form over other gatherings of life.

Here's an example, appearing originally on an ACT UP fact sheet explaining "Why we are angry": "Every major insurance company routinely denies benefits to people with AIDS or at risk for AIDS. That leaves only taxpayer-funded Medicaid, which will not pay for any form of experimental therapy."[53] This names a population logic, one that parcels out resources according to the mathematical purity, the automaticity, the incontestability, the differend of the population form.[54] The protest graphic "All people with AIDS are innocent," first used in April 1988 in the context of the coordinated actions of the ACT NOW coalition, resists this imposed population logic by undividing populations that had been divided precisely to better manage the AIDS crisis. As Douglas Crimp notes, this graphic, more specifically, was "meant to combat the mainstream media's division of people with AIDS into two classes: 'innocent victims'—infants, hemophiliacs, and transfusion-related cases—and, by implication, guilty victims—gay people, IV drug users, sex workers, and so on."[55] The protest action of the kiss-in, used in the same series of protests, performs what the poster declares: the kisses that course through the mass of bodies assembled in protest—already coded as AIDS populations either through their status as "at risk," as "guilty victims," or, most simply and brutally, as homosexuals—reaffiliate that mass around a viral affection of love, of care, of eroticism, of pleasure, of a belonging that is decidedly unquantifiable. As Gonzalez-Torres himself avers, these kinds of actions were as

much a part of his artistic formation as the more often cited influence of minimalism.[56]

It is in light of the form of these protests, and the way those forms attempted to recode the population as a space of habitation, friendship, love, and care, that I think we should read Gonzalez-Torres's explanation for the apolitical appearance of his artwork:

> Two clocks side by side are much more threatening to the powers that be than an image of two guys sucking each other's dicks, because they cannot use me as a rallying point in their battle to erase meaning. It is going to be very difficult for members of Congress to tell their constituents that money is being expended for the promotion of homosexual art when all they have to show are two plugs side by side, or two mirrors side by side, or two bulbs side by side.[57]

To see this as a pragmatic apologia for art forced by the times to hide its politics would be to disregard the ways that Gonzalez-Torres's work engages directly, even programmatically with "the times," a decisive problem of which was to find ways to recode belonging (as friendship, as a kiss, as a space of care) within the dominant biopolitical logic of the population. Seen in light of this specific historical project, Gonzalez-Torres's statement announces an aesthetics of indirection—of winks and parentheses, of viral insiderness spreading within the population form—that has much in common with the skills people are having to learn, two decades later, in networked life, where life is not managed in relation to death but in relation to likes. There, as in Gonzalez-Torres's work, an aesthetics of indirection and inflection functions as a way of curating an atmosphere, of producing a habitable if fleeting and ephemeral tone in spaces that, because of their inherent population logic, mostly seem to lack one.

Tone Check

In the contractual imaginary of the candy works, the candies represent the possibility that people may show up to the work, that many people might be there all at once, that random things might happen.[58] The candy works, in other words, intend a world in some candies that have been left behind. A spill. A pile. But they also intimate the absence of bodies. If, as they lie there, they are objects that might be taken, unwrapped, eaten, then they are at the same time objects that are not being taken, unwrapped, or eaten

in that moment. Each candy imagines the mouth not currently wrapped around it.

To intend a world in absentia says little about the tone of that world, about what people do there, about what it feels like to live inside the parentheses. In fact, the candy works are extremely unbossy about tone. What kind of locution is a pile? What kind of gesture is a spill? Both are forms built through an accumulation of accidents—they cannot have been intended, not in the strong sense that would involve a subject who is more cause than effect. The certificates stipulate the tonal flatness of the work, while themselves performing that flatness. They suggest that the owner should feel free to do as she pleases with regard to the installation, exhibition, and ongoing life of the work, refusing to dictate these terms, while their language is voiced in the flat tones of juridical neutrality. And then the works are untitled, except for the wink of the word in parentheses. The ideal weights are another quiet signal, but with nothing more than the wall text to point to the fact that weight is even a relevant or intelligible factor, and with few cues as to how to read that weight. How to locate or identify the feeling given by a specified weight of candies, a mere number? If one is insider enough to understand the reference to weight as a measure of illness, the slow attrition of a lover's body, but also therefore its endurance, to thereby identify the tone of the works as bittersweet, then what's been identified is less a specific tone than an ambivalent admixture of tones—too much rather than too little information. And in this, insiders are no better off, no more privileged than outsiders. So what tonal cues there are arrive in the space of exhibition as open secrets, winks to people who, in catching the wink, are welcomed as fellow insiders, or repelled by a proffered belonging they might well refuse.

The web is full of tonal diacritics that attempt to create an identifiable atmosphere, something habitable, within what are otherwise affectively flat or ambiguous forms of mediated intimacy. And like so many of the cues given by Gonzalez-Torres's work, the diacritical marks often stand in for an absent body.[59] Emoticons give textual messages a face. "LOL," an acronym for "laughing out loud," is a minimally descriptive form of laughter that reports on an experience and/or tries to induce a sympathetic bodily response in the recipient (if only in the replicative typing of the letters LOL). Whether mimetically or nonmimetically affective, LOL tries to induce a tone around an object or statement that might otherwise be disorienting, even off-putting for its lack of one. Like emoticons, those small

facial icons originally created out of simple grammatical marks (now often automated to be less schematic and slightly more enfleshed), LOL is a kind of diacritic for an environment that, in many of its subspaces or softwares, is still often mediated by text. In that minimally graphic environment, LOL specifies and distinguishes its object; it accentuates; it winks.

Interaction in the absence of tonal clarity is full of affective pitfalls, a slapstick comedy stage for the unconscious. Email has for some time now been the extreme case, an observation substantiated by the existence of ToneCheck, a software created by a company called Lymbix.[60] Lymbix's website announces their project: "We've designed a suite of enterprise and social solutions built on our unique ability to precisely determine the 'tone' in text-based communication." At the center of the project is a downloadable software called ToneCheck that, as the name explains, checks email and other outgoing text-based communications for tonal miscues, just as a spellchecker would scan for spelling mistakes. "Tone-Check by Lymbix gauges words and phrases against 8 levels of connotative feeling, allowing the end user to make real-time corrections and adjust the overall tone of messages using an easy-to-use menu system." ToneCheck stakes its business on the mass recognizability of the problem its product purports to solve; it also advertises that problem as an insecurity that people should feel if they don't already.

Diacritics like LOL address at a personal level the same ambiguities that Limbix regards as an entrepreneurial opportunity. As a form of affective and aesthetic curating, LOL reports on experience, but also tries to induce an experience, to propagate exuberance in the presence of the object it thereby inflects and in the absence of bodies to more immediately reciprocate and amplify affect. LOL, imagined in its distributions, as we might imagine the candies in their distributions, or the footage in its, produces a kind of infectious circulation. It is a diacritical supplement, an acronym that circulates as if it were infectious laughter.[61] Such diacritical curating attempts to generate an affective continuity between distributed bodies that is viral, but also atmospheric. LOL thus interferes with its own medium by generating a tone, by propagating an affect in what is acknowledged, by the very need for that action, as a tonally ambiguous or neutral medium. Gonzalez-Torres's parenthetical portions of his titles, along with the ideal weights, do something similar in relation to the medium of minimalist sculpture, disturbing its apparent neutrality with

a wink of affection, a knowingness that is both openly given and tucked within parentheses.

The proliferation of add-ons to one's web experience provides more evidence of this phenomenon: peer review, the Facebook "Like" button that appears on a growing number of websites,[62] emoticons, LOL and its many variations,[63] review blogs, aggregator sites like Boing Boing, Slashdot, and MetaFilter,[64] and thousands of other ways to inflect, to tonally mark one's own and other people's Internet experiences.[65] The problem being responded to here is not just that people want ways to organize a glut of information, as is often said. They also want ways to create, from a vast and effectively toneless space, specific tonalities, messages that induce or suit particular moods, that thereby form little blocs of solidarity and insiderness. The social media sites that monetize or, in Wendy Brown's terms, economize social relation need precisely these kinds of tonal markers to register, collect, and build populations on which personalized advertising in various forms gets delivered.[66] In this respect, emoticons and LOL can be seen as both engines *of* and improvised supplements *to* life lived in populations.[67]

Jeff Scheible analyzes what I've been calling diacritics as, in his terms, a "cultural logic of punctuation."[68] He views periods, parentheses, and hashtags as forms of punctuation that distinctively mark the "shifts" (not ruptures, but inflections) of digital culture. For Scheible, as in my account, the prevalence of such diacritics deserves attention and might even be seen as a periodizing tool. And his contextualization of diacritics as forms of punctuation (he has an expanded view of what counts, in digital culture, as punctuation, one that includes hashtags) helps us to see the longer history of contemporary forms like emoticons. In this history, punctuation has long had the role of producing a kind of affective clarity in language that on its own might be tonally opaque or ambiguous. This was, Scheible notes, especially important in the transition from oral cultures and the audiences they assembled to print cultures and the mass mediations they disseminated in space and time.

Scheible reads diacritics such as parentheses as displacements of language. They therefore inherit a deconstructive logic of immanent rupture, rupture from within. Like emoticons, parenthetical asides "challenge textual authority and master paradigms." I want this to be true, but feel that it overinflates the efficacy of the gestures by presuming a legible, even famil-

iar milieu in which such gestures might resonate: one where cultural resistance, resistance waged within representation, can matter or even be recognized as such. As I've been speculating throughout this book (gloomily although with an interest in identifying incipient aesthetics of response or resistance), I don't think this milieu holds within networked environments that generate populations as an automatic extraction from various forms of intentional encounter—intentional forms such as "challenging textual authority and master paradigms." Such environments relegate willful gestures, sovereign aesthetics such as the ones described by Scheible, to a separate zone of activity from which they siphon off the data they need to constantly regenerate themselves, precisely in order to accomplish such siphoning—just as the candy works imagine groups, contractually, even if no one ever takes a candy; just as the footage can be understood as the greatest marketing ploy of the century even while it registers, for fans in the F:F:F, as the greatest (i.e., least commodifiable) artwork of the century.[69] The tonelessness of networked spaces marks their strangeness, their parallelistic relation to intentionality, to sovereign forms of subjectivity, self-development, and world building.

Tonelessness can be created not only by an absence of cues but also by a superabundance of them. This would be in accordance with the common complaint that contemporary life is today oversaturated with information in the form of images, messages, and news. What I have wanted to describe here, specifically, is a vast, distributed network that has generated a veritable nonce lexicon, a diacritics of insiderness and outsiderness in response to the broken genre of that network and the group forms it assembles. Such diacritics are often gathered around an aesthetic object or event: a pile of sweets; the contract that imagines the social network of such a pile; a distributed, serialized film; the latest meme. In this context, such tone checks both produce populations (they are exactly the kinds of social activity that are tracked and managed in networks) and are, in effect if not in intent, a response to them, a kind of adaptation or skill.

In such a context, the gathering of people around things becomes less a world building activity than an inflection, a survival instinct, an adaptation to the population form, a "way of life." In this group form, small groups (or large, one never knows) are magnetized around enthusiasms, amassed attentions, fandom, mild liking, passion, preference, cavils of all sorts—the minor and intermittent and sometimes noxious forms of participation that constitute intimate publics. At the same time, in parallel,

such group formations continually generate populations. Gonzalez-Torres theorizes such fraught insiderness as the very condition of his works' revamped politics of the population form. Recall Gonzalez-Torres's statement that "it is going to be very difficult for members of Congress to tell their constituents that money is being expended for the promotion of homosexual art when all they have to show are two plugs side by side." The sexual politics of his work doesn't disappear; it gets encoded in a wink. The point isn't then to decode the politics of his work and revel in the subterfuge; the point is that winks begin to induce a tone and so acknowledge that their milieu is, on its own, toneless, algorithmic, and difficult to inhabit. The candy works catch viewers up in this process; *Pattern Recognition* describes and documents it.

It is perhaps easier to think that this vocabulary of tonal marking, of communicative indirection, is an artifact of Gonzalez-Torres's commitment to the austere language of minimalism and conceptualism. And it is in this framing that the commonplace understanding of his work as generous finds purchase: what minimal and conceptual artists retain, as material or meaning or the authority of authorship, Gonzalez-Torres gives away.[70] Gonzalez-Torres seems thereby to dematerialize the property form by offering it as thousands of small, sweet candies, given as gifts. But in the historical context that I've sketched for his work, distribution, which can feel like generosity, does not disturb the commodity or its property logic. Rather, it realizes it in another form. *Pattern Recognition* describes the process by which this particular commodity form, the population, comes into being, and the losses this entails for people who believe that that which is not for sale (i.e., the unnamable footage; the democratic spirit of the web) is not therefore subject to processes of commodification. The logic of Gonzalez-Torres's candy works emerges, not first from his commitment to the formal vocabulary of the preceding artistic generation, but queerly, as a side effect of its minor efforts (winks and asides) to make a habitable or thinkable form of collectivity, a "way of life," out of the population form and the historical conditions under which it came to dominate scenes and vocabularies of group form.

SEARCH ENGINE SUBJECTIVITIES

Here's a challenge that I predict you are better prepared to meet than you might think. Try to imagine each of the following figures as a person—not representations of people, not images of people, not parts of people who live more fully or more humanly elsewhere, but people in and of themselves. Some are images with integrated text, others are quotations (text only):

Friedrice Nietzsche
@tinynietzsche

will to power less

📍 prussia
🔗 twitter.com/tinyjesus
📅 Joined April 2010

[Tweet to Friedrice Nietzsche]

TWEETS	FOLLOWING	FOLLOWERS	LIKES	LISTS
33.8K	718	72.7K	65.7K	1

Tweets Tweets & replies Media

Friedrice Nietzsche @tinynietzsche · 1h
Don't ask me about nietzsche. I don't know who that is.
↩ ♺ 38 ♥ 101 •••

Friedrice Nietzsche @tinynietzsche · 2h
I would rather die...
○ on a hill

The question isn't "What do we want to know about people?" it's "What do people want to tell about themselves."

— MARK ZUCKERBERG, November 2011 interview with Charlie Rose

I think we have gone through a period when too many children and people have been given to understand "I have a problem, it is the Government's job to cope with it!" or "I have a problem, I will go and get a grant to cope with it!" "I am homeless, the Government must house me!" and so they are casting their problems on society and who is society? There is no such thing!

— MARGARET THATCHER, *Women's Own*, October 1987

One can easily imagine how each of these, as text or image, picture or quote, might stand as a representation of a person. Each is, in that familiar understanding, a selection, partial, incomplete, or, a version, a copy, a simulation. In each case, the referent or whole or person is thought to exist elsewhere. The best each image or text can do is point, gesture, mis-

represent in representing. But insofar as they each have, in a networked social milieu, become a kind of interface to the person, and are often all we get to know about someone we encounter, I think we need to be interested in how they might be persons in a not-partial, not-metonymic, not-representational sense, even if that sense involves some losses and discomforts. What would have to change in our conception of personhood to admit these as people with whom we might have encounters, not just parts of wholes? What has already changed in our encounters with others? Or, more precisely, what has already changed about the form in which others appear and are made available for encounter—made available through that queasy admixture of intention and algorithm that I've been exploring throughout the book? This chapter will explore these questions in the context of search engines, where the encounter with others exacerbates the tension between liberal and algorithmic forms of personhood, where all encounter is also a kind of self-encounter. This will allow us to return one last time to the idea of parallelistic aesthetics that previous chapters have begun to sketch.

Look now at plate 8. Also a kind of quote (although not one that was ever meant to be read by anyone who was not its author), it's a single search query as typed, somewhere, by someone, into a search engine. As are the following:

myspace pregnancy layouts
stages theatre
eros escort
abc private practice
912f
york car parking
duplicity
p38 plan
astrologers

If these were familiar to you as search queries, then that already says something useful about the coming-into-form of search queries as a mode of nascent or nonce *social* interaction (i.e., not just an interaction with a distant computer)—even a form of recognizable personhood. Less obvious is the fact that this string of queries is being fed to us, almost *as* they are being typed, through the interface of an artwork, a networked artwork by British artists Thomson & Craighead.

Thomson & Craighead's BEACON lets people assemble around a new kind of thing, specifically a new form of question: someone else's search query.[1] Whether expressed in the interrogative, the declarative, or a less nameable voice, search queries want something. A band name. A date. An actor's last film. An ex's latest photos. Links to oneself. More direct than most questions, often dispensing with grammar and syntax, and appearing for the most part without punctuation, they could almost be demands, a primitive language game: "slab!" "porn!"[2] Seen in series, as BEACON presents them, there is something innocent about the queries, something guilelessly direct. *Dv332, porn, moustafa nesim, free online games, telephone call recorders, cnn.com, 2008 hot gifs, Free porn, Cartoon network, Brooke burk, 208 ammo surplus, Lolita toplist, Al sharpton, Behind ear headphone loop, justin timberlake's single ladies.*[3] Those are queries that BEACON just now streamed, one after another, although the queries replace one another too quickly for me to type them all.[4] Some queries are simply long strings of numbers; if those are desires, I wouldn't know how to satisfy them. In any case, I am clearly not the addressee; at best, I overhear.

Thomson & Craighead themselves call the queries, taken together and seen in series, "endless concrete poetry," and so imply a particular mode of reading that would arc across the gaps in individual queries, finding meaning (or the disruption of meaning) in aggregation, in contingent patterns, in observer distortions—although the question of what mode of reading is being invited or made possible here will be the work's central problem, as we'll see.[5]

The window in which the queries appear is gray against the gray background of the page. *best vietnamese translator.* A rapid fade-to-black precedes the appearance of each new query. For the most part, BEACON is a static web page, little more than a placeholder, a marker that someone has been there, once, laying down the code and leaving. Only the pace of replacement, one query then another, against the static appearance of a site otherwise reminiscent of homepages of yore, hints that there might be something live about the page—aside from one's own arrival there.

And yet, BEACON runs off a live networked feed, proving how dead or still or static liveness can be. It streams other people's queries as they are being typed into search engines elsewhere online (see plate 9).[6] Behind each search query, then—in fact if not in feeling—there is a searcher possibly near us in space and definitely near us in time, and however much or little access one feels one has to a person via their query, the searchers

are granted some kind of mediated presence by BEACON's liveness. But it is a fleeting presence, a part-presence, not even ghostly because ghosts are thought to linger. If BEACON produces the feeling that other people are present (as what? to what?), or that its viewer is in any case not entirely alone with the queries or with her thoughts about them, then this encounter is only barely more relational than using a search engine to type one's own query. Or just as relational.[7] *daily niner.* Given a live network connection, people are always out there; connection is a technical given.[8] Liveness here, and thus the kind of togetherness on offer, is a technical effect, made possible by a working network connection. BEACON doesn't exist without this connection. But the affective impact of this liveness is far more variable, impossible to predict and recalcitrant to generalization. Does the work make one feel connected? If so, to what? To what kind of thing or person or person effect or part object? Ostensibly, all we're invited to do is monitor it, watch it tick along, scan its opacities, curiosities, and fleeting patterns. If one is therefore tempted to wonder how different this is from watching a television screen, on which images also flick past in rapid succession, adding up to something or very little, remember that looking can never be "mere" or casual or informal in the time of networked interfaces, in the space between populations and publics, where no more than looking is needed to subsume one within an immanently knowable, quantifiable population.[9]

Jon Thomson & Alison Craighead are British artists who have worked collaboratively since they left the MFA program at Duncan of Jordanstone College of Art in Dundee. Trained in video, they now tend to be referred to as Internet (or Net or New Media) artists. Such terms say something about the landscape of Thomson & Craighead's work, but very little about the topography—its recessions, pressures, formations (not unlike calling Jackson Pollock a drip artist, or Morris Louis a Magna artist). In these characterizations, they are victims of the same impulse that restricts the historical and critical ambit of any work to whatever an archive can aver, whatever history conceived as chronology confirms, whatever seems plausible given a literalized, often ahistorical understanding of technology and media that too often considers technologies only in their overt commodity form (i.e., not also in their discursive and technical formations, their sensorial impacts, their structures of feeling, their affective atmospheres, etc.).

For themselves, Thomson & Craighead have always been interested less

in the Internet as an artistic medium and more in the kinds of things (statements, photos, videos) that tend to accumulate online, seen in their relations to the technical conditions that make those accumulations possible. Specifically, they want to know what assemblages and sequencings of those things can do to our sense of self and self-locatedness. They make patterings of found material into nonce cultures and then locate us in those cultures. *The First Person* (2013, plate 10) streams a live (and so unending) series of statements culled from self-help websites and plays them over video of a burning house. *A Live Portrait of Tim Berners-Lee (A Early-Warning System)* (2012, plate 11) constructs a portrait of the eponymous Internet patriarch by using live outdoor webcams situated on opposite sides of the world, eleven time zones apart. Each webcam image constitutes one pixel in the raster of the overall portrait. The contrast between night and day in the individual webcams creates contrastive hues in the portrait, the contours and shadings that articulate a face. The liveness of the source images means that the portrait reverses its value approximately every twelve hours, in sync with the movements of the sun. Most of Thomson & Craighead's works are conceived as installations in which a projection is the locus of attention, although certainly not all there is to see. Some, like BEACON, also have online versions that are more extensions of the work into other scenes than they are instances of a series or editions.[10]

BEACON has three forms or manifestations: in addition to the online version that I've discussed so far (plate 12), there is a projected installation (plate 8) and a split-flap sign (plate 13). I'll be in a better position to say more about what the three versions of the work might have to do with one other at the end of the chapter. My starting question, and the touchstone of this chapter, is relevant to all of the versions: what do we know about a person if all we know about them is one of their search queries? And can we call that, whatever our answer, an encounter with a person? If so, by what logic? Such questions turn out to be correlated to questions about populations with which I began the last chapter. They ask at the level of personhood what the previous chapter asked at the level of the population. One implication is that the relationship between personhood and population is, unlike mass markets, no longer one governed by scale. Rather, personhood and population generate each other and so become less and less discrete.

Search Engines

Led by Google, the search engine industry has established the competitive terrain for search engines as information itself, by which they mean, without any detectable exaggeration, all of it, all the information there is. A search engine launched in July 2008 exemplifies the reach of these ambitions: founded by three ex-Google employees, Cuil.com (pronounced "cool") advertised that it indexed three times as many web pages as Google and ten times as many as Microsoft.[11] You can guess that Google and Microsoft index a lot, well into the multiple billions of pages.[12] *white boy greg.* The pitch of this advertising campaign assumes that information, as a commodity, becomes more valuable the more of it there is—that people want access to specific information, of course (i.e., more relevant search results), but also to information as a horizon of possibility against which one can conjure an always-on, limitless optimism about what it's possible to know, learn, or recall.

Search engines offer access to the feeling that it would be possible to find anything. "Anything," in this context, is precise: anything you want to find, anything you might have forgotten, anything previously hidden to you, anything you need for work or love or to relieve the lack or over-abundance of either. "Anything" is the symbolic pronoun of twenty-first-century commodity culture's democratic claim. "Feeling" is precise as well. How else, except as an ambient optimism hovering over the act of typing a search query, could one experience the capacity to access the 121,617,892,992 web pages that Cuil.com claimed to index as of September 24, 2008? Search engines sell optimism of this sort: knowledge as the great palliative of needling curiosity, lingering questions, things on the tip of your tongue. By selling answers to any question, mediating all inquisitiveness, search engines promise the historical end to a certain feeling: the feeling of not knowing. *customizable information retrieve.* But commoditization here—meaning the selling of search engine users as an audience to the advertisers who are the search engine industry's primary source of revenue—isn't fully totalizing. Not yet. Commoditization in this context confronts new obstacles, most notably the fact that the information to which search engines give access is in significant part the amassed and networked by-product of the not-yet-fully-harnessed energies that motivate people to upload photos, to edit *Wikipedia* entries, to

make comments on stranger's websites, and so on—the kinds of passionate (or not) engagement that were the concern of the previous chapter. These are precisely the energies that make the conversation about the Internet and commoditization such a magnet for both wild anticapitalist optimism and wild paranoia about capitalism's spread.

We hardly need Foucault anymore to perceive the link, the hardwiring, between knowledge and personhood in these scenes of commodified optimism.[13] Consider a stark example: www.criminalsearches.com. Criminal searches.com indexes and archives criminal records and makes them available online in a free searchable database. In other words, it is a specialized search engine. Criminal records in the United States have long been publicly accessible, but they have always required some effort to obtain—at the very least, a trip to the public records office and some time spent in the archives, in other words, more effort than all but the most energetically paranoid citizens are willing to exert. The "practical obscurity" of such records placed limits on their publicity. This meant that many people with criminal offenses could one day, perhaps, get out of jail and start a new life, with the practical obscurity of their past granting them the potential for a different future—however much scarring they bore privately from their time in the prison system. To make criminal records available online, accessible via a simple search, is to fundamentally alter the future of people who have committed crimes in the past. Present and future actions suffer more acutely the drag of past actions, because past actions no longer require patient diligence, an archaeologist's care, to be retrieved. They can be retrieved and publicized in a moment of boredom or randomness, via the unintentionality of a stray forwarded link or the intentionality of a personal attack or the quasi-intentionality of a troll for whom the attack is neither personal nor programmatic.[14]

Search engines grant this kind of access by rewiring the ways people pursue knowledge. *Make a dulcimer.* This in turn impacts how we learn, how we change ourselves, how we move toward horizons of self, and how we alter those very horizons. But the relationship implied here, between personal and structural change, isn't necessarily a predictable recursivity. I don't think there is any reason to assume that search engines' various impacts across the network of the social are symmetrical, synchronous, or rational. The criminal whose future is proleptically stigmatized as an effect of his past becoming searchable is not thereby or reciprocally guar-

anteed any kind of access to information that would allow him to change his fate.[15] Populations are asymmetrical; they disseminate the logic of the differend.[16]

Search engines reanimate a discussion about knowledge as a vast unspecified field within which forms of personhood come into focus, are dis- and then reorganized, and are mobilized in the direction of something else. They alter the terrain for coming into contact with the world, or with a world, or with the multiple worlds of ordinary experience. They alter, and arguably improve, people's resources for making sense of and living within the present tense; at the same time, they facilitate the process by which people are gathered up as populations, on the basis of which a particular form of individuality is manufactured, and finally this entire procedure is sold as a progress narrative that makes lagging behind feel more like a personal than a structural problem.

A Silent Witness

There is a sense in which BEACON merely wants to give us a very partial view of these processes. But the tone of that ambition isn't conspiratorial. We're not being let in on a secret. Instead, it's matter-of-fact, something happening all the time, always elsewhere but never far. The website for the online version of Thomson & Craighead's BEACON tells its visitors that it began live broadcasting other people's search queries at "00:00HRS GMT on 01st January 2005" (plate 12). "Live broadcasting" hints at the connection between personhood and group form that I've been describing, where an address to the everyone and no one of a network, constituted in and by the serialized queries, gathers personhood and whatever knowledge is imparted through that feed up into the folds of a strange relationality. Search queries appear in BEACON, one after another. Each query hails from one person (or one group of people at one computer—from one IP address, anyway). *James g. king + redmond.* While the searchers are anonymous but fleetingly present in the form of their queries, BEACON's audience is anonymous and always absent from the artwork's manifest appearance. Without special technologies, one almost never knows who else is simultaneously looking at any website.[17] This is a defining feature of the aesthetics of networked sociality. It's not just that one doesn't know particular people in a public, or doesn't know everyone—that has always been true of print publics, from books and magazines to websites.[18] It's

that there could always, at any time, be no one, or someone who speaks back but not in reply.

In such encounters, as in the couple form, togetherness might feel like loneliness. It's quite possible that I'm the only one watching BEACON right now. *Beastly stories.* By the time I finish this next sentence, others may have joined me, although I'd never know. *Value place liberty mo.* Of course, the searchers themselves are also included in this group assembled around the site of BEACON's "live broadcast," but they do not know I'm watching, and I know nothing about them . . . *except* for the words they use to formulate a particular search, which is not nothing.

BEACON, in other words, materializes search as a scene of atomized, nonreciprocal togetherness, togetherness that is only barely not the same as being totally alone. Via the liveness of the connection, BEACON situates us with others in view of an activity that is as pervasive as it is recondite: web searches. But this liveness only makes livable, or sensible anyway, a group form that is already the case, algorithmically. Such forms of connection normally happen in parallel to our networked activities: proximate but untouching and not subject to our will or decision making. We know, when we search, that others search at the same time; that search engines rely on that fact. But the togetherness, that of the population, is insensible. BEACON stages an oblique encounter with it, *with* the group form of the population, producing a penumbra of affective togetherness. *Fable— how do I expose lady grey?*

Aside from such parallel forms of contact glimpsed herein—encounter as a by-product of near-simultaneous commodity use—the question of togetherness again raises the question of reception.[19] Do other people's search queries address us at all? If so, in what register? If not, then what is our relation to them? We know that the streamed queries were not intended by their authors for BEACON's viewers, or for any actual person or personified reader. *gadget show speed test.* If written for anyone or anything, they are written for the machinery of search engines, which is maybe to say that they are written for a machine imagined as a kind of oracle (that would be similar to the personified form of ask.com). But they might also be written for something no more personified, in the searcher's imagination, than a money machine or an adding machine (the name *Google* refers, denotatively, to a very large number, a googol, or a 1 followed by 100 zeroes). *"prophetic anointing."* In other words, within this circuit of searcher + desire + addressee, voicing doesn't equal communication, a

give-and-take; it is a promise of potential encounter with something that feels like an answer.[20]

Nevertheless, BEACON's impact, which is intimately related to the specific ways that people think to voice their desires, may be an effect more of a felt transparency than of opacity. *deals on used ford taurus cars*. If intimacy often voices itself in the cosseted idiom of intimation, BEACON's form of contact may lie with the disarming clarity and honesty of its queries.[21] *where to find tic tac silvers*. In part, this is because the idiom in which we write our queries, however unselfconscious, necessarily incorporates the more conventionalized patterns, norms, forms, discourses, and clichés that are available at any one time for the asking of questions and the voicing of desires. In this idiomatic zone, improvisation vies with convention under the influence of expediency. Watching BEACON, we might imagine that we can perceive this tension between the individual and the collective, the personal and the conventional. BEACON restages this zone as a theater by offering visual access to other people's search queries and whatever those queries imaginatively open onto. *illegal cp*.

BEACON's seriality, then, is a procession of encounters or missed encounters: partial, episodic, nonreciprocal, related more to demographic personhood than to anything like subjectivity or personhood understood as replete presence. Nonetheless, BEACON's viewers find themselves confronted with other people's questions, wishes, curiosities, desires, hopes, conundrums, memory lapses, investigations, typos, misspellings, secrets, embarrassments, bored maunderings, desultory free associations, and so on. *Idaho*.

Because it is a live feed, the series is as endless as the search engine it takes as its source. The search engine in question is Dogpile.com, which is in fact a search engine compiler—the name refers to the "pile" of other search engines to which a query typed into Dogpile.com gives one simultaneous access. *Clinton Thomas Lee*. That is to say, BEACON will probably last as long as Dogpile's business lasts, which could be a long time, or, given Google's dominance and the financial precariousness of the tech industry, possibly not long at all.

Endlessness, as an art historical trope, refers to the culture industry and its temporality of numbing repetition, to lives unvaried, endlessly, but always dusted with the glitter of variety. Michael Fried's critical reference to endlessness was an attempt to cordon off this structurally killing repetition from more individualized and, Fried felt, more hopeful aesthetic

temporalities—like those of immediacy, self-referentiality, acknowledgment, or conviction.[22] That is, Fried wanted to assert a distinction between endlessness and true aesthetic events that might transcend such numbing rhythms.[23] But BEACON, with its reference to a specific company and by implication to a specific industry, reveals a structural instability at the heart of endlessness. The form of endlessness that BEACON echoes is tied to the fortunes of the companies who compete for shares of the search engine market, and tied thereby to the for-profit business of organizing "the world's information." What happens to the world's information when the company that organizes it goes bankrupt, or fundamentally changes, as most successful Internet companies do? Maybe some endlessness is less durable than others. A closer, more historicized examination of endlessness probably always reveals such fissures, or arrhythmias, although that doesn't guarantee that life gets better for anyone. *Lesbian ass eating.*

Endlessness, in BEACON, is a product of the liveness of the networked connection and the endless cycle of queries streamed through that link. *Olive garden menu.* Like all varieties of endlessness, this one is infinitely varied if only one can come to care about the variations, to find some purchase in them. It is a heterogeneity so great, so minutely varied, so endless in its limitless unspooling out into some future that it could easily be mistaken as homogeneous, one big chaos of something pre-scripted (by the artists, by Google): mere data. As I've suggested throughout, one thing we seem to be invited to do, confronted with the constancy and impossible heterogeneity of this stream, is try to assimilate a single query to some larger notion of a person or aggregate personhood. Or, if we are more precise taxonomizers: a person engaged in the action of searching, of trying to learn something—which often, as BEACON reveals, involves shopping for something, or in any case, is configured much like shopping and eventuates, through tailored advertisements, in enticements to shop.

Every two seconds BEACON gives us a new search query from a new searcher. The projected version proceeds at the same pace. The split-flap sign, in a concession to its older electro-mechanical circuitry, shows a new query approximately every minute. So the work asks us to attend to the movement from query to query. And if we're still thinking about persons, as I believe the work asks us to do, however fractionally, however tentatively, by whatever fugitive logics of personhood, then now we're thinking across persons, aggregating them, looking for patterns (such as the fact that after 6 p.m. there is a far higher percentage of porn searches). If we

allow lots of variation around how such activities might proceed, I'm not sure what else BEACON invites or even *allows us* to do.

The film *I Love Alaska* (2009) exemplifies this temptation to generalize search queries, as parts, into whole persons whose lives we might thereby access imaginatively. It does so by way of its desire to constellate a narrative around the person of America Online user number 711,391, one of the 650,000 users whose search queries, amassed over three months, AOL accidentally released onto the web in August 2006.[24] The play *User 927*, based on the same event, similarly evidences the will to assert that personhood is the form proper to search queries, the thing they add up to if we're attentive enough, empathetic enough, good enough recognizers of pattern.[25]

But there is another way we need to see search queries, one that doesn't speed toward personhood conceived as a whole, gathering up all parts as qualities that assemble an encompassing representation. That is, *not* as an address to us, but as an address to a search engine; an inducement not toward audience-oriented exchange but toward algorithmic accumulation. The address to and from social media is always split into such parallel streams of activity and address: representation and algorithm, personhood and protocol, patterns and populations. So if the work gives you the sensation that you are spying on someone, note that you are actually being made to feel as though you're spying on a kind of communication whose intended recipient is a corporation and its search technologies. *human comfort ppt.* In that sense, BEACON is not only addressing and so bringing into being a very dissolute kind of group, dispersed in both time and space—an art audience-cum-population that might feel like a public of knowable others—it is also, just as in Sharon Hayes's work, quoting, siphoning an address intended for another and allowing an art population to *overhear* that address.

One of the things we know about how search engines "see" search queries is that they see in a very particular kind of aggregate. Google really does want to organize *all* of the world's information.[26] We also know that search engines "see" in this way because, ultimately, they need to serve us back to ourselves in the form of ads, sponsored links, and personalized responses. Their mode of "seeing" (tracking, logging, aggregating) is an effect of their need to fashion forms of personhood as individualities that make an encounter with a machine feel like reciprocity, like getting an answer to the question we asked.

What is distinctive about this mode of subjectivization is that it is no longer based on an advertising industry's best guess about how certain types of people might be susceptible to certain suggestions made at certain times in certain contexts, as in television ads. That is to say, it is no longer based on deviously intelligent guesswork combined with the power of suggestion to make some of that guesswork come true. Search engines don't generalize people in that way, that is, to give the older method a shorthand, *representationally*. They don't generate an image of a class of people as a *predicate* for the address of the ad and hope people will find their way to the product via some form of identification, including dis-identifications like resistance or ironic attachment.[27]

It is more accurate to say that search engines, through both search results and ads, aspire to produce not classes of people with whom one might identify or disidentify, but the personalized self. Not groups but selves organized around interests and desires that one inevitably recognizes as one's own (or as a near miss such as an errant book suggestion on Amazon—a near miss that one nevertheless can recognize as a derivative of one of their own past searches, or at least one conducted from their own computer). Search engines want their products to become integrated with their recipients, as knowledge, as consumer product, as lifestyle, as work tool, even as something against which one voices complaint and resistance. Unlike older forms of advertising, which were necessarily an appeal to a class or type of person, search engines want to produce an appeal directly to a single individual, built up from the data of a single individual aggregated into a massive database of other people's search queries in order to arrive at such precise targeting. Importantly, this data is constituted by people's actual questions and desires along with the context in which those desires were voiced. It is not a representation of those behaviors.[28] As the author of a trade book about Google reports: "Contempt for traditional advertising permeated Google from the top down. In their original academic paper about Google, Page and Brin [Google's founders] had devoted an appendix to the evils of conventional advertising."[29] And later, elaborating on this contempt and the fruits it bore: "Since Google searches were often unique, with esoteric keywords, there was a possibility to sell ads for categories that otherwise never would have justified placement."[30] *piano man—lil wayne*. The chapter in which these quotes appear goes on to detail both the ways that Google can tailor ads to the "long tail" of businesses looking to place an ad and to the long tail of users to

whom these ads could be increasingly personalized. Whatever it is, this is not strictly a representational logic.

One deviation from the representational is starkly evident: search engines produce a vast amount of knowledge about their users, and in doing so they rely on quantification. Representational logic, by contrast, is predominantly qualitative, relying on qualities, hermeneutic skills, and assertions based on those skills or intuitions.[31] Search engine companies accumulate massive databases of past searches.[32] These databases drive their ad business and help them evolve their search algorithms. Algorithms are the main part of what generates the differences between search engine companies, why a search on one will call up different results than a search on another. They are therefore closely guarded secrets.

BEACON's watchers, on the other hand, are subjected to such data in a form that is as impractical as it is suggestive. Search engines are machines for making use of search queries. BEACON exposes a fast-paced series of search queries to a dispersed group form, and thereby to the fallibility of memory, to short attention spans, to indifference, to a kind of affective charge or fascination that marks the difference between interpretation and computation. *Lompoc newspaper.* The desire behind a search query can seem loudly transparent. *Free nymphet.* It can seem literal and obvious. *Detailed map of Japan.* It can seem cryptic or opaque. *Star on House.*[33] What kinds of things do people search for? What do people want? BEACON offers a vantage from which to generalize about such questions, to see what patterns can be invented and discerned, to play at analysis. In doing so, we would turn those queries into representations. Meanwhile, search engines are machines specifically designed to process such data, to make singular queries into profitable databases, to make populations from scattered singularities as a way to ultimately readdress the individual qua individual, and to do this as endlessly and as precisely as possible, with no remainder of self left outside their personalized address. In the context of such a comparison, staged explicitly by BEACON, we viewers might come off looking like the most plodding sort of interpreters, playing at systematicity, flailing at generalization, too invested in the categories dictated by our psychologized subjectivities. Whatever we feel about the difference, the asymmetry is unavoidable. We need representations to think beyond the individual; search engines do without them.

In the summer of 2008, a defense attorney for an Internet porn site in Florida tried to détourn this asymmetry, revealing in the process some

quiddities of how knowledge can be produced by people who are gathered up into populations. Google Trends is a tool that Google provides to its advertisers to allow them to compile popular web searches, producing operable data about the queries with which, by contrast, BEACON mostly teases its viewers.[34] The defense attorney, Lawrence Walters, attempted to use Google Trends in court to challenge the definition of "obscenity" used to prosecute pornography. The law in question states that obscene material must be judged offensive by "contemporary community standards." *Watch tv online*. Walters tried to prove, using Google Trends, that the "community standards" in Florida, whatever high moral claim they made for themselves, in practice included searching for a lot of porn. Walters's insight was to define community not by what people say about porn in that community, not by how they *represent* their moral values, but by what that community, understood now as a population (known by actions siphoned off of people's more self-conscious, sovereign activities, their self-representational work), does with porn in its free time—as that time and those activities had been archived by Google.[35] *finding missing persons*. By the standards Walters mined, a porn website wouldn't be "obscene" at all; it would be practically a family value, affirmed day after day in act after loving act of domestic intimacy.[36] *history of vegetable squash*.

To be a viewer of BEACON is to be placed in the position that Walters tried, in his defense, to make the court occupy: that of a search engine which collects the kinds of data that BEACON streams and which turns that data into new sources of information (marketing, advertising, and revenue). But it is easy to misrecognize this address as audience-oriented rather than computational, which evidences not the work of ideology so much as the fact that networked life is stuck between two collectivizing logics, that of the public and that of the population. *rubber nobs*.

BEACON thus exposes people to one of the new processes that generate marketing subjects as back-formations of populations. We confront this process (parallelistically) and the versions of ourselves that it generates (directly) in the search results that our own queries return to us. These freely intermingle "objective" results and paid advertising, which altogether constitute a mathematical, biopolitical guess about what we want and who we are in that moment of ascribed, algorithmic desire. This is confirmed by search engines' meretricious but not false claims to be learning more about their users every day, thereby making searching better, giving users more of what they want—that is, returning to us algo-

rithmic versions of ourselves that are more and more nearly mimetic, a more nearly perfect guess about what we want to learn and, in so learning, become, if only in that moment.[37]

This is the formal encounter at the heart of BEACON: it lets us experience, in persistent, endless time, the process by which, in everyday search engine use, we become an avatar of marketing data that amalgamates our own searches with others'. This happens when we watch other people's search queries appear and replace each other, because in this we are experiencing a fallible, affective, unmnemonic facsimile of what search engine databases "see" and record, perfectly, with infallible memories, on the back end of our searches. Search engine databases are better archaeologists of knowledge than we are because they eschew archaeology. I'm suggesting that to watch BEACON is to encounter—in slow motion, with all the distortions thereby entailed in a process for which speed equals knowledge and therefore profit—the new mechanisms for generating populations, engines of generalized, populated personhood that people are constantly forced to encounter (however obliquely or unknowingly) and generate (directly) in their day-to-day networked lives. And so BEACON lets us sense, if only to sense, the process by which the singular query comes to inflect personhood as such.

Ordinarily, such biopolitical processes are invisible or actively obscured except in the ways they are keenly felt when they work to constrain life, flourishing, or equality—for example, in the parceling of resources and care, the attrition of bodies, of lives, of health and optimism.[38] Alexander Galloway argues that such processes, as they have been reinvented for networked life, are constitutively unencounterable, that their very elusiveness *is* what defines networked society.[39] Such effects are obscured, for instance, and not just online, by a pervasive rhetoric of sovereign, even hypertrophic individuality, wherein difficult lives are given to be understood as products of bad decision making, a failure of personal responsibility.[40] *"x-file humbug."* BEACON offers a vantage onto one of the processes by which people are distilled from populations, and stages this encounter around the very questions people ask to change or better or satisfy themselves via autodidacticism, distraction, play, searching.

It should be no surprise, then, given the surplus of needs produced in a time when a pervasive biopolitics of citizenship makes all social burdens the individual's burden, that the phrases BEACON streams often seem to register the violent impacts of such a regime. *Pale. Jockstrap galleries.*

Calculate annual increase. Your porntube. Superheroine fetish. Enzo Angiolini shoe stores. Sometimes watching BEACON is hilarious and enlivening for its cryptic perversities, or for the way queries evidence a beautifully uncomplicated, even optimistic approach to seeking jobs, pleasures, information. Sometimes it crushes one under the weight of a massively indexed lack, as though a million questions expressed a million private disappointments. People's searches often sound like a desire for relief. When noticing such things, the affective difference between representational logics of personhood and algorithmic logics of population building can feel slight.

Search queries are one kind of engine of the process whereby persons are distilled out of populations. And BEACON is a kind of slow-motion picture of this process, or at least a picture of its primary inputs. So, again: are these inputs people? Do we encounter persons when we encounter their search queries? Do search engine companies? One thing I think BEACON stages, beyond a kind of queasy surveillance, is the radical difference and probably the incommensurability between how we might answer that question and how search engines answer it everyday. In a sense, it's stubborn of me to keep insisting on the word *person* here when so much about the case might make us want to turn to a more critical term like *posthuman*.[41] Yet at stake *is* a question of personhood, whatever its temporal relationship to the computing machines that motivate a concept like the posthuman, however that personhood is built—and at stake not just in BEACON, but in search engines themselves and all of the activities in which they are now caught up, insofar as search engines continue to exist as learning tools (thus as a form of self-care) and shopping opportunities (thus as self-elaboration) and advertising for all sorts of things (thus as an important and long-standing, if compromised site of collective life). Personhood is at stake as well in any space of mediated encounter where what happens in that space is built upon a very partial knowledge of someone that might never become part of a whole: queries, likes, pokes, flame wars, emoticons, spam, lurking, a vast and growing diacritics of encounter.

Parallelism, Part II

Here, finally, the different versions of BEACON come to matter.[42] There are, as I described earlier, three manifestations of BEACON. The word *manifestations* in that last sentence, and *versions* in the one before that, are place-

holders, because each begs an important question: the question of the relationship of one work to another. *Manifestations*, like *versions* or *serializations*, already presumes, even if gently or tacitly, that there is a kind of Idea or Form that anchors and threads through all of the works, uniting them. And in that presupposition, something happens to the individual manifestations or instancings of the work: they get slightly demoted, they become subservient in their tethering to a common center. And in that role, there is a concomitant demotion of the encounter with each form, a lessening of its importance in relation to the whole. For now, I'll stay with *manifestation*, with the caveat that what comes to stand in place of that word is really where we're going.

The online version of BEACON has been the ekphrastic source of my writing to this point. There is also a projected version for gallery installation (2006), in which only the search queries themselves appear unframed on a wall, a projector's throw from the machines (projector, computer, networked connection) that produce them (plate 9). The third version is a mechanical railway flap sign fabricated by the Italian company Solari di Udine (2007, plates 13, 14, 15). The flap sign formally and technically replicates an information display system first used in the Liège train station in Belgium in 1956 (plate 16 shows a later version of the same technology), and eventually installed in airports and train stations worldwide. Instead of a grid of constantly updated information about arriving and departing trains and airplanes, BEACON streams search terms, one at a time in a single line of text and once again in networked or live time (i.e., as the queries are being typed in elsewhere). As mentioned previously, this version of BEACON streams queries at a rate of one per minute rather than the faster pace of its online and installed versions. The railway sign version of BEACON was first displayed at the British Film Institute's (BFI) renovated South Bank location in 2007, but after a change in management early in 2008, the piece was relegated to the BFI back room, where it remained until recently.

Solari di Udine, BEACON's fabricators, invented the technology of the split-flap in the late 1940s. First used in clocks (Gino Valle's Cifra 3, 1965–66), it eventually become famous as the technology of large public information display systems. The split-flap's ascension out of everyday domestic use and into aesthetic canonization was nearly complete by 2004, when the Museum of Modern Art's Architecture and Design department purchased their "Split Flap Board Flight Information Display."[43]

In what relation, then, do the three manifestations of BEACON stand to one another? The mere existence of the three, suspending the question of their precise relation to one another for one more minute, is a strong encouragement to think that one of the points of the work is to underscore a certain kind of dematerialization in the logic of search engines and their algorithmic form. The three, taken together, suggest that whatever the particular form, whatever the mode of encounter, the data flow remains the same: a flow that loops from searcher to algorithm to database and back to searcher, restlessly, recursively (so the conceptualist Idea, in that rendering, would exist not in the materialized artwork, whichever manifestation, but in the search engines it takes as its material, medium, and subject). The query is the primary input for this process. The person is the output. Inputs fold into outputs ceaselessly. An effect of this endless process, seen precisely for its endlessness, is that it becomes more possible to ignore those inputs and outputs, to think of them as background against the ground of silky user experience. Ask, receive.

This dematerializing vector in the work rhymes with what might appear to be its avant-garde ambitions. BEACON takes its referent, the search engine, and reverses its logic, introducing shards of defamiliarizing experience (by offering not the results but the queries; not our own, but another's), as well as a kind of economic détournement whereby the operative economic logics of search engines are literally bracketed out of the work: there are no ads, and we cannot make anything out of the results we see streaming past us, cannot add them up into a database, cannot mobilize and monetize that database toward the description of peoples, toward the subtle shaping of their persons. The avant-garde logic here would be that of the strikethrough: that which is undone by the artwork remains in the frame, only to be X'ed out, negated, rendered inoperative. The pedagogical lesson then adheres in the ongoing presence of that which is undone. This is a representational operation. It acquires its optimism only in the degree to which one is able to imagine that search engines' most robust existence is in the mind of the user, as ideology. As such, the avant-garde procedure, in negating the ideology of search engines while showing us the devious persistence of that ideology, can goad us to think differently, and maybe teach us how to think differently, to make better representations and act on those instead.

But the fact remains that whereas, say, a patriarchal or homophobic logic *might* be susceptible to pedagogical nudging of the sort provided,

subtly or aggressively, by such a representational operation, an algorithmic process is bothered not at all about such aesthetic interventions. The most informed search engine user—one who knows full well the biopolitical procedures whereby knowledge is remade as commodity, and results are leveraged as subtle tools of subjectivization—changes nothing about search engines by that knowledge. Search engines are insensate to such pedagogies. Pedagogies do not change search engines. Either they are used or they are not. If they are used, they are operative. When they are not, they remain operative, and the user is, in a sense, the poorer for not having that resource, that source of knowledge about the world. But algorithmic logics do not supersede representational logics; they run smoothly in parallel to them, while hollowing out the forms of resistance that operate on the basis of representational logics. This draws out one key implication of the idea of parallelism: that the generalization of a population logic establishes a space of prophylaxis between that logic and more familiar logics of representation, identification, subjectivity, and relation that have been so much at the center of aesthetic politics since the 1960s.

The coexistence of the three versions of BEACON alludes to this fact. Each represents a common idea: the idea of the work, the idea of streaming other people's search queries, even the idea of rendering inoperable the search engine logics that the work limns. At the same time, the work's live feed, which qualifies the work as networked art, is an acknowledgment, even a strong one, that the work merely siphons off of something that remains fully operative in another realm. In fact, the very dependence of BEACON on that live feed underscores the fragility of the artwork in comparison to the immense robustness of search engines themselves. BEACON is connected to a network that it doesn't and can't substantially change. Likewise, it connects us to a network that we can in no way touch, communicate with, interrupt, or change. No matter how many times people make plays or movies out of search queries, search engines do not address us as an audience.

In this, BEACON does not overturn the logic of search engines: it is homologous with them; it recapitulates them. BEACON presents to us, implicitly, our *inability* to interact with search engines except as users of them, underscoring the asymmetry of that relation, the differend separating us from the spheres of action we otherwise have little choice but to understand as our own. BEACON shares the form of that relation. The noncommunicative, noninteractive form of this grouping is mirrored in

the presentation of other people's search queries, which we can only read, scan, observe; shake our heads at in disgust; laugh at in bemusement or wonder. If one virtue often claimed for artworks is their refusal of an imperative to be efficient, productive, engaged, connected, committed, here BEACON shows that search engines, and the various networked technologies of population building and population management with which they collaborate, are literally untouchable by such a refusal. They cannot be refused, only abjured—and the loss entailed will only be one's own. They make all forms of critique into Luddism, the starkest refusal, worse than Luddism in fact because they work no matter what behavior is thrown at them. Can they be destroyed? Maybe, but the various forms of de- and rematerialization that make distributed networks possible make this very difficult, conceptually as well as technically. The prime directive of electronic networks, when they were being implemented by the U.S. military, was to be robust, to resist known forms of destruction.[44] More vexing still: what would one give up were one to succeed in destroying search engines?

To say that BEACON exceeds a representational logic suggests that BEACON is visualizing precisely the kind of data that has become so valuable in consumer culture today—data that is not imagistic, not based in images and how we read them, but algorithmic. BEACON presents data of this kind in series—a much slower, more anemic version of the form in which search engines receive and archive the same queries. Seriality here is a concession to human perception, not an aesthetic challenge to it.[45] With a database of information like the one compiled by Google and serialized by BEACON, one doesn't need a theory (a representation) of people; one can produce an almost entirely bespoke stream of advertisements, as well as personalized search results, individually tailored according to each searcher's own search history.

Yet BEACON beckons to us with the promise of learning something new about persons. And presented in series, the goad seems to be to consider these persons in the aggregate, via a kind of improvised, on-the-spot social theory in which queries would add up to discernible patterns, out of which representations of persons could be produced. Seen more microscopically, the search query does seem to stand in for the searcher and so is itself ostensibly representational (via the exemplary fact, via metonymy, via indexicality, etc.). But even while these qualities of the work appeal to our familiar faculties of pattern recognition, our representational thinking about the world and people, BEACON operates in homology

with search engines, which do not work representationally. They don't begin with a generalized image of an aggregate of people; they begin with your searches. And they don't end with a representation of a demographic market, as an advertisement might; they produce a version of us, as individuals, that is fed back to us not in the form of a picture or caricature or flattering makeover, but as nothing more simple or complex than the things we might like, based (innocently and individualistically enough) on other things we've liked and done. Not a representation of us, then, but us, period. Aspirationally, at least, this is the case, but also, sometimes, affectively and, to an increasing degree, technically.

The point is not to draw a distinction between savvy and naive search engine users. It is to notice that that particular difference, so pivotal in critical theory, doesn't matter much in this context. And the implications of that observation, even if it's only partially true, are enormous. It means our entire idea of aesthetic intervention might need to change: change to accommodate a structure that cannot be shifted by knowledge, that cannot be interrupted by defamiliarization, or antagonism, or subversion, or queering as these have been understood in the long history of modernist aesthetics. For all of the fun singularity of the encounter with search queries, this sort of encounter with a person-object or part-person is not at all uncommon now (nor, incidentally, is the surveillance structure through which BEACON stages it). And if that encounter is no longer fully or solely guided by a representational logic, as I think it's not, then we have some work to do to figure out intimate encounter again. And to figure out how to figure it.

Notice one last time how quiet all the manifestations of BEACON are, formally. In the online version, arguably the busiest of the three, there is static text, a mostly empty screen, and a single delimited frame in which a cinematic wipe reveals a series of search queries. BEACON doesn't seem to aspire to do more than siphon off existing search engines, and simply present the results of that siphoning to us. There are a variety of amusements we might derive from reading other people's search queries, or we might have a reaction to the experience of seeing *people* who do not know *they* are being seen (creeped out, salacious).[46] But if this were all BEACON did, then it would take its place among any number of cultural forms that induce us to laugh or cringe at other people's behaviors, to condescend, to differentiate ourselves.

In a recent essay for *e-flux*, McKenzie Wark offers the provocation that

there are today only two extant modes of aesthetic practice: negation and what he refers to, after Asger Jorn and the Situationists, as the creation of new forms.[47] And some recent debates in critical theory seem to affirm the same rough bifurcation: critique versus hope;[48] antagonism versus relation;[49] structure versus affect.[50] Wark favors the production of new forms as the only really viable aesthetic practice today because, as he says, today's ruling classes, the information controllers or "vectorialists" in his terminology, the Googles of the world, now prefer negation.[51] They need it to adorn their portfolios and their living rooms and to generate their latest apologies for capitalism's excesses and asymmetries.[52]

I don't think BEACON designs a new form—it's too quotational, too appropriative. I also think it is very clearly *not* calibrated as negation, of search engines or search engine use. Search engines proceed very happily in parallel to the work. BEACON knows this, even relies on that fact. The liveness of the connection between BEACON and the search engines it siphons only underscores this parallelism, as the feed simply reports on what happens somewhere else, without disturbing that somewhere in the least. BEACON *cannot* disturb that somewhere without disrupting itself. That is the effect of its liveness.

The main structure revealed here is the way that search engines collapse something that has structured both modernist and postmodernist aesthetics: the very idea of an outside, a space or time apart, whether that space or time is figured as margin, subculture, bohemian fringe, or, in a more cramped postmodern inflection, cognitive map. In all cases, whatever the idiom, aesthetics relies on an antisepsis of action to the side of whatever. There is no use of search engines that is not also a participation in and, worse, an enhancement of their power to make us into populations. This doesn't mean that the kinds of learning people do through search engines is not genuine, is somehow false or ideological. Whatever knowledge is gained might be genuine, significant, even revolutionary.[53] But whatever that knowledge's effects are *on* the user of the search engine, it also abets the cybernetic systems that feed lives into algorithms to produce populations and thus exert forms of soft and hard control over those populations.

Not all forms of population management are insidious or ill-intentioned. But the absence of an apparent, conceptually available margin or outside—spaces of real antagonism or criticism, spaces with the *potential* to act on the object of critique if only via the mediated slow-motion relay

of representational politics—makes search engine aesthetics tricky, and maybe impossible in a modernist or postmodernist sense. All that would seem to be left is simple refusal or total withdrawal. Détournement, for instance, in our current understanding of it, could amount to nothing more than a fantasy: a fantasy of using search engines in some way that would short-circuit their effects, their economic-technological engines. Fantasies are powerful and politically necessary, but they too run in parallel to search engine technics, except when they themselves are being directly or indirectly influenced by the kinds of knowledge people acquire *through* search engines. But the lines of force or influence do not run in the other direction. Search engines monetize our actions, not our fantasies; they literalize all fantasy.

As if in acknowledgment of these sad facts, BEACON is quiet, understated, barely there. Its form does not stake out a radical position of exteriority either for the work or for the viewer. It simply siphons off other people's searches. It generates no new forms; it simply reports on *the fact and form of* existing ones. Nor does it aspire to interrupt its referent in any familiar sense, modernist, postmodernist, or otherwise. It is neither antagonistic nor ironic. It simply transmits the flat tone of this form of encounter given in the uninterrupted, eventless flow of the work. In this, it contains both the vestiges of representational thinking (as tease or temptation) and a newer, algorithmic, population-building apparatus (that we are too slow to actualize but can still sense). BEACON thus arrays—as parallelism, not syncretism—things that artists and activists have wanted to understand as intersectional within some sphere of action: a referent and a critical angle or reflection on that referent, the world and a critique of that world.

In this parallelism, this fragile exposure of the artwork to its ostensible object, lies perhaps the most powerful claim of the work. What I think BEACON does, in its weird equation of liveness with parallelism, is stage how indifferent networked technologies are not just to a variety of aesthetic interventions, but to most available forms of self-conscious world-building activity: decision making, deliberation, protest, and so on. BEACON, in its quiescence, seems to underscore how indifferent search engines themselves are to these forms of interruption—the very kind of interruption that a work like BEACON seems to promise by its very existence as art, but constitutively cannot deliver. One thing the coexistence of BEACON's three forms does—online, installation, and massive split-flap

sign—is intensify this effect. In a sense, each form on its own is quite formally complex. And yet no matter how complex the large split-flap sign is, no matter how much wonder induced, none does more than simply report on a series of facts, happenings in a parallel realm. They tease us with the familiarity of those facts, their human-like quiddity, while staging their strangeness.

Stuck between the tease of an intimacy that might feel representational (connected to actual people and therefore generalizable) and the impersonal dividuation of a database, BEACON's serial form registers a recent episode in the changing historical relationship between knowledge and power, and so between personhood and collectivity.[54] Its seriality is not the endlessness so feared in the 1960s.[55] Those forms of endlessness are of course still in play. But BEACON signals something else. It transmits the endlessness of data and the cybernetic folds in which data ceaselessly transforms, using people's most personal and impersonal activities as an engine, to become more efficient, more accurate, and more profitable. In the cases I've pursued in this chapter, this data is endlessly generated by search engines and is therefore endlessly productive of knowledge about people mobilized in their diverse individuality, their wants, habits, inclinations, wishes, foibles. By endlessly improving search engines' capacity to understand people, the search query provides people—"users" is apt here—with search results that feel like what they want to know, that feel like personalized knowledge.

The search engine and its associated databases obviate the image as a representational tool because of this special form of endlessness. This is mirrored, dimly, in the feeling—merely the feeling, the tease—that BEACON's seriality accretes into social knowledge, knowledge about our fellow searchers. But search engines' own operation employs sociology without theory, without models, without representations. Just data points. But data points that provide shelter for a particular conception of personhood: personhood as inflected by, if not fully an effect of, repeated encounters with oneself returned as an avatar of marketing data. In a sense, this is the very form of personhood BEACON gives us: instance after instance of trackable, aggregatable search queries, only they are not our own, but another's. They are that with which people's own search queries are mixed to form populations out of which people then reappear as distillations, their individuality returned to them by way of personalization. While we might laugh at other people's queries, as if to signal our distance (of class, race,

intellectual style . . . whatever) from the query that flashes by, our own queries, we know, are no more and no less meaningful for the computers that scan and store them, that know how to read them but don't need to interpret them.

In this, BEACON mirrors the way in which search results themselves are a kind of serialized self-encounter, even if they don't always feel that way. This is self-encounter not in a sense that presumes the prior sameness of the two selves, but in the sense that the search results transform the participant into something she already wanted to be, or know. This happens both via the absorptive uptake of the results qua learning as well as via nonintentional, nonconscious algorithmic processes that remake us as data points in populations in order to feed the results of these biopolitical processes back to us as personalized results. Such a process sits very nicely in parallel with all sorts of cultural activities, even the most scathingly critical ones. It is defined precisely by that parallelism.[56]

By *parallel* and *parallelism* I have meant a few things: first, an acknowledgment that in many ways search engines are in fact a genuine source of knowledge, even while we might admit their complicity with a variety of exploitative and homogenizing practices. The good seems to run in parallel with the bad. The two don't touch and have never yet been synthesized dialectically with and by a third term. I also refer to a technical feature of search engines: the entire apparatus whereby search engines and other networked social technologies build populations in order to feed us back to ourselves. That critically important process is made possible by the logging of search queries or likes or pokes or posts. It happens on the back end of the ways we use search engines or any social media—happens no matter *how* we use them. Thus the parallelism exists more for the user than for the search engine. Still, search engines rely on this parallelism, even if they don't participate fully in it, to help foster the view that they are not data aggregators and spies, but personalized life tools. Finally, parallelism has referred to the peculiar sociality of knowing only a small facet of someone as the basis for encounter with that person (a single search query, say). But not really a facet, part, portion, or representation of any sort. The basis of this kind of encounter is itself parallelistic: it never quite seems to connect with personhood, never needs to connect part to whole, and yet can be impactive, can matter, can even be all we have to make friends, hook up, build collectivities at whatever scale and pace.

So *parallelism* is a counterconcept to *representation* and signals a shift

from the problem of a world overrun by images to something else, something that needs a description before it needs a name. Parallelism is a structure of encounter, now pervasive within the space between populations and publics. All of my cases in this book exemplify this form of relation, this basis for group form, although each works that parallelism differently and to different effects. The challenge such works issue for aesthetics is the same as that issued by so many forms of contemporary culture, including I think most forms of networked life. Namely: how do we change, interrupt, or build worlds to the side of cultural forms that allow us to engage in all sorts of interruptive procedures while they work perfectly well in parallel to, and off the backs of, those activities?[57]

This, in any case, is BEACON's question, and it's a crucial one for a time when so much of the technical basis for social and political life exists now not in contact with people but in parallel: impactive but nontouching, governing but operative in a realm that operates apart from all forms of self-governance. This, in short, is the impasse of living between publics and populations.

APPENDIX

Transcript, Sharon Hayes's *I March . . . ,*
Evening Performance, December 2, 2007, New York, NY

My dear lover, I'm taking to the streets to talk to you because there doesn't seem to be any other way to get through. So that you have a picture of where I am, I'm standing on the street on the corner of Rivington and Orchard. I'm speaking into a megaphone. It's Sunday Dec. 2. Yesterday was World AIDS Day. I need to speak to you my love, of your love . . . your life, my life, your love, I need to speak to you of our past, I need to speak to you of our future, of sweet things that have turned to bitterness, and of bitter things that still could be turned to joy. You refuse to answer my letters, my messages, my phone calls but I know that the ears are the only orifice that can't be closed and so I will speak to you from every street corner if I must. Things here are spiraling so far down I fear that people just can't face it anymore. Everyone seems dreadfully cheery which I know means the violence is at its worst where you are. People are packing up their pain, and their anger, and they're moving on, which I know you would find shocking. You would be surprised at how different it is now from when you were here nine months ago. No one seems to be able to talk about the war. It's like we can't find the words, or we're tired of saying the same thing over and over and over again. There's no movement here, and yet so much happens. In May I started making a list of things I wanted to talk to you about: Cheney's pompous warning to Iran, the Blackwater scandal, the bombings at the Gazil Market, and all of this hurried talk of Baghdad returning to normal. And then more time passed and I started adding things about us: that time in Nov. when I told you I didn't want to love you; and that day in Jan. when I said "the pain is just too great, I was

meant for other things." And then the list grew and grew and I couldn't tell anymore which were the events that happened when we were together and which the ones while we were apart. Why are you leaving me in all this confusion? I waited month after month to hear from you. I know when you left I was sad and I was angry. I know I said I was shutting the doors against you, but you should have remembered that no one can shut the doors against love forever. There is no prison in any world into which love cannot force an entrance. If you don't understand that, you don't understand anything about love at all. I'm speaking with total freedom. What holds me to this megaphone is you. Don't you remember the last time we were on these streets together striding arm in arm in that pack of people, hundreds and hundreds and thousands of them, swaying their bodies, stamping their feet, shouting movement talk, and whispering little nothings that could hardly be heard in the ear they were spoken to, so loud was that crowd. You yelled, you yelled, you yelled and then you lost your voice. The ecstasy of being gay and angry. You made me stop at Fourteenth Street so you could fix your sign. You said you wanted to be more clear. "If everyone acted like us," it said on the front. And you turned it over and wrote "there would be power in the streets." My sign said "together we can change the world," which you said was simplistic and cheesy, but by the end of the day you were shouting it at the top of your lungs as if it was the most important thing in the world to say. We were so in love that day. And we really thought things could change. So when you saw that headline in the paper about the march, you said "now the president would have to respond." You said "that many people can't take to the streets for nothing." And the whole next week you woke up early. You went out, you got us two cups of coffee and a copy of the paper. We lay in bed and we read each one cover to cover looking to see what they would say about us, waiting to find some mention that we had been heard, some evidence that things were shifting, some evidence that ours was a tide that couldn't be stopped, that everyone young and old, political and apolitical was prepared to talk about the war and that everyone would want to, that our message would be repeated in a thousand mouths until the world was full of nothing but voices of protest as far as the ear could hear. By the end of the week you were despondent. You woke up one morning a few days later very clear. You said "this whole country watches us strap on this revolutionary spirit, and they let us spend our waking hours demonstrating, and writing letters, and speaking out like they let an eight year old think she's winning at

Monopoly." You said you felt duped. That you felt like a chump. And how could we ever have believed it could work. We were so stupid you said. And you looked at me like I was the one that tricked you. And I told you "This is how things are. Things are good and then things are bad. Don't take it personally and no no don't give up." But within the month you told me you just couldn't stand being so ignored. You said that this country was arrogant, and that we were manipulative, and that things weren't like this in other parts of the world. I stared at you in disbelief, and you told me that you had bought a plane ticket and were leaving the next morning. And all of that happened in the early part of March and now a great river of life flows between you and that date so distant. I know it might hurt you to have me replay this scene. For you it's history. But for me time itself doesn't progress, it revolves, and suffering is one long moment. For me, this scene occurred not yesterday but today. The moment that you have long ago forgotten is happening to me now and it will happen to me again tomorrow. The past, the present, the future are one and in that one moment you are here with me, and then you are gone. How many times do I have to tell you: you've lighted a fire in me my love and I'm being burned up. If you long for me, I long for you. I'm waiting for the war to end. Come out against war and oppression. I love you. I love you entirely. I love you so much I can't sleep. A dream is a dream. Reality is real. Open the door to the way we feel. The news is grave. Love is so easily wounded. Out of the closets and into the streets. We will not hide our love away. We won't be silent. Act up, fight back. I'm beginning to think we speak in different tongues. Surely you know that desire is cruel. I feel certain that I'm going mad again, nothing is real but you. I'm a stranger in my own country. I feel as though a part of me has been torn away, like a limb in battle. Nothing that has ever gone before was like this. What do we want . . . when do we want it. The aim of love my sweet is to love, no more and no less. How many times can I say this to you.

NOTES

Introduction

1 This conjunction of presentation and representation, of production and re-production, is precisely what's at stake—for different but, as I'll elaborate in the next chapter, convergent reasons—in Fred Moten's important work *In the Break: The Aesthetics of the Black Radical Tradition* (Minneapolis: University of Minnesota Press, 2003).

2 As I'll describe below, Lauren Berlant's trilogy tells an important part of this history: Lauren Berlant, *The Female Complaint: The Unfinished Business of Sentimentality in American Culture* (Durham, NC: Duke University Press, 2008); Lauren Berlant, *The Queen of America Goes to Washington City: Essays on Sex and Citizenship*, Series Q (Durham, NC: Duke University Press, 1997); Lauren Berlant, *The Anatomy of National Fantasy: Hawthorne, Utopia, and Everyday Life* (Chicago: University of Chicago Press, 1991). But here I am also broadly in agreement with Shannon Jackson and her desire to "remember the dimensions of this kind of work ['social works,' in her terms] that induced infrastructural avowal, that is, that understood 'heteronomy' as a socio-political but also as an aesthetic-formal openness to contingency." Shannon Jackson, *Social Works: Performing Art, Supporting Publics* (New York: Taylor and Francis, 2011), 32.

3 It is not the only motivation, of course. Anticapitalist work, anarchist movements, and science fiction all provide differently motivated accounts, although ones that are no less concerned with mass market capitalism and its transformations.

4 Guy Debord, *The Society of the Spectacle* (New York: Zone Books, 1994); McKenzie Wark, *50 Years of Recuperation of the Situationist International* (Princeton, NJ: Princeton Architectural Press, 2008); McKenzie Wark, *The Spectacle of Disintegration: Situationist Passages out of the Twentieth Century* (London: Verso, 2013); McKenzie Wark, *The Beach beneath the Street: The Everyday Life and Glori-*

ous *Times of the Situationist International* (London: Verso, 2015); David Jose-lit, *Feedback: Television against Democracy* (Cambridge, MA: MIT Press, 2007); David Joselit, *After Art* (Princeton, NJ: Princeton University Press, 2013); Helen Molesworth, *This Will Have Been: Art, Love, and Politics in the 1980s* (New Haven, CT: Yale University Press, 2012).

5 Benjamin H. D. Buchloh, *Neo-Avantgarde and Culture Industry: Essays on European and American Art from 1955 to 1975* (Cambridge, MA: MIT Press, 2000); Luc Boltanski and Eve Chiapello, *The New Spirit of Capitalism* (London: Verso, 2005).

6 To take just three prominent examples: Joselit, *After Art*; Mark Seltzer, "Wound Culture: Trauma in the Pathological Public Sphere," *October* 80 (1997): 3–26; Gilles Deleuze and Félix Guattari, *A Thousand Plateaus: Capitalism and Schizophrenia* (Minneapolis: University of Minnesota Press, 1987).

7 "Populations of images" is Joselit's phrase in *After Art*, a way for him to reference image culture not in its spectacularized instances but in its massified effects.

8 But even as early as 1990, Gonzalez-Torres was thinking about "Internets" and "new technologies of information" in the context of the U.S. government's withdrawal of the social safety net and "charged symbolic images of homosexual acts." Felix Gonzalez-Torres, "The Gold Field," in *Earths Grow Thick: Works after Emily Dickenson by Roni Horn* (Columbus: Wexner Center for the Arts, Ohio State University, 1996), 65–69.

9 "Virtual" here refers to a potentiality, not an immateriality. This understanding is indebted to Brian Massumi's version of what was a Deleuzian concept. The virtual, in this sense, deflects attention away from any particular aspect of a given technological environment and toward a potential yet to come into being. Virtuality is not about digital immateriality or irreality but is immanent, proleptic, and not unique to the digital age or any such periodization. Brian Massumi, *Parables for the Virtual: Movement, Affect, Sensation* (Durham, NC: Duke University Press, 2002).

10 Alexander Galloway calls the technical infrastructure that makes such a relation possible "protocological," referring to the Internet protocols, archived in Request for Comment documents, that quite literally govern the movement of data in distributed networks. I will address this concept in more detail in the following chapter. Alexander R. Galloway, *Protocol: How Control Exists after Decentralization* (Cambridge, MA: MIT Press, 2004).

11 It is also a version of the central argument in Jacques Derrida, *Of Grammatology* (Baltimore: Johns Hopkins University Press, 1974).

12 When, for instance, description only knows how to recognize what is familiar, adaptation is often taken to be atavism. This isn't always wrong; just partial. All sorts of confused moralizing happens in Internet literatures as a result. See, for instance, Nicholas G. Carr, *The Shallows: What the Internet Is Doing to Our Brains*, vol. 1 (New York: W. W. Norton, 2010); Sherry Turkle, *Alone Together:*

Why We Expect More from Technology and Less from Each Other (New York: Basic Books, 2011). More evidence of the contiguity of description and life in networked scenes, the way that problems in one realm cause direct and immediate problems in the other, can be found in the tortured debates around participatory art. In those debates, there has usually not been a very clear line drawn between description of the key artworks, let alone their political, social, and cultural referents, and an avant-garde reflex to correct the scenes of life that would or should animate such descriptions.

13 In its original Greek context, as one of the rhetorical arts, ekphrasis always referred to an encounter with an originating image that the audience to the ekphrasis hadn't seen or experienced firsthand. But as an art of rhetoric, of fiction and fabrication, of eloquence, the possibility was there from the start, immanent in the very practice, that no one in the exchange had seen the originating image. In the most famous ekphrasis in the Greek context, that of Achilles's shield in *The Iliad*, this possibility is embodied as a material artifact, the shield itself, that could never, on its own, yield such descriptive richness. Homer, *The Iliad of Homer* (Chicago: University of Chicago Press, 2011), 409, beginning line 478.

14 Shadi Bartsch and Jas Elsner, "Introduction: Eight Ways of Looking at an Ekphrasis," *Classical Philology* 102, no. 1 (2007): i–vi.

15 "There is a sense in which ekphrasis, therefore, is *always* disobedient" (emphasis in the original). Bartsch and Elsner, "Introduction," ii.

16 Eve Kosofsky Sedgwick, "Paranoid Reading, Reparative Reading, or, You're So Paranoid, You Probably Think This Essay Is about You," in *Touching Feeling: Affect, Pedagogy, Performativity* (Durham, NC: Duke University Press, 2003).

17 In fact, it was important to Sedgwick to discuss strong theory and weak theory as "interdigitated." Sedgwick, *Touching Feeling*, 145.

18 I'm thinking of screeds such as Carr, *The Shallows*; Nicholas G. Carr, "Is Google Making Us Stupid? What the Internet Is Doing to Our Brains," *The Atlantic*, August 2008, https://www.theatlantic.com/magazine/archive/2008/07/is-google -making-us-stupid/306868/; Turkle, *Alone Together*. But see also more nuanced critique, such as Galloway, *Protocol*; McKenzie Wark, *A Hacker Manifesto* (Cambridge, MA: Harvard University Press, 2004).

19 On the conflation of naming and branding, see Fredric Jameson, "Fear and Loathing in Globalization," in *Archaeologies of the Future: The Desire Called Utopia and Other Science Fictions* (London: Verso, 2007).

20 J. David Bolter and Richard A. Grusin, *Remediation: Understanding New Media* (Cambridge, MA: MIT Press, 2000).

21 I provide the citational networks for these thoughts in the following two chapters.

22 This is just a sample of some of the major citations: Nicolas Bourriaud, *Relational Aesthetics*, Collection Documents Sur L'art (Dijon: Les Presses du Réel, 2002); Tom Finkelpearl, *What We Made: Conversations on Art and Social Co-*

operation (Durham, NC: Duke University Press, 2013); Suzanne Lacy, *Mapping the Terrain: New Genre Public Art* (Seattle: Bay Press, 1995); Claire Bishop, *Artificial Hells: Participatory Art and the Politics of Spectatorship* (London: Verso, 2012); Grant H. Kester, *Conversation Pieces: Community and Communication in Modern Art* (Berkeley: University of California Press, 2004); Leo Bersani and Ulysse Dutoit, *Arts of Impoverishment: Beckett, Rothko, Resnais* (Cambridge, MA: Harvard University Press, 1993); Leo Bersani and Ulysse Dutoit, *Caravaggio's Secrets* (Cambridge, MA: MIT Press, 1998); Nato Thompson, *Living as Form: Socially Engaged Art from 1991 to 2011* (Cambridge, MA: MIT Press, 2012).

23 Three prominent art history books have recently taken "the art world" as a kind of analytical resource for generating better understandings of (if not better resistance to) networked economies. Lane Relyea, *Your Everyday Art World* (Cambridge, MA: MIT Press, 2013); Pamela M. Lee, *Forgetting the Art World* (Cambridge, MA: MIT Press, 2012); Joselit, *After Art*.

24 For a very recent example, see Nathan Eisenberg, "Abstracting Art," *Hypocrite Reader*, November 2015, http://hypocritereader.com/58/abstracting-art.

25 As Bersani describes it in one interview: "It's a correspondence where you realize that there is a mode in which *your* moving through space coincides with the circulation of something entirely different to you, which is language, and that there was a junction, something happened, there is an intersection which is extremely peaceful because you're out of yourself at the same time" (italics in the original). Leo Bersani, *Is the Rectum a Grave? And Other Essays* (Chicago: University of Chicago Press, 2009), 195.

26 This is not, in other words, a book about avant-garde group form, even while it does see inventive negotiations with convention and other limiting structures as important, as worthy of close description, even as importantly aesthetic and thus as formalistically load-bearing.

27 This understanding of "ordinary life" emerges, many years later, from a Lauren Berlant seminar at the University of Chicago entitled "Ordinariness."

28 For a different kind of debate about the politics of our reception of "new" technologies, see Hans Magnus Enzensberger, *The Consciousness Industry: On Literature, Politics and the Media*, ed. and trans. Michael Roloff (New York: Seabury, 1974); Jean Baudrillard, "Requiem for Media," in *For a Critique of the Political Economy of the Sign*, trans. Charles Levin (St. Louis: Telos, 1981).

29 In this, my work has much in common with Patrick Jagoda, *Network Aesthetics* (Chicago: University of Chicago Press, 2016).

30 In Jameson's work, an encounter with the limits of one's own methods for sensing and describing the present tense becomes a way of studying the specific conditions of the longer period that encompasses one's own particular present tense. This is what Jameson calls "metacommentary." Fredric Jameson, *The Political Unconscious: Narrative as a Socially Symbolic Act* (Ithaca, NY: Cornell University Press, 1981).

Chapter 1: Group Form

1 Longer, of course, but with unequaled aggression and rapidity in those centuries.

2 Reading between Joan W. Scott and Brian Massumi it becomes clear that thought is ultimately not about the separation between analysis and experience, but about their ineluctable conjunction. See Brian Massumi, *Parables for the Virtual: Movement, Affect, Sensation* (Durham, NC: Duke University Press, 2002); Joan W. Scott, "The Evidence of Experience," *Critical Inquiry* 17, no. 4 (1991): 773–97.

3 Leo Bersani, "Is the Rectum a Grave?," in *AIDS: Cultural Analysis, Cultural Activism*, ed. Douglas Crimp (Cambridge, MA: MIT Press, 1993); Leo Bersani and Ulysse Dutoit, *Caravaggio's Secrets* (Cambridge, MA: MIT Press, 1998); Leo Bersani and Ulysse Dutoit, *Arts of Impoverishment: Beckett, Rothko, Resnais* (Cambridge, MA: Harvard University Press, 1993); Leo Bersani and Ulysse Dutoit, *Forms of Being: Cinema, Aesthetics, Subjectivity* (London: BFI, 2004).

4 In his important work *The Political Unconscious*, Jameson tends to call these "levels." Critical analysis or interpretation is, for him, an act that proceeds through three levels, each of which isn't an improvement over the last but is increasingly encompassing as a historical description. Fredric Jameson, *The Political Unconscious: Narrative as a Socially Symbolic Act* (Ithaca, NY: Cornell University Press, 1981).

5 See David Harvey, *A Brief History of Neoliberalism* (New York: Oxford University Press, 2005), esp. chaps. 2 and 3. See also Lauren Berlant, "Slow Death (Sovereignty, Obesity, Lateral Agency)," *Critical Inquiry* 33, no. 4 (summer 2007): 754–80.

6 For two loci classici, see Fredric Jameson, *Marxism and Form: Twentieth-Century Dialectical Theories of Literature* (Princeton, NJ: Princeton University Press, 1972); Michael Fried, *Art and Objecthood: Essays and Reviews* (Chicago: University of Chicago Press, 1998). While the former is explicit about the sources for its understanding of form, a term that recurs throughout Jameson's writings, the latter is silent. One can infer, but only infer, that for Fried "form" comes to mean something like a medium: it's the site at and on which opticality and illusion come into conflict, uniquely, in (for instance) Frank Stella's art. Pursuing a more tendentious line of argument, then, I would say that Fried understands form as a kind of conjunction, a coming into contact of two previously disparate, or seemingly disparate, modes of aesthetic thought. But tradition, a lineage of art making, has also always been important, even central to Krauss's understanding and lifelong commitment to the idea of a medium. See, for her most recent renewal of this commitment, Rosalind E. Krauss, *Under Blue Cup* (Cambridge, MA: MIT Press, 2011).

7 Fried, *Art and Objecthood*. See especially "Shape as Form: Frank Stella's Irregular Polygons."

8 In a series of three lectures from 1999 Krauss articulates her reconceptual-

ization of medium and medium specificity, wresting it from a long tradition of Greenbergian essentialized thinking about mediums (while also wresting Greenberg himself from such understandings of his theory of mediums). Rosalind Krauss, *"A Voyage on the North Sea": Art in the Age of the Post-Medium Condition* (New York: Thames and Hudson, 1999).

9 These debates produced, among other things, Rosalind Krauss's and Yve-Alain Bois's self-avowed polemic and Pompidou exhibition catalogue: Yve-Alain Bois and Rosalind E. Krauss, *Formless: A User's Guide* (New York: Zone Books, 1997).

10 Of course, part of the importance and potential of the *informe* for Bois and Krauss was that it cut across and formed a conjunction between the formal and the formless, rendering the distinction null, or aspiring to do so anyway. Perhaps an appropriate distinction, then, would be to say "ideological form," or form cut off from an acknowledgment of how it came to be informed, rather than form tout court. As Bois and Krauss say, the formless is more a verb than an adjective, more a process than a state.

11 For more on the conjunction of poststructuralism and history, see Fredric Jameson, *Postmodernism, or, The Cultural Logic of Late Capitalism* (Durham, NC: Duke University Press, 1991).

12 See especially Steven Shaviro, "The 'Bitter Necessity' of Debt: Neoliberal Finance and the Society of Control," May 1, 2010, www.shaviro.com/Othertexts /Debt.pdf; Steven Shaviro, *Connected, or, What It Means to Live in the Network Society*, Electronic Mediations (Minneapolis: University of Minnesota Press, 2003); Steven Shaviro, "Beauty Lies in the Eye," *Symploke* 6, no. 1 (1998): 96–108; Alexander R. Galloway, *Protocol: How Control Exists after Decentralization* (Cambridge, MA: MIT Press, 2004); Harvey, *A Brief History of Neoliberalism*; Berlant, "Slow Death."

13 Luc Boltanski and Eve Chiapello, *The New Spirit of Capitalism* (London: Verso, 2005); Manuel Castells, *The Rise of the Network Society: The Information Age: Economy, Society, and Culture* (New York: John Wiley, 2011); Brian Holmes, "The Flexible Personality: For a New Cultural Critique," in *Hieroglyphs of the Future: Art and Politics in a Networked Era* (Zagreb: Whw/Arkzin, 2002). Or see business literature such as Mike Rother, *Toyota Kata: Managing People for Improvement, Adaptiveness and Superior Results* (New York: McGraw-Hill Professional, 2009); Sushil and Gerhard Chroust, eds., *Systemic Flexibility and Business Agility* (New Delhi: Springer, 2015).

14 This dynamic is what Rancière understands as "hatred of democracy": Jacques Rancière, *Hatred of Democracy*, trans. Steve Corcoran (London: Verso, 2006).

15 For more on the trap of connectedness, see Shaviro, *Connected*.

16 From 2003 to 2004, under the aegis of an Economic and Social Research Council grant in the United Kingdom, I conducted interviews with people in British cities who were, at that time, just starting to experiment with putting their personal photographs online (to give a sense of the historical context, Flickr, one of the most popular social media sites for photography today, only

came online in 2004). The sense of formlessness that I'm trying to articulate above is affirmed in the response that most gave to the question "Why do you put your photos online?" Most said, simply, that they just wanted to see what would happen. They literally couldn't imagine what those consequences would be, and this, I'm claiming, is a constitutive part of the population form, at least insofar as it manifests in the experiences of people who build worlds online, or find themselves caught up in a world waiting for them there. For more on this research, see Kris Cohen, "A Welcome for Blogs," *Continuum: Journal of Media and Cultural Studies* 20, no. 2 (2006): 161–73; Kris Cohen, "What Does the Photoblog Want?," *Media, Culture and Society* 27, no. 6 (2005): 883–901.

17 For three influential accounts that have turned our attention to the specific materialities of digital culture: N. Katherine Hayles, *How We Became Posthuman: Virtual Bodies in Cybernetics, Literature, and Informatics* (Chicago: University of Chicago Press, 1999); Mark B. N. Hansen, *New Philosophy for New Media* (Cambridge, MA: MIT Press, 2004); Massumi, *Parables for the Virtual*. For more on how every dematerialization is a rematerialization, see Kris Cohen, "The Painter of Dematerialization," *Journal of Visual Culture* 15, no. 2 (2016): 250–72.

18 I have also learned about group form, and how to write about its aesthetic mediations, from T. J. Clark's accounts of class representation and a public sphere that becomes politicized in paint and painterly gesture. T. J. Clark, *Farewell to an Idea: Episodes from a History of Modernism* (New Haven, CT: Yale University Press, 1999); T. J. Clark, *Image of the People: Gustave Courbet and the Second French Republic, 1848–1851* (Greenwich, CT: New York Graphic Society, 1973). See also Thomas Crow's history of early art publics and the French salon: Thomas E. Crow, *Painters and Public Life in Eighteenth-Century Paris* (New Haven, CT: Yale University Press, 1985).

19 As far as I know, a history of the Situationists that takes their well-known internecine conflicts not just as a petty distraction but as part of, and integral to, their overall aesthetic and political project has yet to be written. McKenzie Wark's books probably come the closest. McKenzie Wark, *50 Years of Recuperation of the Situationist International* (Princeton, NJ: Princeton Architectural Press, 2008); McKenzie Wark, *The Spectacle of Disintegration: Situationist Passages out of the Twentieth Century* (London: Verso, 2013); McKenzie Wark, *The Beach beneath the Street: The Everyday Life and Glorious Times of the Situationist International* (London: Verso, 2015).

20 Nicolas Bourriaud, *Relational Aesthetics*, Collection Documents Sur L'art (Dijon: Les Presses du Réel, 2002).

21 I have elaborated the argument in this paragraph here: Kris Cohen, "No Faith in Form: Review of Claire Bishop's *Artificial Hells: Participatory Art and the Politics of Spectatorship*," *Reviews in Cultural Theory* 3, no. 2 (November 15, 2012). The key texts in this debate, so far, include Nicolas Bourriaud, *The Radicant* (New York: Lukas and Sternberg, 2009); Claire Bishop, "Antagonism and Relational Aesthetics," *October* 110 (fall 2004): 51–79; Claire Bishop, *Artificial Hells:*

Participatory Art and the Politics of Spectatorship (London: Verso, 2012); Liam Gillick, "Contingent Factors: A Response to Claire Bishop's 'Antagonism and Relational Aesthetics,'" *October* 115 (winter 2006): 95–107. Also, in a different but related line of thought, see Grant H. Kester, *Conversation Pieces: Community and Communication in Modern Art* (Berkeley: University of California Press, 2004). See also Shannon Jackson, *Social Works: Performing Art, Supporting Publics* (New York: Taylor and Francis, 2011); Tom Finkelpearl, *What We Made: Conversations on Art and Social Cooperation* (Durham, NC: Duke University Press, 2013); Nato Thompson, *Living as Form: Socially Engaged Art from 1991 to 2011* (Cambridge, MA: MIT Press, 2012).

22 Jean Baudrillard, "Requiem for Media," in *For a Critique of the Political Economy of the Sign* (St. Louis: Telos, 1981).

23 Wendy Brown, "Neo-Liberalism and the End of Liberal Democracy," *Theory and Event* 7, no. 1 (2003); Wendy Brown, *Undoing the Demos: Neoliberalism's Stealth Revolution* (Cambridge, MA: MIT Press, 2015). For more of an overview of how neoliberalism's thought about individuality fits within a longer capitalist program, see Harvey, *A Brief History of Neoliberalism*.

24 Elmer et al. make a related argument in the introduction to their edited collection: Greg Elmer, Ganaele Langlois, and Joanna Redden, eds., *Compromised Data: From Social Media to Big Data* (New York: Bloomsbury USA, 2015).

25 Melissa Gregg, "Inside the Data Spectacle," *Television and New Media* 16, no. 1 (January 2015): 38.

26 Melissa Gregg, "The Gift That Is Not Given," in *Data, Now Bigger and Better!*, ed. Tom Boellstorff and Bill Maurer (Chicago: Prickly Paradigm, 2015), 61–62.

27 Tom Boellstorff et al., *Data: Now Bigger and Better!* (Chicago: Prickly Paradigm, 2015); Elmer, Langlois, and Redden, *Compromised Data*; Gregg, "Inside the Data Spectacle"; Trebor Scholz, *Digital Labor: The Internet as Playground and Factory* (New York: Routledge, 2013). For a conceptualization of data that is parallelistic and at the same time self-reflexive or auto-poetic, and so medium-specific in its way, see Gina Neff and Dawn Nafus, *The Quantified Self* (Cambridge, MA: MIT Press, 2016).

28 I have learned a great deal about the need for alternatives to critique from Stefano Harney and Fred Moten, *The Undercommons: Fugitive Planning and Black Study* (Wivenhoe, UK: Minor Compositions, 2013). This is a theme that will recur throughout the book.

29 Bersani and Dutoit sometimes also call this a "communication of forms." The key texts have been Bersani and Dutoit, *Arts of Impoverishment*; Bersani and Dutoit, *Caravaggio's Secrets*; Bersani and Dutoit, *Forms of Being*. Bersani reflects on this work here: Leo Bersani et al., "A Conversation with Leo Bersani," *October* 82 (autumn 1997): 3–16.

30 Berlant tells this story in her trilogy: Lauren Berlant, *The Female Complaint: The Unfinished Business of Sentimentality in American Culture* (Durham, NC: Duke University Press, 2008); Lauren Berlant, *The Queen of America Goes to Wash-*

ington City: Essays on Sex and Citizenship, Series Q (Durham, NC: Duke University Press, 1997); Lauren Berlant, *The Anatomy of National Fantasy: Hawthorne, Utopia, and Everyday Life* (Chicago: University of Chicago Press, 1991).

31 Jameson, *The Political Unconscious.*

32 I say "net art" and not "net.art." Net.art, as a historical formation, never wanted to operate as a categorical imperative that must fetishize its technological component. It always had a more expansive, uncontained, or uncontainable idea of technology. See, for instance, the conversation recorded as "Net.art per se," which emphasized conversation, crossroads, and "neuralgic" points of contact within the crossroads of art and technology. Some of that event is archived here: "Net.art Per Se," www.ljudmila.org/naps/home.htm (last accessed February 23, 2017).

33 Fred Moten, *In the Break: The Aesthetics of the Black Radical Tradition* (Minneapolis: University of Minnesota Press, 2003); Harney and Moten, *The Undercommons.*

34 The literal needn't and, in light of the dematerializations of digital media, probably shouldn't be thought of as simple self-evidence. What, in an era variously characterized as algorithmic or digital or networked, could be less literal than the literal itself? But this is still how the literal tends to be understood.

Chapter 2: Between Populations and Publics

1 Media theorist Geert Lovink has called this generalizing impulse toward technology "vapor theory": Geert Lovink, *Dark Fiber: Tracking Critical Internet Culture* (Cambridge, MA: MIT Press, 2002), 9. See, for example, almost any scholarship that frames itself as being about or addressing "the digital." Precedent-setting accounts in this vein include Martin Heidegger, "The Age of the World Picture," in *The Question Concerning Technology and Other Essays*, trans. William Lovitt (New York: Harper and Row, 1977); Guy Debord, *The Society of the Spectacle*, trans. Donald Nicholson-Smith (New York: Zone Books, 1994). Each points the way to a very different framing of technology's significance, the first in the realm of epistemology, ontology, and power, the second in the realm of capitalism and its Marxist analyses. More recently, Fredric Jameson has characterized late twentieth-century communication technologies as the euphoric embrace of Foucault's disciplinary look or scopic regime, a happily blind embrace of the technologies that themselves literally embody the logic of self-policing. Fredric Jameson, "Transformations of the Image in Postmodernity," in *The Cultural Turn: Selected Writings on the Postmodern 1983–1998* (London: Verso, 1998), 110–12. See also David Joselit, *After Art* (Princeton, NJ: Princeton University Press, 2013); Benjamin H. D. Buchloh, "Conceptual Art 1962–1969: From the Aesthetics of Administration to the Critique of Institutions," *October* 55 (winter 1990): 105–43; Rosalind Krauss, *"A Voyage on the North Sea": Art in the Age of the Post-Medium Condition* (New York: Thames and Hudson, 1999); Hal Foster, *The Return of the Real: The Avant-Garde at the*

End of the Century (Cambridge, MA: MIT Press, 1996). Political scientist Jodi Dean's most recent work sees the contemporary conflation of technology and democracy, especially in the form of the Internet, as today's reigning ideology, an ideology she calls "communicative capitalism." Jodi Dean, *Publicity's Secret: How Technoculture Capitalizes on Democracy* (Ithaca, NY: Cornell University Press, 2002); Jodi Dean, *Democracy and Other Neoliberal Fantasies: Communicative Capitalism and Left Politics* (Durham, NC: Duke University Press, 2009). A very notable and recent exception to this tendency in art history is Jennifer L. Roberts, *Transporting Visions: The Movement of Images in Early America* (Berkeley: University of California Press, 2014).

2 Kelty, *Two Bits: The Cultural Significance of Free Software* (Durham, NC: Duke University Press, 2008), 85.

3 For example, actor network theory. For a retrospective overview, see John Law and John Hassard, eds., *Actor Network Theory and After* (Oxford: Blackwell, 1999).

4 Pamela Lee makes a related point in *Chronophobia*, especially in relation to the impact of various systems theories on art in the 1960s. Pamela M. Lee, *Chronophobia: On Time in the Art of the 1960s* (Cambridge, MA: MIT Press, 2004).

5 Fredric Jameson, *The Geopolitical Aesthetic: Cinema and Space in the World System* (Bloomington: Indiana University Press, 1992), 1.

6 Jameson, *The Geopolitical Aesthetic*, 11.

7 For more on the messianic as a mode of contemporary theory, see David Graeber, "The Sadness of Post-Workerism, or, 'Art and Immaterial Labour' Conference, a Sort of Review (Tate Britain, Saturday 19 January, 2008)," *The Commoner: A Web Journal for Other Values* 13 (April 1, 2008).

8 Debord, *The Society of the Spectacle*.

9 See, for example, David Joselit, *Feedback: Television against Democracy* (Cambridge, MA: MIT Press, 2007); Lee, *Chronophobia*; Miwon Kwon, *One Place after Another: Site-Specific Art and Locational Identity* (Cambridge, MA: MIT Press, 2002); Retort, *Afflicted Powers: Capital and Spectacle in a New Age of War*, new ed. (London: Verso, 2005).

10 Joselit's source of authority here is not, as one might expect, Fredric Jameson but Hannah Arendt. Joselit, *Feedback*, xiii.

11 Joselit, *Feedback*.

12 Joselit, *After Art*.

13 "4. The spectacle is not a collection of images; rather, it is a social relationship between people that is mediated by images." Debord, *The Society of the Spectacle*, 12.

14 Joselit accounts for variation through the concept of formatting. "The term *image* is a slippery one. I will use it here to indicate a quantum of visual content (say a digital photograph) that can assume a variety of formats" (italics in original). Joselit, *After Art*, 1.

15 Michel Foucault, *The Birth of Biopolitics: Lectures at the Collège de France, 1978–1979* (New York: Picador, 2008), 105–18.

16 Foucault's, of course, is not the only account of this period and the neoliberal revolution. Both Boltanski and Chiapello, as well as Brian Holmes, have historicized this as the period where flexibility comes to have value in capitalist discourse. The new corporation, and the new employees of the corporation, were to be flexible and diverse precisely in order to resist homogeneity. Holmes, "The Flexible Personality"; Luc Boltanski and Eve Chiapello, *The New Spirit of Capitalism* (London: Verso, 2005). Shannon Jackson recounts some of this history in relation to the art practices that she calls "social works": Shannon Jackson, *Social Works: Performing Art, Supporting Publics* (New York: Taylor and Francis, 2011), 24–25. On economization as the defining activity of neoliberalism, something closely related to my interests in algorithm and protocol, see Wendy Brown, *Undoing the Demos: Neoliberalism's Stealth Revolution* (Cambridge, MA: MIT Press, 2015).

17 Stuart Elden, "Governmentality, Calculation, Territory," *Environment and Planning D: Society and Space* 25, no. 3 (June 1, 2007): 566. Elden is quoting from Michel Foucault, *Sécurité, Territoire, Population: Cours au Collège de France (1977–78)*, ed. M. Senellart (Paris: Gallimard, 2004), 72. Ruppert calls the individual in the context of populations an "interpassive subject": not robbed of agency so much as generated as product. This allows all sorts of agency and feelings of agency to coexist peacefully with the production of subjectivity. This will become clearer in the discussion below about algorithms and data populations. Evelyn Ruppert, "Population Objects: Interpassive Subjects," *Sociology* 45, no. 2 (April 1, 2011): 218–33. For more on population logics as they operate across a wide range of disciplines and practices, see Irus Braverman, "Governing the Wild: Databases, Algorithms, and Population Models as Biopolitics," *Surveillance and Society* 12, no. 1 (2014): 15–37; Sujatha Raman and Richard Tutton, "Life, Science, and Biopower," *Science, Technology and Human Values* (October 27, 2009): 711–34; Amade M'charek, Katharina Schramm, and David Skinner, "Technologies of Belonging: The Absent Presence of Race in Europe," *Science, Technology and Human Values* 39, no. 4 (July 1, 2014): 459–67; Torsten Heinemann and Thomas Lemke, "Biological Citizenship Reconsidered: The Use of DNA Analysis by Immigration Authorities in Germany," *Science, Technology and Human Values* 39, no. 4 (July 1, 2014): 488–510.

18 See, for instance, Eli Pariser, *The Filter Bubble: What the Internet Is Hiding from You* (New York: Penguin Press, 2011); or Dean, *Democracy and Other Neoliberal Fantasies.*

19 The neoliberalism literature tends to focus on the following as key features: widespread privatization motivated by a faith in free markets as generators of both wealth and equality; a privileging of individuality in the form of "personal responsibility" as the most marketable, accountable form of citizenship; and a mimetic impulse to remake all countries as neoliberal economies using the

soft imperialism of loans and structural readjustment. All of these character-istics have been treated in far more depth and specificity elsewhere. See David Harvey, *A Brief History of Neoliberalism* (New York: Oxford University Press, 2005). Both Wendy Brown and Lisa Duggan have documented neoliberalism's deforming impacts on the Left and liberal democracy. Wendy Brown, "Neo-Liberalism and the End of Liberal Democracy," in *Edgework: Critical Essays on Knowledge and Politics* (Princeton, NJ: Princeton University Press, 2005); Lisa Duggan, *The Twilight of Equality? Neoliberalism, Cultural Politics, and the Attack on Democracy* (Boston: Beacon, 2003). Jodi Dean has begun to trace neoliber-alism's ideologies of democracy and technology. Dean, *Democracy and Other Neoliberal Fantasies*. The Comaroffs describe neoliberalism's reliance on faith and compensatory cultures. Jean Comaroff, "The Politics of Conviction: Faith on the Neo-Liberal Frontier," *Social Analysis* 53, no. 1 (spring 2009): 17–38; Jean Comaroff and John L. Comaroff, eds., *Millennial Capitalism and the Culture of Neoliberalism* (Durham, NC: Duke University Press, 2001). Lauren Berlant has begun the work of describing the period's historical formations and deforma-tions of personhood. Lauren Berlant, "Intuitionists: History and the Affective Event," *American Literary History* 20, no. 4 (2008): 845–60; Lauren Berlant, "Cruel Optimism: On Marx, Loss, and the Senses," *New Formations* 63 (win-ter 2007–8): 33–51; Lauren Berlant, "Slow Death (Sovereignty, Obesity, Lat-eral Agency)," *Critical Inquiry* 33, no. 4 (summer 2007): 754–80; Lauren Ber-lant, "Nearly Utopian, Nearly Normal: Post-Fordist Affect in *La Promesse* and *Rosetta*," *Public Culture* 19, no. 2 (2007): 273–301. David Theo Goldberg has begun to conceptualize what he calls a "racial neoliberalism." David Theo Gold-berg, *The Threat of Race: Reflections on Racial Neoliberalism* (Malden, MA: Wiley-Blackwell, 2009).

20 Jürgen Habermas, *The Structural Transformation of the Public Sphere: An Inquiry into a Category of Bourgeois Society*, trans. Thomas Burger and Frederick Law-rence (Cambridge, MA: MIT Press, 1989).

21 Nancy Fraser, "Rethinking the Public Sphere: A Contribution to the Critique of Actually Existing Democracy," *Social Text*, nos. 25/26 (1990): 56–80; Oskar Negt and Alexander Kluge, *Public Sphere and Experience: Toward an Analysis of the Bourgeois and Proletarian Public Sphere*, trans. Peter Labanyi, Jamie Daniel, and Assenka Oksiloff (Minneapolis: University of Minnesota Press, 1993); Michael Warner, *Publics and Counterpublics* (New York: Zone Books, 2002).

22 Jodi Dean, *Publicity's Secret*; Slavoj Žižek, "The Spectre of Ideology," in *Mapping Ideology*, ed. Slavoj Žižek (London: Verso, 1994); Slavoj Žižek, *The Sublime Ob-ject of Ideology* (London: Verso, 1989).

23 Berlant tells this story in her trilogy: Lauren Berlant, *The Anatomy of National Fantasy: Hawthorne, Utopia, and Everyday Life* (Chicago: University of Chicago Press, 1991); Lauren Berlant, *The Queen of America Goes to Washington City: Essays on Sex and Citizenship* (Durham, NC: Duke University Press, 1997);

Lauren Berlant, *The Female Complaint: The Unfinished Business of Sentimentality in American Culture* (Durham, NC: Duke University Press, 2008).

24 The following is only a small sampling of the growing literature: Mark Poster, "Cyberdemocracy: The Internet and the Public Sphere," in *Reading Digital Culture*, ed. David Trend (Malden, MA: Blackwell, 2001); Zizi Papacharissi, "The Virtual Sphere," *New Media and Society* 4, no. 1 (2002): 9–27; Antje Gimmler, "Deliberative Democracy, the Public Sphere and the Internet," *Philosophy and Social Criticism* 27, no. 4 (2001): 21–39; Peter Dahlgren, "The Internet, Public Spheres, and Political Communication: Dispersion and Deliberation," *Political Communication* 22, no. 2 (2005): 147–62; W. Lance Bennett and Robert M. Entman, eds., *Mediated Politics: Communication in the Future of Democracy* (Cambridge: Cambridge University Press, 2001); Nick Crossley and John M. Roberts, eds., *After Habermas: New Perspectives on the Public Sphere* (Oxford: Blackwell, 2004); Craig Calhoun, "Community without Propinquity Revisited: Communications Technology and the Transformation of the Urban Public Sphere," *Sociological Inquiry* 68, no. 3 (1998): 373–97; Nancy Fraser, "Transnationalizing the Public Sphere: On the Legitimacy and Efficacy of Public Opinion in a Post-Westphalian World," *Theory, Culture and Society* 24, no. 4 (2007): 7–30.

25 See, for instance, Melissa Gregg's research on white-collar work in the neoliberal economy. Melissa Gregg, "Freedom to Work: The Impact of Wireless on Labour Politics," *Media International Australia*, no. 125 (November 2007); Melissa Gregg, "The Normalisation of Flexible Female Labour in the Information Economy," *Feminist Media Studies* 8, no. 3 (September 2008). See also Andrew Ross, *No-Collar: The Humane Workplace and Its Hidden Costs* (New York: Basic Books, 2003).

26 These are all features of the public sphere documented by Warner, *Publics and Counterpublics*. Anthropologist Christopher Kelty makes much out of these features in his ethnography of the Free Software movement. For more on Kelty, see below. Christopher M. Kelty, *Two Bits: The Cultural Significance of Free Software* (Durham, NC: Duke University Press, 2008).

27 For examples, see: *Chatbots.org*, Abraham Lincoln chatbot: www.chatbots.org /chatterbot/abraham_lincoln/. Hillary Clinton chatbot: www.chatbots.org /chatterbot/hillary_clinton/. Sarah Palin chatbot: www.chatbots.org/chatter bot/palinspeak/. Barack Obama chatbot: www.chatbots.org/chatterbot/barak _obama/ (accessed February 23, 2017).

28 For a recent example of this ambivalent embrace, see Dorothy Howard, "Feed My Feed: Radical Publishing in Facebook Groups," *Rhizome.org*, July 22, 2015, http://rhizome.org/editorial/2015/jul/22/feed-my-feed/ (accessed February 23, 2017).

29 Kelty, *Two Bits*.

30 Michel Foucault, *"Society Must Be Defended": Lectures at the Collège de France, 1975–76* (New York: Picador, 2003); Michel Foucault, *Security, Territory, Popula-*

tion: Lectures at the Collège de France, 1977–78 (New York: Palgrave Macmillan, 2007); Michel Foucault, *The Birth of Biopolitics*.

31 Michel Foucault, "17 March 1976," in *"Society Must Be Defended,"* 240–41.

32 Berlant, "Slow Death."

33 Warner, *Publics and Counterpublics*.

34 Alexander R. Galloway, *Protocol: How Control Exists after Decentralization* (Cambridge, MA: MIT Press, 2004).

35 Galloway, *Protocol*, 7.

36 Michel Foucault, "Governmentality," in *The Foucault Effect: Studies in Governmentality*, ed. Graham Burchell, Colin Gordon, and Peter Miller (Chicago: University of Chicago Press, 1991).

37 This is the primary difference between my adaptation of Galloway's concept of protocol and David Joselit's format concept. Like protocol, a format in Joselit's terms is a form of agile connection. But while formats, like the artistic mediums they update, seem to be things that particular subjects—for example, artists and business people—actively manipulate and manage as a way of managing the glut of images available in a networked world, protocols and populations are assembled in a realm parallel to those in which subjects act, choose, and maintain fantasies of action and choice. Joselit, *After Art*.

38 See, for example, Stephanie Clifford, "Web Coupons Know Lots about You, and They Tell," *New York Times*, April 16, 2010.

39 Brian Massumi, "The Future Birth of the Affective Fact: The Political Ontology of Threat," in *The Affect Theory Reader*, ed. Melissa Gregg and Gregory J. Seigworth (Durham, NC: Duke University Press, 2010).

40 Eve Kosofsky Sedgwick, "Paranoid Reading, Reparative Reading, or, You're So Paranoid, You Probably Think This Essay Is about You," in *Touching Feeling: Affect, Pedagogy, Performativity* (Durham, NC: Duke University Press, 2003).

41 This is why Jodi Dean argues that the generation of talk as a profitable commodity is the ideology of contemporary democracy. She calls this milieu "communicative capitalism." Dean, *Publicity's Secret*; Dean, *Democracy and Other Neoliberal Fantasies*.

42 I'm riffing here on Eve Sedgwick's idea of "nonce taxonomy": Eve Kosofsky Sedgwick, *The Epistemology of the Closet* (Berkeley: University of California Press, 1990), 23.

Chapter 3: Broken Genres

1 For examples, see chapter 2, note 24. For a Marxist analysis of the literature that optimistically *and* critically theorizes the link between democracy and Internet technology, see Nick Dyer-Witheford, *Cyber-Marx: Cycles and Circuits of Struggle in High-Technology Capitalism* (Urbana: University of Illinois Press, 1999), 15–37.

2 Jodi Dean makes a related point here: Jodi Dean, *Publicity's Secret: How Techno-*

culture Capitalizes on Democracy (Ithaca, NY: Cornell University Press, 2002). Much of the post-Habermasian literature on the public sphere—the various updatings of the concept—can be read as a history of changes to the relationship between commodity capitalism and public life. For instance, see Oskar Negt and Alexander Kluge, *Public Sphere and Experience: Toward an Analysis of the Bourgeois and Proletarian Public Sphere*, trans. Peter Labanyi, Jamie Daniel, and Assenka Oksiloff (Minneapolis: University of Minnesota Press, 1993); Nancy Fraser, "Rethinking the Public Sphere: A Contribution to the Critique of Actually Existing Democracy," *Social Text*, nos. 25/26 (1990): 56–80; Craig Calhoun, "Community without Propinquity Revisited: Communications Technology and the Transformation of the Urban Public Sphere," *Sociological Inquiry* 68, no. 373 (1998); Rosalyn Deutsche, *Evictions: Art and Spatial Politics* (Cambridge, MA: MIT Press, 1996); Michael Warner, *Publics and Counterpublics* (New York: Zone Books, 2002); Lauren Berlant, *The Queen of America Goes to Washington City: Essays on Sex and Citizenship* (Durham, NC: Duke University Press, 1997); Lauren Berlant, *The Female Complaint: The Unfinished Business of Sentimentality in American Culture* (Durham, NC: Duke University Press, 2008).

3 The inverse view, that it is technology that is to blame, held by authors such as Sherry Turkle and Nicholas Carr, amounts to much the same thing insofar as it is the fallible human element that makes us vulnerable to technology's seductions. In both cases, the argument is predicated on keeping two categories distinct: the human and the technological. See Sherry Turkle, *Reclaiming Conversation: The Power of Talk in a Digital Age* (New York: Penguin, 2015); Sherry Turkle, *Alone Together: Why We Expect More from Technology and Less from Each Other* (New York: Basic Books, 2011); Nicholas G. Carr, *The Shallows: What the Internet Is Doing to Our Brains*, vol. 1 (New York: W. W. Norton, 2010); Nicholas G. Carr, "Is Google Making Us Stupid? What the Internet Is Doing to Our Brains," *The Atlantic*, August 2008, https://www.theatlantic.com/maga zine/archive/2008/07/is-google-making-us-stupid/306868/. Recently, Google has started to tout software that can fix the problem of noxious speech online. See Jared Cohen, "When Computers Learn to Swear: Using Machine Learning for Better Online Conversations," *The Keyword* [Google's blog], https://blog .google/topics/machine-learning/when-computers-learn-swear-using-machine -learning-better-online-conversations/ (accessed February 23, 2017).

4 Stuart Hall, "Deviance, Politics, and the Media," in *The Lesbian and Gay Studies Reader*, ed. Henry Abelove, Michele Aina Barale, and David M. Halperin (New York: Routledge, 1993). Rancière characterizes attacks on bad behavior in a democracy as "hatred of democracy," that is, a hatred of the way that democracies, in his terms, are nothing more or less than the potential for action, and so potentialize all sorts of wayward, unproductive, and odious actions. In this sense, the Internet looks both democratic and nonreciprocal. Jacques Rancière, *Hatred of Democracy*, trans. Steve Corcoran (London: Verso, 2006).

5 Nancy Fraser has most directly discussed this exculpatory logic: Nancy Fraser, "Rethinking the Public Sphere: A Contribution to the Critique of Actually Existing Democracy," *Social Text*, nos. 25/26 (1990): 56–80.

6 Mary Anne Franks makes a related claim: "The idealist position does, however, treat such harms as aberrations, as occasional malfunctions in an otherwise smoothly operating system." Mary Anne Franks, "Unwilling Avatars: Idealism and Discrimination in Cyberspace," SSRN Scholarly Paper (Rochester, NY: Social Science Research Network, October 21, 2009), 226, http://papers.ssrn .com/abstract=1374533.

7 Habermas called this mode of interpersonal exchange an "audience-oriented subjectivity." He didn't mean that people could imagine an actual audience as the *endpoint* of their speech; he meant that a sort of internalized audience became the *predicate* for speech. Every individual, to put it in terms that Habermas favored, could imagine herself as the protagonist of a novel. When one spoke or wrote in public, it was with this subjective matrix, this imaginative (and always proleptic) reciprocity, already in place. Jürgen Habermas, *The Structural Transformation of the Public Sphere: An Inquiry into a Category of Bourgeois Society* (Cambridge, MA: MIT Press, 1989). Both Foucault and, more recently, David Harvey have discussed the generalization of competition in and as neoliberal sociality: Michel Foucault, *The Birth of Biopolitics: Lectures at the Collège de France, 1978–1979*, ed. Michel Senellart, trans. Graham Burchell (New York: Picador, 2008); David Harvey, *A Brief History of Neoliberalism* (New York: Oxford University Press, 2005). For me, competition is just one way to name the effect, and in many ways, the feeling of a population logic once it is grafted onto the ideals of the liberal public sphere.

8 The changes alluded to here are described in far more detail in the introduction and chapter 1. Michel Foucault, *The Birth of Biopolitics*, 226. See also Steven Shaviro, "The 'Bitter Necessity' of Debt: Neoliberal Finance and the Society of Control," May 1, 2010, www.shaviro.com/Othertexts/Debt.pdf.

9 This is Jonathan Crary's suggestion. See Jonathan Crary, *24/7: Late Capitalism and the Ends of Sleep* (London: Verso, 2013).

10 For a history of the imbrication of twentieth-century life worlds with the commodity form, see Lauren Berlant, *The Anatomy of National Fantasy: Hawthorne, Utopia, and Everyday Life* (Chicago: University of Chicago Press, 1991); Berlant, *The Queen of America Goes to Washington City*; Berlant, *The Female Complaint*.

11 "Genres are essentially contracts between a writer and his readers; or rather, to use the term which Claudio Guillén has so usefully revived, they are literary *institutions*, which like the other institutions of social life are based on tacit agreements or contracts." Fredric Jameson, "Magical Narratives: Romance as Genre," *New Literary History* 7, no. 1 (October 1, 1975): 135. See also Jameson, *The Political Unconscious*.

12 Lauren Berlant, "Slow Death (Sovereignty, Obesity, Lateral Agency)," *Critical Inquiry* 33, no. 4 (summer 2007): 760.

13 Lauren Berlant, "Intuitionists: History and the Affective Event," *American Literary History* 20, no. 4 (2008): 847.

14 "For genre to exist as a norm it has first to circulate as a form, which has no ontology, but which is generated by repetitions that subjects learn to read as organised inevitability." Lauren Berlant, "Trauma and Ineloquence," *Cultural Values* 5, no. 1 (2001): 46.

15 This disjuncture or break between fantasy and structure, between what we want networked media to be and how they are structured technically, is why there is so much talk *on* the web about the broken promises *of* the web. This is why trolls and other bad actors online are so confounding, so endemic, and so iconic all at once: they inhabit various social formats that embody all the democratic promises of new networked socialities (bulletin boards, chat forums, comment fields, etc.), while seeming to poison those very forms.

16 Alexander Galloway also deals with the jarring, even paradoxical relationship between people's expectations for social and political encounter and the form of the networks through which so many of these encounters now take place. See Alexander Galloway, *Protocol: How Control Exists after Decentralization* (Cambridge, MA: MIT Press, 2004).

17 Jean-François Lyotard, *The Differend: Phrases in Dispute* (Minneapolis: University of Minnesota Press, 1988). I note, as a point of disciplinary record keeping relevant to this book if not directly to this chapter, that the differend is not synonymous with what Claire Bishop, in her criticism of relational aesthetics, calls "antagonism." The antagonism concept comes from Laclau and Mouffe's work on radical social democracy, and Bishop uses it to champion a difficult, challenging, even offensive mode of art practice (i.e., an avant-garde one) over what she views, in stark contrast, as a soft, convivial, easy mode of art making in social practice or relational aesthetics. Bishop means something like difficulty when she refers to antagonism, which is not exactly what Laclau and Mouffe meant by the same term. In referring to antagonism as the limit of every objectivity, they mean something far closer to Lyotard's differend. In any case, antagonism, in Bishop's use, entails a kind of engagement: oppositional, difficult, challenging, offensive, hard to process, but a mode of engagement nevertheless, given precisely in those challenges. The differend is a refusal of engagement, a gap across which phrases cannot link. The differend is, in other words, nonreciprocal, whereas antagonism, however estranging, is a form of reciprocity, a recognition, a return. Bishop, "Antagonism and Relational Aesthetics," *October* 110 (fall 2004); Claire Bishop, *Artificial Hells: Participatory Art and the Politics of Spectatorship* (London: Verso, 2012). See also Ernesto Laclau and Chantal Mouffe, *Hegemony and Socialist Strategy: Towards a Radical Democratic Politics*, vol. 2 (London: Verso, 2001).

18 See the last sections of this chapter and of chapter 5 for a more extensive discussion of parallelism as a key aesthetic structure of the graft between populations and publics.

19 *I March in the Parade of Liberty, but as Long as I Love You I'm Not Free* was performed eight times between December 1, 2007, and January 12, 2008. Each time, Hayes carried a microphone to record her own voice (lapel mike attached to her coat, battery pack tucked invisibly underneath). From these recordings, Hayes assembled an audio track of the address, which was played on a loop through a single speaker mounted high on a stand in a small gallery space. The show ran until January 27, 2008, at the New Museum. Near this speaker was a wall text that gave basic details about the work. The room, really more of a landing along a stairwell, accommodated approximately ten people. Along with *I March in the Parade of Liberty, but as Long as I Love You I'm Not Free,* Hayes's love addresses include *Everything Else Has Failed! Don't You Think It's Time for Love* (2007) and *Revolutionary Love: I Am Your Worst Fear, I Am Your Best Fantasy* (2008), a work that Hayes calls an extension of the love addresses. I discuss these works, briefly, in the last section of the present chapter. See also Julia Bryan-Wilson, "We Have a Future: An Interview with Sharon Hayes," *Grey Room,* no. 37 (2009): 81.

20 But, as Jennifer Moxley explores in her book of poems *Often Capital,* the political love letter might be its own genre. Thanks to Christa Robbins for this observation. Jennifer Moxley, *Often Capital* (Chicago: Flood Editions, 2005).

21 This is why so many writers have focused their analyses of postmodernism and finance capitalism around Manhattan. For example, see Fredric Jameson, "The Brick and the Balloon: Architecture, Idealism, and Land Speculation," in *The Cultural Turn: Selected Writings on the Postmodern, 1983–1998* (New York: Verso, 1998). See also Douglas Crimp's memoir, which is substantively about Manhattan in the 1960s and 1970s: Douglas Crimp, *Before Pictures* (Brooklyn: Dancing Foxes Press, 2016).

22 Hayes did not speak at the corner of Rivington and Orchard when I saw the performance. The direct quotes I use are taken from the transcript of a different performance.

23 In the appendix to this book I have included a transcript of one full address from one performance of *I March.* . . .

24 This idea about absorptive noise, here understood as a kind of group form, comes from Nigel J. Thrift, "But Malice Aforethought: Cities and the Natural History of Hatred," *Transactions of the Institute of British Geographers* 30, no. 2 (2005): 133–50.

25 Bob Dylan, "Abandoned Love," *Biograph,* 1985, Columbia Records.

26 Lauren Berlant, "The Subject of True Feeling: Pain, Privacy, Politics," in *Cultural Pluralism, Identity Politics, and the Law,* ed. Austin Sarat (Ann Arbor: University of Michigan Press, 2001); Berlant, *The Female Complaint.*

27 Thrift, "But Malice Aforethought." Artist James Nares, in his video "Street," employs the camera and editing to simulate and exacerbate this harmonizing of disparate elements. See James Nares, *Street,* Vimeo.com, https://vimeo.com /47457051 and www.jamesnares.com (accessed February 23, 2017).

28 Clearly this chapter is a kind of response, but as a critical response to a work of art, separated in time from the event, it, like all of the more immediate responses on the street, operates at the remove of a differend. This differend, however, the one that separates art history from art, is an expected, even conventional one.

29 Mary Jane Jacob and Michael Brenson, *Conversations at the Castle: Changing Audiences and Contemporary Art* (Cambridge, MA: MIT Press, 1998); Claire Bishop, *Participation* (London: Whitechapel; Cambridge, MA: MIT Press, 2006); Nicolas Bourriaud, *Relational Aesthetics* (Dijon: Les Presses du Réel, 2002); Grant H. Kester, *Conversation Pieces: Community and Communication in Modern Art* (Berkeley: University of California Press, 2004).

30 Early futurist manifestoes, for instance, included calls for artists to take to the streets, that is, to abandon their studios and their easels. RoseLee Goldberg, *Performance Art: From Futurism to the Present* (New York: Thames and Hudson, 2001), 16.

31 Goldberg, *Performance Art*, 9.

32 On "situation" as an impaction of body, voice, scene, and technologies of mediation, see Lucille Alice Suchman, *Plans and Situated Actions: The Problem of Human-Machine Communication* (Cambridge: Cambridge University Press, 1987), 203.

33 I don't claim this to be the defining trajectory in the history of performance art, just one tendency, significant for its analogical and actual connections to a mode of social performance that I think has become pervasive in networked social environments.

34 Carrie Lambert-Beatty, *Being Watched: Yvonne Rainer and the 1960s* (Cambridge, MA: MIT Press, 2008).

35 Lambert-Beatty, *Being Watched*, 7.

36 Lambert-Beatty, *Being Watched*, 9.

37 A longer genealogy along these lines would also need to incorporate the maintenance art of Mierle Laderman Ukeles.

38 On the selling of New York's image, see Robert Fitch, *The Assassination of New York* (London: Verso, 1993); Fredric Jameson, "The Brick and the Balloon."

39 Eve Kosofsky Sedgwick, "Privilege of Unknowing," *Genders* 1 (spring 1988).

40 Lauren Berlant and Michael Warner, "Sex in Public," *Critical Inquiry* 24, no. 2 (1998).

41 For two very different ways of approaching the conventionality of love and sex, see Leo Bersani, Tim Dean, Kaja Silverman, and Hal Foster, "A Conversation with Leo Bersani," *October* 82 (autumn 1997): 3–16; Lauren Berlant, "Love, a Queer Feeling," in *Homosexuality and Psychoanalysis*, ed. Tim Dean and Christopher Lane (Chicago: University of Chicago Press, 2001).

42 Darby English, "Aesthetics of Dispossession: William Pope.L's Performance Interventions," in *How to See a Work of Art in Total Darkness* (Cambridge, MA: MIT Press, 2007), 257.

43 English, "Aesthetics of Dispossession," 259.

44 Lyotard, *The Differend*.

45 For more on political depression, see the work of Feel Tank. E.g., "Anxiety, Urgency, Outrage, Hope . . . A Conference on Political Feeling," http://political feeling.uchicago.edu/ (accessed February 23, 2017).

46 Electronic searches are spatially analogous, even though the human searcher usually sits in one place. Conducting a search authorizes the search engine to spider out over the grid of the electronic network, bringing back what it finds. Search engines spatialize this form of systematic spreading out and are at the heart of chapter 5.

47 Kris Cohen, "What Does the Photoblog Want?," *Media, Culture and Society* 27, no. 6 (2005): 883–901.

48 Berlant, *The Female Complaint*.

49 Anna Constable, "Women's 'Voiceless Speech': Story of Police Interference with It from the Woman's Side," *New York Times*, January 5, 1913; "Call Suffragist to Court: 'Voiceless Speech' Obstructs Traffic, Is the Complaint," *New York Times*, December 29, 1912; "Voiceless Speech Too Loud: Judge Tells Ms. Constable She Must Not 'Talk' Again," *New York Times*, December 1, 1912; "Now the Voiceless Speech: Suffragists Have a New Way to Beat Anti-Talking Rules," *New York Times*, November 19, 1912; "Advertising Suffrage Ball: 'Voiceless Speeches' to Be Ground Out at 5th Avenue Milliner's," *New York Times*, December 13, 1912.

50 Danielle Citron, "Cyber Civil Rights," *Boston Law Review* 89 (2009): 61–125.

51 The law conference I discuss in the following pages produced some exemplary cases of what I refer to here, but popular media, as well as comment spaces everywhere, have also long been full of such editorials. One good source for such sentiments is the "Don't Read the Comments" meme. See, for example: "'Don't Read the Comments': The Trolls, Racists, and Abusers Won—Reasonable Online Feedback Is a Thing of the Past," *Salon*, September 11, 2015, http://www.salon.com/2015/09/11/dont_read_the_comments_the_trolls_racists _and_abusers_won_reasonable_online_feedback_is_a_thing_of_the_distant _past/ (accessed February 16, 2017). Or, Krystal D'Costa, "Don't Read the Comments! (Why Do We Read the Online Comments When We Know They'll Be Bad?)," *Scientific American*, Anthropology in Practice series, July 29, 2013, https://blogs.scientificamerican.com/anthropology-in-practice/done28099t -read-the-comments-why-do-we-read-the-online-comments-when-we-know -theye28099ll-be-bad/ (accessed February 16, 2017). *Snark* is another word that indexes a great mass of such sentiments. See, for example, journalist Michael B. Duff, "Is Snark Killing the Web?," https://michaelduff.net/2008/09 /29/is-snark-killing-the-web/ (accessed February 16, 2017).

52 S.v. "Internet troll," *Wikipedia*, http://en.wikipedia.org/wiki/Internet_troll (accessed February 3, 2009).

53 E. Gabriella Coleman, "Phreaks, Hackers, and Trolls and the Politics of Trans-

gression and Spectacle," in *The Social Media Reader*, ed. Michael Mandiberg (New York: New York University Press, 2012).

54 My thanks to Chris Miller for an extremely helpful series of interviews about trolls and the efforts of prominent websites to control their disruptions. At the time of this writing, Miller worked for YouTube, although not in the YouTube work group that is dedicated, full-time, to controlling bad behavior on the website. Previously he was the founder of one of the first online chat groups, a site called Bianca's Smut Shack, which as Miller attests, saw its fair share of antisocial behavior. The *Wikipedia* entry for Bianca even includes a section of the Smut Shack's history called "Flooding, Cyberattacks, and the Demise." S.v. "Bianca," *Wikipedia*, http://en.wikipedia.org/wiki/Bianca.com (accessed July 11, 2009).

55 Mattathias Schwartz, "Malwebolence: The World of Web Trolling," *New York Times*, August 3, 2008.

56 S.v. "Troll (Internet)," *Wikipedia*, http://en.wikipedia.org/wiki/Troll (Internet) (accessed July 11, 2009).

57 In our conversations, Chris Miller called this "disinhibition," and thereby links trolling, causally, to the same psychological conditions that make possible the frank discussion of sex on a site like Bianca's Smut Shack, the one he ran for years. See note 54.

58 S.v. "Anonymous (group)," *Wikipedia*, http://en.wikipedia.org/wiki/Anonymous (group) (accessed May 13, 2010).

59 Mark Seltzer, "Wound Culture: Trauma in the Pathological Public Sphere," *October* 80 (spring 1997): 3–26.

60 Gabriella Coleman uses the concept of "spectacle" to refer to a similar dynamic of publicity and feedback. Coleman, "Phreaks, Hackers, and Trolls and the Politics of Transgression and Spectacle."

61 Here is how the U.S. Computer Emergency Readiness Team defines denial-of-service attacks: "In a denial-of-service (DoS) attack, an attacker attempts to prevent legitimate users from accessing information or services. By targeting your computer and its network connection, or the computers and network of the sites you are trying to use, an attacker may be able to prevent you from accessing email, websites, online accounts (banking, etc.), or other services that rely on the affected computer. The most common and obvious type of DoS attack occurs when an attacker 'floods' a network with information. When you type a URL for a particular website into your browser, you are sending a request to that site's computer server to view the page. The server can only process a certain number of requests at once, so if an attacker overloads the server with requests, it can't process your request. This is a 'denial of service' because you can't access that site." U.S. Computer Emergency Readiness Team, *Official Website of the Department of Homeland Security*, www.us-cert.gov/cas/tips/ST04-015.html (accessed July 11, 2008).

62 Robert Vamosi, "Anonymous Hackers Take on the Church of Scientology,"

CNET, January 25, 2008, http://news.cnet.com/8301-10789_3-9857666-57.html (accessed February 16, 2017). The Church of Scientology's response: Wikinews, "Church of Scientology: '"Anonymous"' Will Be Stopped," http://en.wikinews .org/wiki/Church_of_Scientology:_%27%22Anonymous%27_will_be_stopped %22 (accessed February 6, 2017). Anonymous calls this campaign Project Chanology: s.v. "Project Chanology," *Wikipedia*, http://en.wikipedia.org/wiki /Project_Chanology (accessed February 4, 2009).

63 "Message to Scientology" (2:03), YouTube, www.youtube.com/watch?v=JCbKv 9yiLiQ (accessed February 16, 2017).

64 Both groups employ anonymity as a tactic. Both make use of the web as a medium for their activities and a megaphone for their voice. Both practice what might be called an aesthetics of disruption, including disruptions to socioeconomic commerce. Both take large, avaricious corporations like McDonald's as their targets. Lambert-Beatty refers to the Yes Men's actions as "hijinks." Carrie Lambert-Beatty, *Being Watched: Yvonne Rainier and the 1960s* (Cambridge, MA: MIT Press, 2008), 317–21. And the Yes Men's own website has a section entitled "Hijinks," www.theyesmen.org/ (accessed October 19, 2009).

65 S.v. "Anonymous (group)," *Wikipedia*, July 13, 2015, https://en.wikipedia.org/w /index.php?title=Anonymous_(group)&oldid=671276411.

66 See, for instance, their two utopian hoaxes, newspapers whose articles and headlines spectacularly fulfill the political dreams of leftists. The first was a hoax of a *New York Post* newspaper, handed out in subways. It was formerly archived at this address: http://nypost-se.com/. The other was a hoax version of *New York Times*, handed out in subways on July 4, 2009, and available here: www.nytimes-se.com/ (accessed February 16, 2017).

67 Of course, Tea Party–aligned libertarians in the United States like Rand Paul, Ron Paul's son, have been no friend of women's rights.

68 The pronouns *they* and *their* in these passages are tricky. They can't index any specific person, given the constitutive anonymity of trolls. But neither can they index a specific (if dispersed) aggregate of individuals, because the troll group form doesn't work like that. This is part of why I try to think here about trolls as a kind of structural or technical effect. This is what "they" and "their" awkwardly reference, so from here forward scare quotes will be implied.

69 Habermas, *The Structural Transformation of the Public Sphere*, 36.

70 Schwartz entertains the question of causes in his article in the *New York Times Magazine*, as does Judith Donath in her study of identity in online communities. Schwartz, "Malwebolence"; Judith Donath, "Identity and Deception in the Virtual Community," in *Communities in Cyberspace*, ed. Marc A. Smith and Peter Kollock (London: Routledge, 1999). See also Chris Miller, "A Case Study in User Centered Design of a High Traffic World Wide Web Virtual Community" (MA thesis, University of Illinois, Chicago, 1996), www.freeform.org /thesis/ (accessed August 11, 2010).

71 This is marketing analyst John Battelle's term for a new phase of commerce

in which the real commodity being sold (e.g., through brands and websites) is conversation. See Battelle, Searchblog: Thoughts on the Intersection of Search, Media, Technology, and More (blog), http://battellemedia.com/archives /category/the-conversatio (accessed February 16, 2017). See also David Armano, "It's the Conversation Economy, Stupid," *Bloomberg*, April 9, 2007, www.bloomberg.com/bw/stories/2007-04-09/its-the-conversation-economy -stupidbusinessweek-business-news-stock-market-and-financial-advice (accessed February 23, 2017).

72 Section 230 of the Communications Decency Act, also known as Title V of the Telecommunications Act of 1996, provides immunity to providers of an "interactive computer service" for "offensive material" published on their site. Title V is reproduced here: Cornell University Law School, Legal Information Institute, U.S. Code § 230 — Protection for Private Blocking and Screening of Offensive Material, www.law.cornell.edu/uscode/47/230.html (accessed February 16, 2017).

73 Foucault, *The Birth of Biopolitics*, 302–8.

74 From 2009 to 2012, Sunstein was the Administrator of the White House Office of Information and Regulatory Affairs in the Obama administration.

75 The program for the conference can be found here: The University of Chicago Law School, Conference: "Speech, Privacy, and the Internet: The University of Beyond," www.law.uchicago.edu/node/1080 (accessed February 16, 2017).

76 Saul Levmore, "The Internet's Anonymity Problem" (paper presented at "Speech, Privacy, and the Internet: The University and Beyond," University of Chicago Law School, November 21–22, 2008).

77 Quote taken from the abstract, www.law.uchicago.edu/events/index.html ?Event=447 (accessed February 9, 2009). Brian Leiter, "Cleaning Cyber Cesspools" (paper presented at "Speech, Privacy, and the Internet: The University and Beyond," University of Chicago Law School, November 21–22, 2008).

78 For a psychological analysis of the Internet in this vein, see Patricia Wallace, *The Psychology of the Internet* (Cambridge: Cambridge University Press, 1999).

79 Citron, "Cyber Civil Rights"; Frank Pasquale, "Resolving Struggles for Salience Online: Toward a Fair Reputation Reporting Act" (paper presented at "Speech, Privacy, and the Internet: The University and Beyond," University of Chicago Law School, November 21–22, 2008). A proposal for identification cards can be found here: John Markoff, "Do We Need a New Internet?," *New York Times*, February 14, 2009, www.nytimes.com/2009/02/15/weekinreview/15markoff .html?pagewanted=all.

80 Citron, "Cyber Civil Rights."

81 One version of Megan Meier's "cyber-bullying" case can be found here, on the website of the foundation set up by Megan's mother in the wake of Megan's death: Megan Meier Foundation, www.meganmeierfoundation.org/ (accessed May 19, 2010).

82 For a rundown of this controversy, see Caitlin Dewey, "The Only Guide to

Gamergate You Will Ever Need to Read," *Washington Post*, October 14, 2014, www.washingtonpost.com/news/the-intersect/wp/2014/10/14/the-only-guide -to-gamergate-you-will-ever-need-to-read/.

83 Donna Haraway, *Simians, Cyborgs, and Women: The Reinvention of Nature* (New York: Routledge, 2013), 163.

84 Coleman's book is excellent for showing how hard it is to decide, ultimately, who trolls are and what they represent. Gabriella Coleman, *Hacker, Hoaxer, Whistleblower, Spy: The Many Faces of Anonymous* (London: Verso, 2014).

85 This would be close to political scientist Jodi Dean's argument. She understands networked sociality as a distinctively neoliberal formation, bound up, compensatorily, with the great idealized promise of democratic participatory politics that she calls "communicative capitalism," and whose icon and instrument is the Internet. Synthesizing a long history of democratic theory, Dean expresses its ideal: "Democracy is envisioned as an exchange of reasons by participants in a discussion characterized by equality, inclusivity, reciprocity, and transparency." But in a neoliberal economy of communicative capitalism, to sketch Dean's argument, where participation is an ideal that papers over the defining antagonisms of a democracy remade as competition, people "chatter" while politicians *decide*, heedless of the chatter—or, worse, they cite the chatter as justification *for* their decisions, evidence that democracy is functioning as it should, still at its reciprocal best. Talk itself, in Dean's characterization, is the ideology that makes space for a rule of competition to supplant an ethos of equal exchange. Dean describes how the contemporary public spheres of democratic nations are rife with unsympathetic political intimacies and compensatory promises of political reciprocity, and how the political Left, by renewing calls for democracy, for participation, for interactivity, is peddling the problem (i.e., more participation) as a solution. Jodi Dean, *Democracy and Other Neoliberal Fantasies: Communicative Capitalism and Left Politics* (Durham, NC: Duke University Press, 2009), 78.

86 Named individuals who identify as trolls may, in fact, be misogynists, but this is beside the point of their collective effect via the pathological public sphere of the web, because that sphere is a population as well as a public and so is not strictly a mediated accumulation of particular, critical voices.

87 Thanks to one of my anonymous readers for help in developing this point. Provocative work in this regard includes Susan Stryker, *Transgender History* (Berkeley, CA: Seal Press, 2008); Elizabeth Reis, *Bodies in Doubt: An American History of Intersex* (Baltimore: Johns Hopkins University Press, 2009). I have also learned a great deal about how transgender theory matters for aesthetics from David Getsy's book: David J. Getsy, *Abstract Bodies: Sixties Sculpture in the Expanded Field of Gender* (New Haven, CT: Yale University Press, 2015). Harney and Moten also argue against equality as the goal of radical politics. Stefano Harney and Fred Moten, *The Undercommons: Fugitive Planning and Black Study* (Wivenhoe, UK: Minor Compositions, 2013).

88 Galloway, *Protocol*, 30.

89 The recent National Security Agency PRISM revelation spectacularly proves this point; it asserts, in fact, that our intended conversations are really just the excuse for, or substrate of, a massive effort to operationalize those conversations, across an insuperable differend, for another sphere of action altogether. Astonishingly, the U.S. government's defense so far has been to assert that this differend, the fact of a sphere of antiterrorism activities separate from the sphere of ordinary U.S. life, should be reassuring to the average U.S. citizen.

90 Another, more optimistic way to say this would be to borrow from Agamben and say "an indirect encounter that makes everyone indifferent." Giorgio Agamben, *The Coming Community*, trans. Michael Hardt (Minneapolis: University of Minnesota Press, 1993).

91 My description of this woman can only be conjecture drawn from external cues. I confirmed the question she asked Hayes in conversation with the artist, December 2, 2007.

92 The second part of this discussion occurs at the end of chapter 5.

93 Conversation with the artist, summer 2007.

94 "New York Artist Sharon Hayes Makes the Personal Political at the Republican National Convention" (press release), Walker Art Center, Minneapolis, 2008, available at www.walkerart.org/press/browse/press-releases/2008/new-york -artist-sharon-hayes-makes-the-person (accessed November 13, 2014). *Revolutionary Love* was performed in Denver, Colorado, and Saint Paul, Minnesota.

95 *In the Near Future* was performed in New York, London, Vienna, Warsaw, Brussels, and Paris.

96 Harvey, *A Brief History of Neoliberalism*; Berlant, "Slow Death"; Foucault, *The Birth of Biopolitics*. For more on the figure of the individual, see also Thomas C. Heller, Morton Sosna, and David E. Wellbery, *Reconstructing Individualism: Autonomy, Individuality, and the Self in Western Thought* (Stanford, CA: Stanford University Press, 1986); Lisa Duggan, *The Twilight of Equality? Neoliberalism, Cultural Politics, and the Attack on Democracy* (Boston: Beacon, 2003); David Theo Goldberg, *The Threat of Race: Reflections on Racial Neoliberalism* (Malden, MA: Wiley-Blackwell, 2009).

97 Steven Shaviro, *Connected, or, What It Means to Live in the Network Society*, Electronic Mediations (Minneapolis: University of Minnesota Press, 2003); Jodi Dean, *Publicity's Secret: How Technoculture Capitalizes on Democracy* (Ithaca, NY: Cornell University Press, 2002); Dean, *Democracy and Other Neoliberal Fantasies*.

98 Melissa Gregg, *Work's Intimacy* (Cambridge: Polity, 2011); Andrew Ross, *No-Collar: The Humane Workplace and Its Hidden Costs* (New York: Basic Books, 2003).

99 Other examples include the Chelsea Manning and Edward Snowden revelations, the National Security Agency, spam, malware, viruses, flame wars, doxing, a server going down, algorithmic marketing, identity theft, hacked ac-

counts, a picture getting zero likes, not knowing whether anyone has read one's most recent post . . . The list grows daily and ranges from the spectacular to the ordinary.

100 I note that my notion of parallelism, of realms or registers of action that are related but not via sovereignty or self-conscious action, is not derived from Baruch Spinoza's parallelism, which concerns the noncorrelation between thought and extension, or ideas and bodies, although obviously there are some resonances. Benedictus de Spinoza, *A Spinoza Reader: The Ethics and Other Works*, trans. Edwin M. Curley (Princeton, NJ: Princeton University Press, 1994).

101 This thought about discontinuous temporalities comes from Harry Haroo-tunian, "Remembering the Historical Present," *Critical Inquiry* 33 (spring 2007): 471–94.

102 Bryan-Wilson, "We Have a Future," 81.

Chapter 4: Toneless

1 On not counting politically, see Jacques Rancière, *Disagreement: Politics and Philosophy* (Minneapolis: University of Minnesota Press, 1999).

2 Even bare life might be too lush and human of a concept in this context, although I hope it's obvious that the comparison here is not of pain or suffering. As will become clear in what follows, the suffering that results from people's existence in populations is indirect, a question of the allocation of resources, of scarcity and plenty, and that can always be blamed on the victim, on a lack of hard work, of ambition, of resourcefulness. The rhetoric of sovereignty is alive and well in populations. The very word *resourceful*—which turns a noun (something that can be allotted or withheld) into an adjective (a human quality)—performs the liveness of the sovereignty concept. Giorgio Agamben, *Homo Sacer: Sovereign Power and Bare Life*, trans. Daniel Heller-Roazen (Stanford, CA: Stanford University Press, 1998).

3 The cloud quite literally embodies this idea of a flexible deployment of data. See Tung-Hui Hu, *A Prehistory of the Cloud* (Cambridge, MA: MIT Press, 2015).

4 Michel Foucault, *The Birth of Biopolitics: Lectures at the Collège de France, 1978–1979* (New York: Picador, 2008); Michel Foucault, "17 March 1976," in *"Society Must Be Defended": Lectures at the College de France 1975–1976* (New York: Picador, 1997); Michel Foucault, "Two Lectures," in *Power/Knowledge: Selected Interviews and Other Writings 1972–1977*, ed. Colin Gordon (New York: Pantheon, 1980); Michel Foucault, "The Birth of Biopolitics," in *Ethics: Subjectivity and Truth*, ed. Paul Rabinow (New York: New Press, 1994); Michel Foucault, *The History of Sexuality: An Introduction*, vol. 1 (New York: Vintage Books, 1978). Terranova moves our understanding of populations in a related direction. Tiziana Terranova, *Network Culture: Politics for the Information Age* (London: Pluto Press, 2004): 108–9.

5 See also Lisa Duggan, *The Twilight of Equality? Neoliberalism, Cultural Politics, and the Attack on Democracy* (Boston: Beacon, 2003); David Harvey, *A Brief History of Neoliberalism* (New York: Oxford University Press, 2005).

6 Alexander Galloway's work in this area associates the idea of protocol, derived from the programming logics of the Internet, with Foucault's biopolitics. Protocol is Galloway's way of naming the automaticity I describe here. In Galloway's thinking, protocols are the dominant form of control in the biopolitical historical moment—our moment. Alexander R. Galloway, *Protocol: How Control Exists after Decentralization* (Cambridge, MA: MIT Press, 2004).

7 In Google's case, that figure was more than 95 percent in the first quarter of 2012: see Terrence O'Brien, "Google Reports $10.65 Billion in Revenue for Q1 2012, Splits Stock," *Endgadget.com*, April 12, 2012, www.engadget.com/2012 /04/12/google-reports-10-65-billion-in-revenue-for-q1-2012-splits-sto/. For Facebook, it was 85 percent in 2011: *Search Engine Watch*, "Facebook IPO Show Ad Revenue Increased 69% in 2011," February 2, 2012, http://searchengine watch.com/article/2143126/Facebook-IPO-Show-Ad-Revenue-Increased-69 -in-2011.

8 Michael Warner, *Publics and Counterpublics* (New York: Zone Books, 2002), 87–96.

9 And so, therefore, is the modernist faith in self-reflexivity, a fact that points to the substantial overlap in Scott Richmond's recent book and my own, despite their very different aesthetic cases and theoretical allegiances. Scott Richmond, *Cinema's Bodily Illusions: Flying, Floating, and Hallucinating* (Minneapolis: University of Minnesota Press, 2016).

10 On Target and data mining, see Charles Duhigg, "How Companies Learn Your Secrets," *The New York Times*, February 16, 2012, www.nytimes.com/2012/02 /19/magazine/shopping-habits.html.

11 Joan W. Scott's cautionary tale about the evidence of experience is doubly warranted here, where experience is probably not even the right term for modes or zones of existence that are barely self-conscious or where the impact of self-consciousness on the named "experience" is minimal or nonexistent. Joan W. Scott, "The Evidence of Experience," *Critical Inquiry* 17, no. 4 (1991): 773–97.

12 On the management of preferences, see Eli Pariser, *The Filter Bubble: What the Internet Is Hiding from You* (New York: Penguin Press, 2011).

13 The key citations here are Foucault, *The Birth of Biopolitics*; Lauren Berlant, *The Queen of America Goes to Washington City: Essays on Sex and Citizenship* (Durham, NC: Duke University Press, 1997); Lauren Berlant, *The Female Complaint: The Unfinished Business of Sentimentality in American Culture* (Durham, NC: Duke University Press, 2008).

14 Hereafter referred to as "Certificates of Authenticity" or just "certificates."

15 William Gibson, *Pattern Recognition* (New York: G. P. Putnam's Sons, 2003), 65. Hereafter page references are given in the text.

16 Cayce's special skills, or intuitions, are the focus of Lauren Berlant's essay on *Pattern Recognition* and Colson Whitehead's novel *The Intuitionists*. Lauren Berlant, "Intuitionists: History and the Affective Event," *American Literary History* 20, no. 4 (2008).

17 Fredric Jameson, "Fear and Loathing in Globalization," in *Archaeologies of the Future: The Desire Called Utopia and Other Science Fictions* (London: Verso, 2007), 389–90.

18 Stanley Cavell, *Must We Mean What We Say? A Book of Essays* (Cambridge: Cambridge University Press, 1976).

19 "To curl fetal there, and briefly marvel, as a final wave crashes over her, at the perfect and now perfectly revealed extent of her present loneliness" (Gibson, *Pattern Recognition*, 24).

20 Bigend: "My passion is marketing, advertising, media strategy, and when I first discovered the footage, that is what responded in me. I saw attention focused daily on a product that may not even exist. You think that wouldn't get my attention?" (Gibson, *Pattern Recognition*, 65).

21 To render is also to recite or repeat, to decipher, to take apart.

22 In a lecture that updates *Discipline and Punish*, Foucault discusses prisoners as sources of information and redistribution: Michel Foucault, "Alternatives to the Prison: Dissemination or Decline of Social Control?," *Theory, Culture and Society* 26, no. 6 (2009): 22.

23 For another account of the intersection between the contemporary "attention economy" and aesthetics, see Jonathan Beller, *The Cinematic Mode of Production: Attention Economy and the Society of the Spectacle* (Hanover, NH: Dartmouth College Press, 2006).

24 Gonzalez-Torres openly acknowledges his "fascination" with minimalist work. Robert Nickas and Felix Gonzalez-Torres, "Felix Gonzalez-Torres: All the Time in the World (an Interview with Robert Nickas)," in *Felix Gonzalez-Torres*, ed. Julie Ault (Göttingen: Steidl Verlag, 2006), 39.

25 Ross Bleckner and Felix Gonzalez-Torres, "Felix Gonzalez-Torres by Ross Bleckner," *Bomb* 51 (spring 1995), http://bombmagazine.org/article/1847/felix -gonzalez-torres; Hal Foster, "The Crux of Minimalism," in *The Return of the Real: The Avant-Garde at the End of the Century* (Cambridge, MA: MIT Press, 1996); Julia Bryan-Wilson, *Art Workers: Radical Practice in the Vietnam War Era* (Berkeley: University of California Press, 2009); David Joselit, *American Art since 1945*, World of Art (London: Thames and Hudson, 2003); Benjamin H. D. Buchloh, "Conceptual Art 1962–1969: From the Aesthetics of Administration to the Critique of Institutions," *October* 55 (winter 1990): 105–43; Alexander Alberro, *Conceptual Art and the Politics of Publicity* (Cambridge, MA: MIT Press, 2003): 236; Alexander Alberro and Blake Stimson, *Conceptual Art: A Critical Anthology* (Cambridge, MA: MIT Press, 1999).

26 Suzanne Perling Hudson, "Beauty and the Status of Contemporary Criticism," *October* 104 (spring 2003): 115–30.

27 Joe Scanlan, "The Uses of Disorder," *Artforum* 48, no. 6 (2010): 166–67.

28 Robert Storr, "When This You See Remember Me," in *Felix Gonzalez-Torres*, ed. Julie Ault (Göttingen: Steidl Verlag, 2006), 7n3.

29 Hudson, "Beauty and the Status of Contemporary Criticism."

30 Shaviro, "Beauty Lies in the Eye," *Symploke* 6, no. 1 (1998): 106.

31 For a related take on the politics of oblique community in Gonzalez-Torres's work, one based in the philosophy of Jean-Luc Nancy and his notion of being singular plural, see John Paul Ricco, "Naked Sharing: On Felix Gonzalez-Torres's Bed" (paper presented at "Feeling Photography" conference, Toronto, Canada, October 16, 2009). See also John Paul Ricco, *The Decision between Us: Art and Ethics in the Time of Scenes* (Chicago: University of Chicago Press, 2014).

32 Robert Nickas and Felix Gonzalez-Torres, "Felix Gonzalez-Torres: All the Time in the World (an Interview with Robert Nickas)," in *Felix Gonzalez-Torres*, ed. Julie Ault (Göttingen: Steidl Verlag, 2006), 49.

33 Fredric Jameson, discussing William Gibson's *Pattern Recognition*, describes postmodernism's relentless drive to give names to all of its objects, names that take the form of brands and the various accoutrements of property. Jameson, "Fear and Loathing in Globalization."

34 The list of elements that do differentiate the candy works is all behind the scenes information, something not available in ordinary phenomenological encounters with the works. Those elements include exhibition history, owner- ship, bibliographic history, uniqueness as defined by the artist, Certificates of Authenticity or Certificates of Authenticity and Ownership, date, medium, and ideal weight.

35 Nancy Spector says that the parenthetical titles add content to what otherwise seem to be purely formal works, but that statement invests too much mean- ing in words and too little in the diacritical formatting of words. Nancy Spector, *Felix Gonzalez-Torres* (New York: Guggenheim Museum, 1995), 106.

36 Spector, *Felix Gonzalez-Torres*, 106.

37 Simon Garfield, "The Rise and Fall of AZT," *The Independent*, May 1, 1993, www .independent.co.uk/arts-entertainment/the-rise-and-fall-of-azt-it-was-the-drug -that-had-to-work-it-brought-hope-to-people-with-hiv-and-aids-and-millions-for -the-company-that-developed-it-it-had-to-work-there-was-nothing-else-but-for -many-who-used-azt—it-didnt-2320491.html (accessed July 8, 2015).

38 Douglas Crimp and Adam Rolston, AIDS *Demo Graphics* (Seattle: Bay Press, 1990); Leo Bersani, "Is the Rectum a Grave?," in AIDS: *Cultural Analysis, Cul- tural Activism*, ed. Douglas Crimp (Cambridge, MA: MIT Press, 1993); Judith Butler, "Imitation and Gender Insubordination," in *Inside/Out: Lesbian Theories, Gay Theories*, ed. Diana Fuss (New York: Routledge, 1991).

39 Robert Storr and Felix Gonzalez-Torres, "Felix Gonzalez-Torres: Être un espion (Interview with Robert Storr)," in *Felix Gonzalez-Torres*, ed. Julie Ault (Göttin- gen: Steidl Verlag, 2006), 238; Spector, *Felix Gonzalez-Torres*, 58.

40 For Derrida, the virus was a figure for his philosophy tout court, for the in-

fection of meaning, reading, and interpretation by the supplement after deconstruction. Jacques Derrida, "The Spatial Arts: An Interview with Jacques Derrida," *Deconstruction and the Visual Arts: Art, Media, Architecture,* ed. Peter Brunette and David Wills (Cambridge: Cambridge University Press, 1994), 12.

41 For more on countermodels to a form of critique that seeks to expose and reveal, see Vered Maimon, "The Third Citizen: On Models of Criticality in Contemporary Artistic Practices," *October* 129 (summer 2009): 85–112.

42 In other words, the viral is a name for the outcome, the extraction or derivative of what Italian autonomists have called "immaterial labor," where that concept does not name a type or class of labor but, rather, describes how tastes, preferences, pleasures, and choices are put to work in the cultural-economic realm. Michael Hardt, "Affective Labor," *boundary 2* 26, no. 2 (summer 1999): 89–100; Maurizio Lazzarato, "Immaterial Labour," in *Radical Thought in Italy: A Potential Politics,* ed. Michael Hardt and Paolo Virno, trans. Paul Colilli and Ed Emory (Minneapolis: University of Minnesota Press, 1996); David Graeber, "The Sadness of Post-Workerism, or, 'Art and Immaterial Labour' Conference, a Sort of Review (Tate Britain, Saturday 19 January, 2008)," *The Commoner: A Web Journal for Other Values* 13 (April 1, 2008).

43 This is as good a place as any to note the relationship of this essay to the Gonzalez-Torres literature that understands the dissipation of the candy pieces as a metaphor for the wasting away of the body, and therefore understands the role of viewers in terms of personal responsibility, choice, etc. I don't disagree with this interpretation, which often appears to be voiced by Gonzalez-Torres himself in some of the interviews he's given. But I do think that it accounts too much, and perhaps too anachronistically, for a form of individual agency and too little for the collective forms that Gonzalez-Torres's work historicizes and assembles. For examples of this argument, see Nancy Spector, ed., *Felix Gonzalez-Torres: America: United States Pavilion, 52nd Venice Biennale* (New York: Guggenheim Museum Publications, 2007), 55–56; Emily Boone Hagenmaier, "'Untitled' (Queer Mourning and the Art of Felix Gonzalez-Torres)," in *Dying, Assisted Death and Mourning,* ed. Asa Kasher (Amsterdam: Rodopi, 2009); Robert Storr, "The Here and Now That's Here to Stay," *MoMA* 26 (autumn 1997): 19–21. While her focus is less on the metaphorics of death and dissipation, Miwon Kwon also understands the candy works primarily in terms of private personhood. Miwon Kwon, "The Becoming of a Work of Art: FGT and a Possibility of Renewal, a Chance to Share, a Fragile Truce," in *Felix Gonzalez-Torres,* ed. Julie Ault (Göttingen: Steidl Verlag, 2006). For more on Kwon's argument, see note 50.

44 Advertising used to be what one marketing expert called corporate America's "last bastion of unaccountable spending," but this is no longer the case. The expert here is Google CEO Eric Schmidt, as quoted by John Battelle. Battelle, *The Search: How Google and Its Rivals Rewrote the Rules of Business and Transformed Our Culture* (New York: Portfolio, 2005), 167.

45 Seventeen out of the twenty candy works that Gonzalez-Torres produced in his life have references to ideal weights. The ones that do not give ideal sizes or dimensions.

46 From the Certificate of Authenticity for *"Untitled" (Aparición)* (1991), Andrea Rosen Gallery, New York. Cited in David Deitcher, "Contradictions and Containment," in *Felix Gonzalez-Torres*, ed. Julie Ault (Göttingen: Steidl Verlag, 2006), 322n11.

47 Some of Gonzalez-Torres's paper stacks, which share many formal similarities with the candy works, do not have accompanying certificates and are not manifest anew in each exhibition or available to be taken by visitors to the exhibition.

48 The language of the certificates for the candy and the paper stacks is built on a similar template, and as it is now the Felix Gonzalez-Torres's Foundation policy not to allow access to the certificates, I quote here from the Certificate of Authenticity for the paper stack entitled *"Untitled" (National Front)*, 1992: "A part of the intention of the work is that third parties may take individual sheets of paper from the stack. These individual sheets and all individual sheets taken from the stack collectively do not constitute a unique work of art nor can they be considered the piece. The owner has the right to replace, at any time, the quantity of sheets necessary to regenerate the piece back to ideal height." Quoted in Cristiane Meyer-Stroll, "Felix Gonzalez-Torres: Revolution of Silence," in *Felix Gonzalez-Torres, Roni Horn*, ed. Nancy Spector, trans. Baker and Harrison (Munich: Sammlung Goetz, 1995), 46. Robert Storr notes that Gonzalez-Torres sometimes instructed museum guards to encourage people to take candies and to explain the formal references of the piece. Storr, "When This You See Remember Me," 5.

49 See Nicolas Bourriaud, *Relational Aesthetics*, Collection Documents Sur L'art (Dijon: Les Presses du Réel, 2002); Claire Bishop, "Antagonism and Relational Aesthetics," *October* 110 (fall 2004): 51–79; Liam Gillick, "Contingent Factors: A Response to Claire Bishop's 'Antagonism and Relational Aesthetics,'" *October* 115 (winter 2006): 95–107.

50 Miwon Kwon sees the certificates as important precisely because they don't present themselves to viewers. In their invisibility and immateriality, they perform a kind of radical withholding, retaining the "private" kernel of the artworks in an otherwise meretricious art market, as though against the kinds of groups assembled by marketing and in favor of some less compromised group form. She understands the certificates, in other words, as part of Gonzalez-Torres's radical reworking of the art market, specifically the relationship between artist and owner. Kwon describes the certificates as "the behind-the-commercial-scenes contracts of transaction that regulate the work's conditions of ownership, exchange, public presentation." In Kwon's reading, the private aspect of Gonzalez-Torres's work is noncommercial, more like a private conversation than a private corporation. In its noncommercial form, privacy insists on an irreducible opacity at the heart of all intimacy, an opacity that Kwon

aligns with a mode of social and political antagonism and a strain of democracy that acknowledges the play of difference among its subjects. In her evocation of this private kernel, Kwon wants to rescue Gonzalez-Torres from a complaint that has unified critics of relational aesthetics, namely, that it harbors a naive faith in togetherness, that in its practices, togetherness is too easy as compared to the hard work of actual democracy. And so, these critics conclude, the relationality in relational aesthetics can only be an illusion whose acceptance as reality comes at the expense of certain excluded parties—in short, an ideology. Gonzalez-Torres has been contentiously associated with relational aesthetics since Nicolas Bourriaud's eponymous book named him as the origin of contemporary relational aesthetics practices. Miwon Kwon, "The Becoming of a Work of Art." For a more ambivalent take on the certificates, see Joe Scanlan, "The Uses of Disorder."

51 There isn't much documentation of Gonzalez-Torres's work with ACT UP, so when I discuss coalition building in that context, I'm generalizing, perhaps unfairly or inaccurately from a biographical perspective (which is not really my perspective), from the documented history of ACT UP to the specific case of Gonzalez-Torres's own involvement. For accounts of coalition building in ACT UP, see Douglas Crimp, "Right on, Girlfriend!," in *Melancholia and Moralism: Essays on AIDS and Queer Politics* (Cambridge, MA: MIT Press, 2002); Gregg Bordowitz, "Picture a Coalition," in *AIDS: Cultural Analysis, Cultural Activism*, ed. Douglas Crimp (Cambridge, MA: MIT Press, 1988); Deborah B. Gould, *Moving Politics: Emotion and ACT UP's Fight against AIDS* (Chicago: University of Chicago Press, 2009).

52 Michel Foucault, "Friendship as a Way of Life," in *Ethics: Subjectivity and Truth, Essential Works of Michel Foucault, 1954–1984*, ed. Paul Rabinow (New York: New Press, 1997).

53 Crimp and Rolston, *AIDS Demo Graphics*.

54 For more on the differend, see chapter 3.

55 Crimp and Rolston, *AIDS Demo Graphics*, 53.

56 This is amply evidenced by Gonzalez-Torres's activist work and his expansions of activism through his involvement with Group Material. About minimalism, Nancy Spector calls Gonzalez-Torres's relation to the preceding generation of minimalists not linear but "dialogic." Spector, *Felix Gonzalez-Torres*.

57 Spector, *Felix Gonzalez-Torres*, 73.

58 This possibility, seen optimistically, is one reason for Bourriaud's enthusiasm about Gonzalez-Torres's work. Bourriaud, *Relational Aesthetics*.

59 Gonzalez-Torres elected to use diacritical marks as part of his name when it was used in Spanish-speaking contexts (either publications or nations). He chose not to use diacritical marks in any other language contexts, including English. This suggests, at the very least, that Gonzalez-Torres was aware of the connection that I've been sketching here between diacritics and the circulation of the body through particular scenes or mediations.

60 *Lymbix Inc.*, http://www.lymbix.com/ (accessed February 20, 2017).

61 Some of the evolutionary literature on laughter addresses its infectious quali-ties. See, for example, Christian F. Hempelmann, "The Laughter of the 1962 Tanganyika 'Laughter Epidemic,'" *Humor* 20, no. 1 (2007): 49–71; Matthew Gervais and David Sloan Wilson, "The Evolution and Functions of Laugh-ter and Humor: A Synthetic Approach," *Quarterly Review of Biology* 80, no. 4 (2005): 395–429.

62 For more on this Facebook feature, see "Like Button for the Web," *Facebook for Developers*, http://developers.facebook.com/docs/reference/plugins/like (ac-cessed February 21, 2017).

63 For a list of these variations, see the "LOL" entry, *Wikipedia*, http://en.wikipedia.org/wiki/LOL (accessed July 29, 2010).

64 See, for example, Boing Boing, http://boingboing.net/; Slashdot, http://slashdot.org/; and MetaFilter, www.metafilter.com/ (all accessed August 11, 2010).

65 Much of the writing on LOL and emoticons regards them merely as symptoms, and uses them as a moralizing shuttle to some other register of analysis. It sees them, for instance, as symptoms of the degradation of language and writing or the decline of education and a possible obstacle to the smooth profession-alization of a new generation of children—two problems often thought to be endemic to web cultures. For more, see the debate between technology writer Nicolas Carr and psychologist Steven Pinker: Steven Pinker, "Mind over Mass Media," *New York Times*, June 10, 2010; Nicholas Carr, "Steven Pinker and the Internet," *Rough Type*, www.roughtype.com/archives/2010/06/steven_pinker_a.php (accessed February 21, 2017). For more moralizing responses to the Inter-net from Carr, see Nicholas G. Carr, *The Shallows: What the Internet Is Doing to Our Brains* (New York: W. W. Norton, 2010); Nicholas G. Carr, "Is Google Making Us Stupid? What the Internet Is Doing to Our Brains," *The Atlantic* (July/August 2008), https://www.theatlantic.com/magazine/archive/2008/07/is-google-making-us-stupid/306868. See also Sali A. Tagliamonte and Derek Denis, "Linguistic Ruin? LOL! Instant Messaging and Teen Language," *Ameri-can Speech* 83, no. 1 (2008): 3–34. Tagliamonte contains a good bibliography for the arguments about the degradation of language; Jeffrey T. Hancock, "LOL: Humor Online," *Interactions* 11, no. 5 (2004): 57–58.

66 Wendy Brown, *Undoing the Demos: Neoliberalism's Stealth Revolution* (Brooklyn, NY: Zone Books, 2015).

67 The paradigm cases for (or maybe they're only the most obvious examples of) creating specific tonalities through the inflection of things on the web are prob-ably now Tumblr (www.tumblr.com) and Pinterest (www.pinterest.com). Both rose to prominence in the time that I've been writing this chapter.

68 Jeff Scheible, *Digital Shift: The Cultural Logic of Punctuation* (Minneapolis: Uni-versity of Minnesota Press, 2015), 98; Jacques Derrida, *Limited Inc* (Evanston, IL: Northwestern University Press, 1977).

69 For a different but related explanation of the emergence of figures of non-

sovereignty, see Lauren Berlant, "Slow Death (Sovereignty, Obesity, Lateral Agency)," *Critical Inquiry* 33 (summer 2007): 754–80.

70 See, for instance, Bourriaud, *Relational Aesthetics*, 49–64; Robert Storr and Felix Gonzalez-Torres, "Felix Gonzalez-Torres: Être un espion (Interview with Robert Storr)."

Chapter 5: Search Engine Subjectivities

1 BEACON can be found at Thomson & Craighead, BEACON, www.automated beacon.net/ (accessed February 20, 2017).

2 Ludwig Wittgenstein, *Philosophical Investigations*, 3rd ed. (Oxford: Blackwell, 1968), 2–3.

3 As I type the sentences of this chapter, I watch the online version of BEACON. It is like watching my subject evolve as I try to write about it. It is also like watching my subject escape. I will occasionally transcribe the search queries I see, not in order to fix them in their specificity as a site for commentary (our capacity or incapacity to perform just such an operation is exactly what is at stake in this chapter), but in order to offer an alternative descriptive system next to that of my own prose. As I'll later elaborate, there is something affective but brokenly cumulative in BEACON's endless seriality, and I want that effect present on the page. These interpolated queries will appear at random and in italics. I will transcribe the interpolated search queries in exactly the form in which they appeared in BEACON, reproducing spelling, capitalization, and punctuation.

4 One every two seconds. Figure obtained in conversation with the artists, December 10, 2008.

5 Thomson & Craighead, BEACON, www.automatedbeacon.net/ (accessed February 20, 2017).

6 The search engine that BEACON siphons is called Dogpile.com. More on Dogpile below.

7 Some search engines have experimented with personification. AskJeeves was an example, although it is now simply called Ask (www.ask.com), an admission that simulated interpersonal relation failed to cut into the profits of Google, Yahoo!, or MSN/Live.

8 Steven Shaviro, *Connected, or, What It Means to Live in the Network Society*, Electronic Mediations (Minneapolis: University of Minnesota Press, 2003).

9 Stanley Cavell, in a pivotal early essay that asked why television had, up to that point, not been considered a serious topic for thought, characterized television as a monitoring relation. Cavell's exact phrase for the medium of television is a "current of simultaneous event reception," whose "mode of perception" is "monitoring." Stanley Cavell, *Themes out of School: Effects and Causes* (Chicago: University of Chicago Press, 1988).

10 On the series as a modernist aesthetic form, closely related to medium, see Stanley Cavell, *The World Viewed: Reflections on the Ontology of Film* (Cambridge, MA: Harvard University Press, 1979).

11 Cuil.com shut down its servers in 2010. It is now archived at the Internet Archive: https://web.archive.org/web/20100910203434/http://www.cuil.com/ (accessed September 20, 2017).

12 Google once published the total number of pages it indexed at the bottom of its home page, but it no longer does, having shifted its marketing from quantity to quality ("relevance") of search. Microsoft's search engine is called Live (www .live.com/).

13 Before search engines, Michel Foucault began a conversation about the relationship between personhood and the impossibly vast and kaleidoscopically varied concept of knowledge. His related concept *discourse* makes the reference to knowledge more precise, in certain situations, by organizing statements into collections that produce intelligibility around people, things, or events. Discourses are knowledge atomized, organized, valued, and put to work. But knowledge for Foucault—its very possibility as well as its fields of organization—is the matrix of possibility for all statements and the discourses that galvanize them. In *The Archaeology of Knowledge*, Foucault argues that the historical conceptualization of knowledge as continuous and linear provides cover for a dominant, albeit subterranean, conceptualization of the human subject as also continuous and linear, i.e., as sovereign. The self-determining, self-continuous subject thrives so long as the self-continuous, linear conceptualization of knowledge thrives. Knowledge and subjectivity share a form, which is perhaps a way to say that they are subject to the same types of manipulations: for example, the discretion of disciplines (institutions, taxonomies) and the statistical norms of biopolitics (demographics, polls, folksonomies). Foucault's challenge to continuous histories is therefore also a challenge to the subject conceived as sovereign. By redescribing history as a series of statements that organize zones of intelligibility, Foucault disperses knowledge as part of an effort to loosen the constraints on personhood, and more precisely, to disrupt the ways that personhood becomes subject to the discursive intelligibility of particular, marked qualities. Michel Foucault, *The Archaeology of Knowledge and the Discourse on Language*, trans. A. M. Sheridan Smith (New York: Pantheon, 1972), 12. The idea of "folksonomies" goes some way toward connecting Foucault with search engines: "Folksonomies are an emergent phenomenon of the Social Web. They arise from data about how people associate terms with content that they generate, share, or consume." In other words, they are a system of organization that emerges through many discontinuous encounters of people with stuff, one result of which is that people are moved to attach keywords or tags to the stuff they encounter. The resulting schema is chaotic, non-mutually-exclusive, and non-categorically-inclusive, and the labor that produces it is largely unpaid. Thomas Gruber, "Ontology of Folksonomy: A Mash-up of Apples and Oranges," *International Journal on Semantic Web and Information Systems* 3, no. 2 (2007): 1–11. See also Clay Shirky, "Ontology Is Overrated: Categories, Links, and Tags," *Clay Shirky's Writings about the Internet*, www

.shirky.com/writings/ontology_overrated.html, 2005 (accessed February 20, 2017).

14 For a legal discussion about the dangers of a social milieu that records everything we do and never forgets, as well as possible legal remedies, see Daniel J. Solove, *The Future of Reputation: Gossip, Rumor, and Privacy on the Internet* (New Haven, CT: Yale University Press, 2007); Jonathan Zittrain, *The Future of the Internet and How to Stop It* (New Haven, CT: Yale University Press, 2008). See also Jeffrey Rosen, "The Web Means the End of Forgetting," *New York Times*, July 21, 2010.

15 This problem is specifically addressed in Zittrain's notion of "reputation bankruptcy": Zittrain, *The Future of the Internet and How to Stop It*.

16 My discussion of the differend appears in chapter 3. There, I describe it as a mode of nonrelation that characterizes the space between populations and publics.

17 The social software Chatsum was designed around a recognition of this basic social fact of life online. "Chatsum is a FREE add-on for your web browser that lets you chat with all the other Chatsum users that [sic] are looking at the same website as you." Like so many other websites of yore, Chatsum is now archived at the Internet Archive, https://web.archive.org/web/20080828194027/http://chatsum.com/ (accessed February 23, 2017). It was a project of George Grinsted (http://www.imgeorge.org/).

18 Michael Warner, *The Letters of the Republic: Publication and the Public Sphere in Eighteenth-Century America* (Cambridge, MA: Harvard University Press, 1990), 205.

19 This question comes up first in chapter 3.

20 Stanley Cavell, *Must We Mean What We Say? A Book of Essays* (Cambridge: Cambridge University Press, 1976).

21 Lauren Berlant, "Intimacy: A Special Issue," in *Intimacy* (Chicago: University of Chicago Press, 2000).

22 Michael Fried, "Art and Objecthood," *Artforum* 5, no. 10 (1967): 12–23.

23 Pamela Lee historicizes this more broadly and less polemically as what she calls "chronophobia," a widespread condition that arose, Lee argues, in relation to the new technologies of the 1960s. Pamela M. Lee, *Chronophobia: On Time in the Art of the 1960s* (Cambridge, MA: MIT Press, 2004).

24 You can watch Lernert Engelberts and Sander Plug's film *I Love Alaska: the Heartbreaking Search History of AOL user #711391* here: Minimovies, www.minimovies.org/documentaires/view/ilovealaska/ (accessed July 15, 2015).

25 *User 927*, by Katharine Clark Grey, directed by Michael Alltop, Brat Productions, Philadelphia, PA, June 6, 2008. Grey cites Battelle's book *The Search* as one of her influences. John Battelle, *The Search: How Google and Its Rivals Rewrote the Rules of Business and Transformed Our Culture* (New York: Portfolio, 2005). Battelle himself provides a final example of this impulse to anthropomorphize search queries: "Still smarting from the loss of my own internet

business and wondering whether the internet story could ever pick itself up off the ground, I stumbled across a link to the first edition of Google Zeitgeist. Zeitgeist is a clever public relations tool that summarizes search terms that are gaining or losing momentum during a particular period of time. By watching and counting popular search terms, Zeitgeist provides a fascinating summary of what our culture is looking for or finds interesting, and, conversely, what was once popular that is losing cultural momentum. . . . I was transfixed. Zeitgeist revealed to me that Google had more than its finger on the pulse of our culture, it was directly jacked into the culture's nervous system. This was my first glimpse into what I came to call the Database of Intentions—a living artifact of immense power. My God, I thought, Google knows what our culture wants!" Battelle, *The Search*, 1–2. *The Search* is one of the first cultural analyses of search engines, which is also—in a paradigmatic example of what Fredric Jameson describes as postmodernism's collapse of culture into economy— a business analysis. As Battelle describes it, Google Zeitgeist, and by extension, Google's vast database of user behavior, communicates something he optimistically translates as "intentions." Battelle is not just a practitioner or passive example of this collapse, but an entrepreneur, having made the theory into not just a replicable practice for others but a life for himself. *Pattern Recognition*'s Hubertus Bigend is his novelistic avatar (my discussion of *Pattern Recognition* appears in chapter 4). William Gibson, *Pattern Recognition* (New York: G. P. Putnam's Sons, 2003). Jameson's most emphatic and condensed statement on culture, understood in this way, is in "Postmodernism, or, the Cultural Logic of Late Capitalism," *New Left Review* 146 (July–August 1984): 53–92. Arguably, though, all of Jameson's writings since the 1980s have tried to work out the implications of this insight and map out new analytic responses to the problem it identifies.

26 "Google's mission is to organize the world's information and make it universally accessible and useful." See "From the Garage to the Googleplex," *Google .com*, https://www.google.com/intl/en/about/our-story/ (accessed February 23, 2017).

27 Diana Fuss, *Identification Papers: Readings on Psychoanalysis, Sexuality, and Culture* (New York: Routledge, 1995). For a more recent take on processes of identification, one that closely considers the impact of new media on those processes, see "Special Issue: New Approaches to Cinematic Identification," ed. Elizabeth Reich and Scott Richmond, *Film Criticism* 39, no. 2 (winter 2015).

28 The following popular and technology industry books give some helpful detail about how search engines work, technically, but also how they monetize search: John Battelle, *The Search*; Steven Levy, *In the Plex: How Google Thinks, Works, and Shapes Our Lives* (New York: Simon and Schuster, 2011). For a more critical and historical take, see Institute of Network Cultures, "Online Search," *Society of the Query* 2 (2015), http://networkcultures.org/blog/publication /society-of-the-query-magazine/ (accessed February 23, 2017).

29 Levy, *In the Plex*, 84.

30 Levy, *In the Plex*, 85.

31 This is one of the conflicts staged explicitly in Gibson's *Pattern Recognition*, which I discuss in chapter 4. Cayce's skills, understood mystically as a kind of intuition and highly valued precisely on that basis (she is described as a "dowser"), stand in stark contrast to the processes of tracking, aggregation, and population building that her employer, Bigend, makes possible. Perhaps the novel's greatest fear, its most fervent warning, lies in its desire to show how those types of processes might be seen as antithetical in a narrative context (good v. evil, human v. machine) even while, in the historical context the novel enacts as our very near future, they work in perfect collaboration, practically constituting each other.

32 "Clearly, we can never measure anything close to all the queries Google will get in the future. Every day, in fact, Google gets many millions of queries that we have never seen before, and will never see again. Therefore, we measure statistically." Scott Huffman, Engineering Director, *Official Google Blog*, September 15, 2008, http://googleblog.blogspot.com/2008/09/search-evaluation-at-google.html (accessed February 23, 2017).

33 Here, admittedly, while watching BEACON, I waited for search queries that suited my sentence's needs, although I didn't have to wait long for any of the queries above.

34 Google Trends, https://trends.google.com/trends/ (accessed February 20, 2017).

35 William Saletan, "Dr. Jekyll and Mr. Orgy," *Slate*, June 27, 2008, www.slate.com/articles/health_and_science/human_nature/2008/06/dr_jekyll_and_mr_orgy.html (accessed February 20, 2017).

36 Žižek might say that Walters had expertly articulated a contemporary form of ideology critique, taking ideology to be manifest in actions rather than in statements that self-consciously articulate belief. Jodi Dean describes Žižek's updating of "ideology" here: Jodi Dean, *Publicity's Secret: How Technoculture Capitalizes on Democracy* (Ithaca, NY: Cornell University Press, 2002), 4–8.

37 For example, consider this passage from Google's official blog: "Thus, computer systems will have greater opportunity to learn from the collective behavior of billions of humans. They will get smarter, gleaning relationships between objects, nuances, intentions, meanings, and other deep conceptual information. Today's Google search uses an early form of this approach, but in the future many more systems will be able to benefit from it. What does this mean to Google? For starters, even better search. We could train our systems to discern not only the characters or place names in a YouTube video or a book, for example, but also to recognize the plot or the symbolism. The potential result would be a kind of conceptual search: 'Find me a story with an exciting chase scene and a happy ending.' As systems are allowed to learn from interactions at an individual level, they can provide results customized to an indi-

vidual's situational needs: where they are located, what time of day it is, what they are doing." Posted by Alfred Spector, vice president of engineering, and Franz Och, research scientist, *Official Google Blog: The Intelligent Cloud*, https://googleblog.blogspot.com/2008/09/intelligent-cloud.html (accessed February 20, 2017).

38 And very pointedly not felt when they produce prosperity, or remove obstacles, as happens, for instance, when white men slot frictionlessly into jobs in corporate America, in Google, in engineering graduate programs. Michel Foucault, "The Birth of Biopolitics," in *Ethics: Subjectivity and Truth*, ed. Paul Rabinow (New York: New Press, 1994).

39 Alexander R. Galloway, *The Interface Effect* (Cambridge: Polity, 2012).

40 See the introduction for more on individuality as a neoliberal person form. Lauren Berlant historicizes these effects, and their obfuscation, in her essay "Slow Death," and in much of her recent work. Lauren Berlant, "Slow Death (Sovereignty, Obesity, Lateral Agency)," *Critical Inquiry* 33 (summer 2007): 754–80.

41 N. Katherine Hayles, *How We Became Posthuman: Virtual Bodies in Cybernetics, Literature, and Informatics* (Chicago: University of Chicago Press, 1999).

42 The first part of this discussion appears at the end of chapter 3.

43 Accession number 500.2004.

44 Alexander R. Galloway, *Protocol: How Control Exists after Decentralization* (Cambridge, MA: MIT Press, 2004), 5.

45 Pamela Lee understands seriality in the art of the 1960s, by contrast, as a test of human patience. Lee, *Chronophobia*, 368.

46 Grammar, too, all but forces the anthropomorphizing of queries into whole persons.

47 McKenzie Wark, "Designs for a New World," *e-flux*, October 2014, www.e-flux.com/journal/designs-for-a-new-world/.

48 José Esteban Muñoz, *Cruising Utopia: The Then and There of Queer Futurity* (New York: New York University Press, 2009); Lee Edelman, *No Future: Queer Theory and the Death Drive*, Series Q (Durham, NC: Duke University Press, 2004).

49 Nicolas Bourriaud, *Relational Aesthetics*, Collection Documents Sur L'art (Dijon: Les Presses du Réel, 2002); Claire Bishop, *Artificial Hells: Participatory Art and the Politics of Spectatorship* (London: Verso, 2012).

50 Eugenie Brinkema, *The Forms of the Affects* (Durham, NC: Duke University Press, 2014).

51 McKenzie Wark, *A Hacker Manifesto* (Cambridge, MA: Harvard University Press, 2004).

52 Luc Boltanski and Eve Chiapello, *The New Spirit of Capitalism* (London: Verso, 2005).

53 Although, there are complications here of course, for example, of the sort identified by Eli Pariser, *The Filter Bubble: What the Internet Is Hiding from You* (New York: Penguin Press, 2011).

54 *Dividuation* is Deleuze's term for a form of personhood that comes to exist in networked life—or as he periodizes it, in "societies of control"—in which life becomes equated with not a liberal individuation but an algorithmic dividuation, a subjection of all persons to processes of data collection and management. "Dividual" is a possible name for what becomes of the subject in populations. Gilles Deleuze, "Postscript on the Societies of Control," *October* 59 (winter 1992): 3–7.

55 In Fried's version, an assembly line of object production reduces all subjectivity to a theatrical to-be-seen-ness, an instrumentalized performance for others. Fried, *Art and Objecthood*. In Lee's version, the fear of digital technologies replaces lived history with the repetitive time of technocultural commodification, where subjectivity first gets paranoid, then ultimately becomes an actor in a Warhol film, deadened and bored. Lee, *Chronophobia*.

56 Anthropologist David Graeber has argued that the presence of governmental tactics, like the biopolitics of marketing, is never in itself reason to ignore or lose faith in the various projects of "counterpower" that he sees it as the task of anthropologists and other public intellectuals to describe and make more available. For Graeber, time spent trying to more and more elegantly describe the totalizing mechanisms of power is time stolen from the project of documenting the places where people are experimenting with actually existing alternative forms of world building. I agree, to an extent. Or, I believe both projects are necessary. But the feature of search engines that I'm underscoring most emphatically is the way they laminate counterpower to power, not in the form of the alternative or oppositional relation that Graeber describes, and not in a Foucauldian spatiality of the outside, but as a literal weld or graft, a becoming-inseparable that is, almost immediately, an accomplished inseparability. In other words, with respect to search engines, power's loss is not counterpower's gain; both improve together. The structure and the effects of this weld are, in part, what I have tried to describe in the chapter to this point. David Graeber, *Fragments of an Anarchist Anthropology* (Chicago: Prickly Paradigm, 2004); David Graeber, *Possibilities: Essays on Hierarchy, Rebellion and Desire* (Oakland, CA: AK Press, 2007); Michel Foucault, "Sex, Power, and the Politics of Identity," in *Ethics: Subjectivity and Truth*, ed. Paul Rabinow, vol. 1, *Essential Works of Michel Foucault, 1954–1984* (New York: New Press, 1997), 167.

57 I hope it is obvious that this conceptualization of a networked parallelism as a kind of cultural condition that is mirrored darkly in contemporary aesthetic practices, one that establishes the conditions for a particular structure of group form, intends to build on the many, many accounts of the ways that capitalism has learned from artistic and cultural production. One might argue that all accounts of modernist aesthetics tell this story, as though capitalism were a form of artificial life whose software is modernist artistic production. For a more direct explanation, see Boltanski and Chiapello, *The New Spirit of Capitalism*.

SELECTED BIBLIOGRAPHY

Adomavicius, Gediminas, and Alexander Tuzhilin. "Toward the Next Generation of Recommender Systems: A Survey of the State-of-the-Art and Possible Extensions." IEEE *Transactions on Knowledge and Data Engineering* 17, no. 6 (June 2005): 734–49.

"Advertising Suffrage Ball: 'Voiceless Speeches' to Be Ground Out at 5th Avenue Milliner's." *New York Times*, December 13, 1912.

Alberro, Alexander. *Conceptual Art and the Politics of Publicity.* Cambridge, MA: MIT Press, 2003.

Alberro, Alexander, and Blake Stimson. *Conceptual Art: A Critical Anthology.* Cambridge, MA: MIT Press, 1999.

Auden, W. H. *The Shield of Achilles.* New York: Random House, 1955.

Bartsch, Shadi, and Jas Elsner. "Introduction: Eight Ways of Looking at an Ekphrasis." *Classical Philology* 102, no. 1 (2007): i–vi.

Battelle, John. *The Search: How Google and Its Rivals Rewrote the Rules of Business and Transformed Our Culture.* New York: Portfolio, 2005.

Berlant, Lauren. *The Anatomy of National Fantasy: Hawthorne, Utopia, and Everyday Life.* Chicago: University of Chicago Press, 1991.

———. *The Female Complaint: The Unfinished Business of Sentimentality in American Culture.* Durham, NC: Duke University Press, 2008.

———. "Intuitionists: History and the Affective Event." *American Literary History* 20, no. 4 (2008): 845–60.

———. *The Queen of America Goes to Washington City: Essays on Sex and Citizenship.* Series Q. Durham, NC: Duke University Press, 1997.

———. "Slow Death (Sovereignty, Obesity, Lateral Agency)." *Critical Inquiry* 33, no. 4 (summer 2007): 754–80.

———. "Trauma and Ineloquence." *Cultural Values* 5, no. 1 (2001): 41–58.

Bersani, Leo. "Is the Rectum a Grave?" In *AIDS: Cultural Analysis, Cultural Activism*, edited by Douglas Crimp. Cambridge, MA: MIT Press, 1993.

———. *Is the Rectum a Grave? And Other Essays*. Chicago: University of Chicago Press, 2009.

Bersani, Leo, Tim Dean, Kaja Silverman, and Hal Foster. "A Conversation with Leo Bersani." *October* 82 (autumn 1997): 3–16.

Bersani, Leo, and Ulysse Dutoit. *Arts of Impoverishment: Beckett, Rothko, Resnais*. Cambridge, MA: Harvard University Press, 1993.

———. *Caravaggio's Secrets*. Cambridge, MA: MIT Press, 1998.

———. *Forms of Being: Cinema, Aesthetics, Subjectivity*. London: BFI, 2004.

Bishop, Claire. "Antagonism and Relational Aesthetics." *October* 110 (fall 2004): 51–79.

———. *Artificial Hells: Participatory Art and the Politics of Spectatorship*. London: Verso, 2012.

Bleckner, Ross, and Felix Gonzalez-Torres. "Felix Gonzalez-Torres by Ross Bleckner." *Bomb* 51 (spring 1995). http://bombmagazine.org/article/1847/felix -gonzalez-torres.

Boellstorff, Tom, Genevieve Bell, Bill Maurer, Melissa Gregg, and Nick Seaver. *Data: Now Bigger and Better!* Chicago: Prickly Paradigm, 2015.

Bois, Yve-Alain, and Rosalind E. Krauss. *Formless: A User's Guide*. New York: Zone Books, 1997.

Boltanski, Luc, and Eve Chiapello. *The New Spirit of Capitalism*. London: Verso, 2005.

Bolter, J. David, and Richard A. Grusin. *Remediation: Understanding New Media*. Cambridge, MA: MIT Press, 2000.

Bourriaud, Nicolas. *The Radicant*. New York: Lukas and Sternberg, 2009.

———. *Relational Aesthetics*. Collection Documents Sur L'art. Dijon: Les Presses du Réel, 2002.

Braverman, Irus. "Governing the Wild: Databases, Algorithms, and Population Models as Biopolitics." *Surveillance and Society* 12, no. 1 (2014): 15–37.

Brinkema, Eugenie. *The Forms of the Affects*. Durham, NC: Duke University Press, 2014.

Brown, Wendy. "Neo-Liberalism and the End of Liberal Democracy." In *Edgework: Critical Essays on Knowledge and Politics*. Princeton, NJ: Princeton University Press, 2005.

———. *Undoing the Demos: Neoliberalism's Stealth Revolution*. Cambridge, MA: MIT Press, 2015.

Bryan-Wilson, Julia. *Art Workers: Radical Practice in the Vietnam War Era*. Berkeley: University of California Press, 2009.

———. "We Have a Future: An Interview with Sharon Hayes." *Grey Room*, no. 37 (2009): 78–93.

Buchloh, Benjamin H. D. "Conceptual Art 1962–1969: From the Aesthetics of Administration to the Critique of Institutions." *October* 55 (winter 1990): 105–43.

———. *Neo-Avantgarde and Culture Industry: Essays on European and American Art from 1955 to 1975*. Cambridge, MA: MIT Press, 2000.

"Call Suffragist to Court: 'Voiceless Speech' Obstructs Traffic, Is the Complaint." *New York Times*, December 29, 1912.

Carr, Nicholas G. "Is Google Making Us Stupid? What the Internet Is Doing to Our Brains." *The Atlantic*, July/August 2008. https://www.theatlantic.com/magazine/archive/2008/07/is-google-making-us-stupid/306868/.

———. *The Shallows: What the Internet Is Doing to Our Brains*. Vol. 1. New York: W. W. Norton, 2010.

Castells, Manuel. *The Rise of the Network Society: The Information Age: Economy, Society, and Culture*. New York: John Wiley, 2011.

Cavell, Stanley. *Themes out of School: Effects and Causes*. Chicago: University of Chicago Press, 1988.

———. *The World Viewed: Reflections on the Ontology of Film*. Enlarged ed. Cambridge, MA: Harvard University Press, 1979.

Citron, Danielle. "Cyber Civil Rights," *Boston University Law Review* 89 (2009): 61–125.

Clark, T. J. *Farewell to an Idea: Episodes from a History of Modernism*. New Haven, CT: Yale University Press, 1999.

———. *Image of the People: Gustave Courbet and the Second French Republic, 1848–1851*. Greenwich, CT: New York Graphic Society, 1973.

Cohen, Kris. "The Painter of Dematerialization." *Journal of Visual Culture* 15, no. 2 (2016): 250–72.

———. "A Welcome for Blogs." *Continuum: Journal of Media and Cultural Studies* 20, no. 2 (2006): 161–73.

———. "What Does the Photoblog Want?" *Media, Culture and Society* 27, no. 6 (2005): 883–901.

Coleman, Gabriella. *Hacker, Hoaxer, Whistleblower, Spy: The Many Faces of Anonymous*. London: Verso, 2014.

———. "Phreaks, Hackers, and Trolls and the Politics of Transgression and Spectacle." In *The Social Media Reader*, edited by Michael Mandiberg. New York: New York University Press, 2012.

Constable, Anna. "Women's 'Voiceless Speech': Story of Police Interference with It from the Woman's Side." *New York Times*, January 5, 1913.

Crary, Jonathan. *24/7: Late Capitalism and the Ends of Sleep*. London: Verso, 2013.

Crimp, Douglas. *Before Pictures*. Brooklyn: Dancing Foxes Press, 2016.

Crimp, Douglas, and Adam Rolston. *AIDS Demo Graphics*. Seattle: Bay Press, 1990.

Crow, Thomas E. *Painters and Public Life in Eighteenth-Century Paris*. New Haven, CT: Yale University Press, 1985.

Dean, Jodi. *Democracy and Other Neoliberal Fantasies: Communicative Capitalism and Left Politics*. Durham, NC: Duke University Press, 2009.

———. *Publicity's Secret: How Technoculture Capitalizes on Democracy*. Ithaca, NY: Cornell University Press, 2002.

Debord, Guy. *The Society of the Spectacle*. New York: Zone Books, 1994.

Deleuze, Gilles. "Postscript on the Societies of Control." *October* 59 (winter 1992): 3–7.

Deleuze, Gilles, and Félix Guattari. *A Thousand Plateaus: Capitalism and Schizophrenia*. Minneapolis: University of Minnesota Press, 1987.

Derrida, Jacques. *Limited Inc*. Evanston, IL: Northwestern University Press, 1977.

———. *Of Grammatology*. Baltimore: Johns Hopkins University Press, 1974.

Dewey, Caitlin. "The Only Guide to Gamergate You Will Ever Need to Read." *Washington Post*, October 14, 2014. http://www.washingtonpost.com/news/the-intersect/wp/2014/10/14/the-only-guide-to-gamergate-you-will-ever-need-to-read/.

Duggan, Lisa. *The Twilight of Equality? Neoliberalism, Cultural Politics, and the Attack on Democracy*. Boston: Beacon, 2003.

Edelman, Lee. *No Future: Queer Theory and the Death Drive*. Series Q. Durham, NC: Duke University Press, 2004.

Eisenberg, Nathan. "Abstracting Art." *The Hypocrite Reader*, November 2015. http://hypocritereader.com/58/abstracting-art.

Elden, Stuart. "Governmentality, Calculation, Territory." *Environment and Planning D: Society and Space* 25, no. 3 (2007): 562–80.

Elmer, Greg, Ganaele Langlois, and Joanna Redden, eds. *Compromised Data: From Social Media to Big Data*. New York: Bloomsbury, 2015.

Finkelpearl, Tom. *What We Made: Conversations on Art and Social Cooperation*. Durham, NC: Duke University Press, 2013.

Foster, Hal. "The Crux of Minimalism." In *The Return of the Real: The Avant-Garde at the End of the Century*. Cambridge, MA: MIT Press, 1996.

———. *The Return of the Real: The Avant-Garde at the End of the Century*. Cambridge, MA: MIT Press, 1996.

Foucault, Michel. "17 March 1976." In *"Society Must Be Defended": Lectures at the Collège de France 1975–1976*. New York: Picador, 1997.

———. "The Birth of Biopolitics." In *Ethics: Subjectivity and Truth*, edited by Paul Rabinow. New York: New Press, 1994.

———. *The Birth of Biopolitics: Lectures at the Collège de France, 1978–1979*. New York: Picador, 2008.

———. "Friendship as a Way of Life." In *Ethics: Subjectivity and Truth, Essential Works of Michel Foucault, 1954–1984*, edited by Paul Rabinow. New York: New Press, 1997.

———. *The History of Sexuality: An Introduction*. Vol. 1. New York: Vintage, 1978.

———. "Sex, Power, and the Politics of Identity." In *Ethics: Subjectivity and Truth*, vol. 1 of *Essential Works of Michel Foucault, 1954–1984*, edited by Paul Rabinow. New York: New Press, 1997.

———. "Two Lectures." In *Power/Knowledge: Selected Interviews and Other Writings 1972–1977*, edited by Colin Gordon. New York: Pantheon, 1980.

Franks, Mary Anne. "Unwilling Avatars: Idealism and Discrimination in Cyber-

space." SSRN Scholarly Paper, October 21, 2009. Rochester, NY: Social Science
Research Network. http://papers.ssrn.com/abstract=1374533.

Fraser, Nancy. "Rethinking the Public Sphere: A Contribution to the Critique of
Actually Existing Democracy." *Social Text*, nos. 25/26 (1990): 56–80.

Fried, Michael. *Art and Objecthood: Essays and Reviews*. Chicago: University of Chicago Press, 1998.

Fuss, Diana. *Identification Papers: Readings on Psychoanalysis, Sexuality, and Culture*.
New York: Routledge, 1995.

Galloway, Alexander R. *The Interface Effect*. Cambridge: Polity, 2012.

———. *Protocol: How Control Exists after Decentralization*. Cambridge, MA: MIT
Press, 2004.

Galloway, Alexander R., and Eugene Thacker. *The Exploit: A Theory of Networks*.
Electronic Mediations. Minneapolis: University of Minnesota Press, 2007.

Garfield, Simon. "The Rise and Fall of AZT." *The Independent*, May 1, 1993. http://
www.independent.co.uk/arts-entertainment/the-rise-and-fall-of-azt-it-was-the
-drug-that-had-to-work-it-brought-hope-to-people-with-hiv-and-aids-and-millions
-for-the-company-that-developed-it-it-had-to-work-there-was-nothing-else-but-for
-many-who-used-azt--it-didnt-2320491.html.

Getsy, David J. *Abstract Bodies: Sixties Sculpture in the Expanded Field of Gender*. New
Haven, CT: Yale University Press, 2015.

Gillick, Liam. "Contingent Factors: A Response to Claire Bishop's 'Antagonism and
Relational Aesthetics.'" *October* 115 (winter 2006): 95–107.

Goldberg, David Theo. *The Threat of Race: Reflections on Racial Neoliberalism*.
Malden, MA: Wiley-Blackwell, 2009.

Gonzalez-Torres, Felix. "The Gold Field." In *Earths Grow Thick: Works after Emily
Dickinson by Roni Horn*, 65–69. Columbus: Wexner Center for the Arts, The Ohio
State University, 1996.

Gould, Deborah B. *Moving Politics: Emotion and ACT UP's Fight against AIDS*. Chicago:
University of Chicago Press, 2009.

Graeber, David. *Fragments of an Anarchist Anthropology*. Chicago: Prickly Paradigm,
2004.

———. *Possibilities: Essays on Hierarchy, Rebellion and Desire*. Oakland, CA: AK
Press, 2007.

Gregg, Melissa. "The Gift That Is Not Given." In *Data, Now Bigger and Better!*,
edited by Tom Boellstorff and Bill Maurer. Chicago: Prickly Paradigm, 2015.

———. "Inside the Data Spectacle." *Television and New Media* 16, no. 1 (January 1,
2015): 37–51.

———. *Work's Intimacy*. Cambridge: Polity, 2011.

Gruber, Thomas. "Ontology of Folksonomy: A Mash-up of Apples and Oranges."
International Journal on Semantic Web and Information Systems 3, no. 2 (2007):
1–11.

Hansen, Mark B. N. *New Philosophy for New Media*. Cambridge, MA: MIT Press,
2004.

Haraway, Donna. *Simians, Cyborgs, and Women: The Reinvention of Nature*. New York: Routledge, 2013.

Harney, Stefano, and Fred Moten. *The Undercommons: Fugitive Planning and Black Study*. Wivenhoe, UK: Minor Compositions, 2013.

Harootunian, Harry. "Remembering the Historical Present." *Critical Inquiry* 33, no. 3 (spring 2007): 471–94.

Harvey, David. *A Brief History of Neoliberalism*. New York: Oxford University Press, 2005.

Hayles, N. Katherine. *How We Became Posthuman: Virtual Bodies in Cybernetics, Literature, and Informatics*. Chicago: University of Chicago Press, 1999.

Heinemann, Torsten, and Thomas Lemke. "Biological Citizenship Reconsidered Use of DNA Analysis by Immigration Authorities in Germany." *Science, Technology and Human Values* 39, no. 4 (2014): 488–510.

Heller, Thomas C., Morton Sosna, and David E. Wellbery. *Reconstructing Individualism: Autonomy, Individuality, and the Self in Western Thought*. Stanford, CA: Stanford University Press, 1986.

Holmes, Brian. "The Flexible Personality: For a New Cultural Critique." In *Hieroglyphs of the Future: Art and Politics in a Networked Era*. Paris: Visual Culture NGO, 2012.

Homer. *The Iliad of Homer*. Chicago: University of Chicago Press, 2011.

"How Companies Learn Your Secrets." *New York Times*, February 19, 2012. http://www.nytimes.com/2012/02/19/magazine/shopping-habits.html?.

Howard, Dorothy. "Feed My Feed: Radical Publishing in Facebook Groups." *Rhizome.org*. http://rhizome.org/editorial/2015/jul/22/feed-my-feed/. Accessed July 29, 2015.

Hu, Tung-Hui. *A Prehistory of the Cloud*. Cambridge, MA: MIT Press, 2015.

Institute of Network Cultures. "Online Search." *Society of the Query* 2 (2015). http://networkcultures.org/blog/publication/society-of-the-query-magazine/ Accessed July 8, 2015.

"It's the Conversation Economy, Stupid." *Bloomberg*, April 9, 2007. http://www.bloomberg.com/bw/stories/2007-04-09/its-the-conversation-economy-stupid businessweek-business-news-stock-market-and-financial-advice.

Jackson, Shannon. *Social Works: Performing Art, Supporting Publics*. New York: Taylor and Francis, 2011.

Jagoda, Patrick. *Network Aesthetics*. Chicago: University of Chicago Press, 2016.

Jameson, Fredric. "The Brick and the Balloon: Architecture, Idealism, and Land Speculation." In *The Cultural Turn: Selected Writings on the Postmodern, 1983–1998*. New York: Verso, 1998.

———. "Fear and Loathing in Globalization." In *Archaeologies of the Future: The Desire Called Utopia and Other Science Fictions*. London: Verso, 2007.

———. *The Geopolitical Aesthetic: Cinema and Space in the World System*. Perspectives. London: BFI; Bloomington: Indiana University Press, 1992.

————. "Magical Narratives: Romance as Genre." *New Literary History* 7, no. 1 (1975): 135–63. doi:10.2307/468283.

————. *Marxism and Form: Twentieth-Century Dialectical Theories of Literature.* Princeton, NJ: Princeton University Press, 1972.

————. *The Political Unconscious: Narrative as a Socially Symbolic Act.* Ithaca, NY: Cornell University Press, 1981.

————. *Postmodernism, or, The Cultural Logic of Late Capitalism.* Durham, NC: Duke University Press, 1991.

Joselit, David. *After Art.* Princeton, NJ: Princeton University Press, 2013.

————. *American Art since 1945.* World of Art. London: Thames and Hudson, 2003.

————. *Feedback: Television against Democracy.* Cambridge, MA: MIT Press, 2007.

Kester, Grant H. *Conversation Pieces: Community and Communication in Modern Art.* Berkeley: University of California Press, 2004.

Krauss, Rosalind E. *Under Blue Cup.* Cambridge, MA: MIT Press, 2011.

————. *"A Voyage on the North Sea": Art in the Age of the Post-Medium Condition.* New York: Thames and Hudson, 1999.

Kwon, Miwon. *One Place after Another: Site-Specific Art and Locational Identity.* Cambridge, MA: MIT Press, 2002.

Laclau, Ernesto, and Chantal Mouffe. *Hegemony and Socialist Strategy: Towards a Radical Democratic Politics.* 2nd ed. London: Verso, 2001.

Lacy, Suzanne. *Mapping the Terrain: New Genre Public Art.* Seattle: Bay Press, 1995.

Lee, Pamela M. *Chronophobia: On Time in the Art of the 1960s.* Cambridge, MA: MIT Press, 2004.

————. *Forgetting the Art World.* Cambridge, MA: MIT Press, 2012.

Levy, Steven. *In the Plex: How Google Thinks, Works, and Shapes Our Lives.* New York: Simon and Schuster, 2011.

Lyotard, Jean-François. *The Differend: Phrases in Dispute.* Minneapolis: University of Minnesota Press, 1988.

Massumi, Brian. "The Future Birth of the Affective Fact: The Political Ontology of Threat." In *The Affect Theory Reader,* edited by Melissa Gregg and Gregory J. Seigworth. Durham, NC: Duke University Press, 2010.

————. *Parables for the Virtual: Movement, Affect, Sensation.* Durham, NC: Duke University Press, 2002.

M'charek, Amade, Katharina Schramm, and David Skinner. "Technologies of Belonging: The Absent Presence of Race in Europe." *Science, Technology and Human Values* 39, no. 4 (2014): 459–67.

Molesworth, Helen. *This Will Have Been: Art, Love, and Politics in the 1980s.* New Haven, CT: Yale University Press, 2012.

Moten, Fred. *In the Break: The Aesthetics of the Black Radical Tradition.* Minneapolis: University of Minnesota Press, 2003.

Moxley, Jennifer. *Often Capital.* Chicago: Flood, 2005.

Muñoz, José Esteban. *Cruising Utopia: The Then and There of Queer Futurity.* Sexual Cultures. New York: New York University Press, 2009.

Neff, Gina, and Dawn Nafus. *The Quantified Self*. Cambridge, MA: MIT Press, 2016.

Nickas, Robert, and Felix Gonzalez-Torres. "Felix Gonzalez-Torres: All the Time in the World (an Interview with Robert Nickas)." In *Felix Gonzalez-Torres*, edited by Julie Ault. Göttingen: Steidl Verlag, 2006.

"Now the Voiceless Speech: Suffragists Have a New Way to Beat Anti-Talking Rules." *New York Times*, November 19, 1912.

Pariser, Eli. *The Filter Bubble: What the Internet Is Hiding from You*. New York: Penguin Press, 2011.

Raman, Sujatha, and Richard Tutton. "Life, Science, and Biopower." *Science, Technology and Human Values*, October 27, 2009, 711–34.

Rancière, Jacques, and Steve Corcoran. *Hatred of Democracy*. London: Verso, 2006.

Reis, Elizabeth. *Bodies in Doubt: An American History of Intersex*. Baltimore: Johns Hopkins University Press, 2009.

Relyea, Lane. *Your Everyday Art World*. Cambridge, MA: MIT Press, 2013.

Retort. *Afflicted Powers: Capital and Spectacle in a New Age of War*. New ed. London: Verso, 2005.

Ricco, John Paul. *The Decision between Us: Art and Ethics in the Time of Scenes*. Chicago: University of Chicago Press, 2014.

Richmond, Scott. *Cinema's Bodily Illusions: Flying, Floating, and Hallucinating*. Minneapolis: University of Minnesota Press, 2016.

Roberts, Jennifer L. *Transporting Visions: The Movement of Images in Early America*. Berkeley: University of California Press, 2014.

Rosen, Jeffrey. "The Web Means the End of Forgetting." *New York Times*, July 21, 2010.

Ross, Andrew. *No-Collar: The Humane Workplace and Its Hidden Costs*. New York: Basic Books, 2003.

Rother, Mike. *Toyota Kata: Managing People for Improvement, Adaptiveness and Superior Results*. New York: McGraw-Hill Professional, 2009.

Ruppert, Evelyn. "Population Objects: Interpassive Subjects." *Sociology* 45, no. 2 (2011): 218–33.

Scheible, Jeff. *Digital Shift: The Cultural Logic of Punctuation*. Minneapolis: University of Minnesota Press, 2015.

Scholz, Trebor. *Digital Labor: The Internet as Playground and Factory*. New York: Routledge, 2013.

Schwartz, Mattathias. "Malwebolence: The World of Web Trolling." *New York Times*, August 3, 2008.

Scott, Joan W. "The Evidence of Experience." *Critical Inquiry* 17, no. 4 (1991): 773–97.

Sedgwick, Eve Kosofsky. "Paranoid Reading, Reparative Reading: or, You're So Paranoid, You Probably Think This Essay Is about You." In *Touching Feeling: Affect, Pedagogy, Performativity*. Durham, NC: Duke University Press, 2003.

Sedgwick, Eve Kosofsky, and Adam Frank. *Touching Feeling: Affect, Pedagogy, Performativity*. Durham, NC: Duke University Press, 2003.

Seltzer, Mark. "Wound Culture: Trauma in the Pathological Public Sphere." *October* 80 (1997): 3–26.

Shaviro, Steven. "Beauty Lies in the Eye." *Symploke* 6, no. 1 (1998): 96–108.

———. "The 'Bitter Necessity' of Debt: Neoliberal Finance and the Society of Control." May 1, 2010. http://www.shaviro.com/Othertexts/Debt.pdf.

———. *Connected, or, What It Means to Live in the Network Society.* Electronic Mediations. Minneapolis: University of Minnesota Press, 2003.

Shirky, Clay. "Ontology Is Overrated: Categories, Links, and Tags." *Clay Shirky's Writings about the Internet: Economics & Culture, Media & Community*, 2005. http://www.shirky.com/writings/ontology_overrated.html.

Spector, Nancy. *Felix Gonzalez-Torres.* New York: Guggenheim Museum, 1995.

Spinoza, Benedictus de. *A Spinoza Reader: The Ethics and Other Works.* Translated by Edwin M. Curley. Princeton, NJ: Princeton University Press, 1994.

Storr, Robert. "When This You See Remember Me." In *Felix Gonzalez-Torres*, edited by Julie Ault. Göttingen: Steidl Verlag, 2006.

Storr, Robert, and Felix Gonzalez-Torres. "Felix Gonzales-Torres: Être un espion (Interview with Robert Storr)." In *Felix Gonzalez-Torres*, edited by Julie Ault. Göttingen: Steidl Verlag, 2006.

Stryker, Susan. *Transgender History.* Berkeley, CA: Seal Press, 2008.

Sushil, and Gerhard Chroust, eds. *Systemic Flexibility and Business Agility.* New Delhi, India: Springer, 2015.

Thompson, Nato. *Living as Form: Socially Engaged Art from 1991 to 2011.* Cambridge, MA: MIT Press, 2012.

Turkle, Sherry. *Alone Together: Why We Expect More from Technology and Less from Each Other.* New York: Basic Books, 2011.

"Voiceless Speech Too Loud: Judge Tells Ms. Constable She Must Not 'Talk' Again." *New York Times*, December 1, 1912.

Wark, McKenzie. *The Beach beneath the Street: The Everyday Life and Glorious Times of the Situationist International.* London: Verso Books, 2015.

———. "Designs for a New World" *e-flux* 58, October 2014. http://www.e-flux.com/journal/designs-for-a-new-world/.

———. *50 Years of Recuperation of the Situationist International.* Princeton, NJ: Princeton Architectural Press, 2008.

———. *A Hacker Manifesto.* Cambridge, MA: Harvard University Press, 2004.

———. *The Spectacle of Disintegration: Situationist Passages out of the Twentieth Century.* London: Verso Books, 2013.

Warner, Michael. *Publics and Counterpublics.* New York: Zone Books, 2002.

Zittrain, Jonathan. *The Future of the Internet and How to Stop It.* New Haven, CT: Yale University Press, 2008.

INDEX

"Abandoned Love" (Dylan), 50–51
Acconci, Vito, 56; *Seed Bed*, 54–55
actor network theory, 148n3
ACT UP, 97, 170n51
address, modes of, 115–16, 118, 121
advertising, traditional vs. search-engine, 119–20
affect: BEACON's seriality and, 172n3; Hayes's *I March* and, 51; liveness, affective impact of, 110; representational vs. algorithmic logic and, 123
affective contacts. *See* tonalities and communicative indirection
AIDS activism, 97–98, 170n51
algorithmic logics: of competition, 43–44; representational logic vs., in search queries, 118–20, 123, 125–31; transition from genre to, 71–74
Amazon, 38
anamorphosis, 11–12
anonymity, 62–63, 68
Anonymous, 63–65
antagonism, 55–56, 155n17
Archaeology of Knowledge, The (Foucault), 173n13
Arendt, Hannah, 148n10
art history: conjunction in, 18; of group form, 21–22; visual studies, 29

attention, in Gibson's *Pattern Recognition*, 85–88
Auden, W. H., 15
audience: art audience-cum-population, 118; "audience-oriented subjectivity," 154n7; Fraser's *Museum Highlights* and, 53–54; Hayes's *I March* and, 47–50

bad citizen behavior. *See* broken genres, reciprocity ideals, and nonreciprocity
bare life, 164n2
Bataille, Georges, 18–19
Battelle, John, 160n71, 168n44, 174n25
Baudrillard, Jean, 22, 30
BEACON (Thomson & Craighead), 109–10, 111, 114–18, 120–33, 172n3
beauty, experience of, 91
Berlant, Lauren: group form and, 26; on intimate publics, 7, 25–26, 34; on neoliberalism, 150n19; "ordinary life," 142n27
Bersani, Leo: "correspondence of forms," 7, 12, 24–25, 142n25; group form and, 26; nonrepresentability, 27; on vocabulary, form, and sexuality, 16–17
Beuys, Joseph, 56
Bianca's Smut Shack, 159n54, 159n57
biopolitics, 36–37, 80, 82
Bishop, Claire, 22, 155n17

Bois, Yve-Alain, 18–19, 144nn9–10
Bourriaud, Nicolas, 22, 170n58
broken genres, reciprocity ideals, and non-
reciprocity: algorithmic logic of compe-
tition, 43–44; diacritics and, 102; the dif-
ferend and, 43, 45–46, 56–57, 61, 66, 70;
genre and broken genre, 44–45; Hayes's
"love addresses" and, 43, 46–53, 56–61,
74–75; intimacy without reciprocity as
broken genre, 42; law, civil rights con-
ception of personhood, and, 67–69, 71;
liberal, democratic ideal, 41–42, 61–62;
modernist antagonism and defamil-
iarization and, 55–56; parallelism and,
74–77; performance art, spectatorship,
and, 52–55; Piper's *My Calling Card #1*,
Acconci's *Seed Bed*, and, 54–55; Pope.L's
crawl pieces and, 56; search queries and
nonreciprocal togetherness, 115; suffrag-
ist "voiceless speech" tactic and, 60–61;
transition from genre to algorithm,
71–74; trolls and bad online behavior,
61–71
Brown, Wendy, 101, 150n19

candy works (Gonzalez-Torres), 89–93,
95–96, 98–99, 168n43, 168n45
capitalism: "communicative," 152n41,
162n85; the formless and, 19; group
form and, 11; mass market, 3; parallelism
and, 178n57
Carr, Nicholas, 153n3
Cavell, Stanley, 172n9
Certificates of Authenticity in Gonzalez-
Torres, 82, 88–89, 90, 95–96, 99,
169n50
Chatsum software, 174n17
chronophobia, 174n23
Citron, Danielle, 68
civil rights conception of personhood,
68–69, 71
Clark, T. J., 145n18
"Cleaning Cyber Cesspools" (Leiter),
67–68
Coleman, Gabriella, 62, 64–65, 162n84
Comaroff, Jean, 150n19

Communications Decency Act, 161n72
communicative indirection. *See* tonalities
and communicative indirection
competition, 43–44, 45
conjunction, Jamesonian, 17–18
connectivity as demand, 75–76
conversation economy, 67
correspondence of forms, 7, 24–25, 142n25
counterpower, 178n56
Craighead, Alison, 110. *See also* Thom-
son & Craighead
"Craigslist Experiment" (Fortuny), 62
criminalsearches.com, 113–14
Crimp, Douglas, 97
Cruise, Tom, 63
Cuil.com, 112

data: "Big Data," 23–24; "data sweat," 23;
endlessness and, 129; parallelism and,
24; populations as data accumulations
and as population generators, 38, 79–81;
recursive public sphere and, 35–36;
search queries and, 120
databases: criminalsearches.com, 113–14;
"Database of Intentions," 175n25; de-
materialization logic of search engines
and, 125; as grouping, 38; search engine
aggregates, 119–20, 122, 127, 131
Dean, Jodi, 34, 148n1, 150n19, 152n41,
162n85
Debord, Guy, 4, 30, 31
defamiliarization, 55
Deleuze, Gilles, 140n9, 178n54
democracy, "hatred of," 153n4
denial-of-service (DoS) attacks, 63, 65,
159n61
Derrida, Jacques, 167n40
description and life, conjunction of, 7,
141n12
diacritics of tone, 81–82, 99–103
differend: AIDS activism and, 97; antago-
nism and, 155n17; as automatism, 66;
Hayes's "love addresses" and, 46, 56–57;
Lyotard's concept of, 43, 45–46; search
queries and, 114; trolls and, 66, 70; voice-
less speech and, 61

disruption, aesthetics of, 160n64
distributed denial-of-service (DDoS) attacks, 63, 65
"dividuation," 131, 178n54
Dogpile.com, 116
Duchamp, Marcel, 56
Duggan, Lisa, 150n19
Dutoit, Ulysse, 7, 12, 16–17, 24–25
Dylan, Bob, 50–51

ekphrasis, 7–8, 27, 124, 141n13, 141n15
Elden, Stuart, 32
email, 40, 100
emoticons, 99–102, 171n65
endlessness, 116–17, 129
English, Darby, 56
Everything Else Has Failed! Don't You Think It's Time for Love (Hayes), 74

fandom, 81, 83
Feyerabend, Paul, 29
First Person, The (Thomson & Craighead), 111
"folksonomies," 173n13
footage, in Gibson's *Pattern Recognition*, 84–88, 102
form and formlessness, 17–20, 145n16
Fortuny, Jason: "Craigslist Experiment," 62
Foucault, Michel: *The Archaeology of Knowledge*, 173n13; on biopolitics, 36–37, 80, 82, 165n6; on friendship, 97; on neoliberalism, 31–32, 36–37, 80, 82; on personhood, knowledge, and discourse, 173n13; on prisoners, 166n22; on social cohesion, 67; on technology, 147n1
Frankfurt School, 30, 31
Franks, Mary Anne, 154n6
Fraser, Andrea: *Museum Highlights*, 53–54
Fraser, Nancy, 34
Free Software movement, 151n26
Fried, Michael, 18, 116–17, 143n6, 178n55

Galloway, Alexander, 37, 71, 122, 140n10, 152n37, 155n16, 165n6
gender: absented in "you" of Hayes's *I March*, 60; trolls and, 68, 70

genre, 44–45, 49, 52. *See also* broken genres, reciprocity ideals, and nonreciprocity
Gibson, William: *Pattern Recognition*, 82–89, 103, 167n33, 175n25, 176n31
Goldberg, David Theo, 150n19
Goldberg, RoseLee, 52
Gonzalez-Torres, Felix: AIDS activism, 93, 97–98; candy works, 89–93, 95–96, 98–99, 168n43, 168n45; Certificates of Authenticity, 82, 88–89, 90, 95–96, 99, 169n50; diacritics, use of, 170n59; on insiderness and outsiderness, 96, 98, 99, 102–3; on "Internets," 140n8; minimalism, conceptualism, and, 83, 89, 91, 98, 103; paper stacks, 95, 169nn47–48; parenthetical phrases and winks, 92, 96, 98, 100–101, 103; on personhood, 94–95, 96; *"Untitled" (National Front)*, 169n48; *"Untitled" (Placebo)*, 90–93; the viral and, 93–94
Gonzalez-Torres Foundation, 89, 169n48
Google, 112, 118, 119, 165n7, 175n26, 176n37
Google Trends, 121
Google Zeitgeist, 175n25
Graeber, David, 178n56
Gregg, Melissa, 23
Grey, Katharine Clark, 174n25
group form: in art history, 21–22; BEACON and, 114, 115, 120; Big Data and, 23–24; built not through will or even consciousness, 36–40; correspondence or communication of forms, 7, 24–25; diacritics and, 102–3; differend and, 46; dispersed, 120; in distributed networks and electronic networks, 4; form and formlessness, 17–20; freighted vocabularies of collectivity, 1; Gonzalez-Torres's candy works and, 95–96, 103, 169n50; "group," 15–17; Hayes's *I March*, audience, and, 48, 50; the individual and, 22–23; intimate publics and, 25–26; of the mass, anxiety about, 30; neoliberal theory and, 33; parallelism and, 4, 10, 133; as placeholder phrase, 2; representational logics,

group form (*continued*)
the nonrepresentable, and, 26–27;
search-engine data and, 80; tonelessness
and, 102; trolls and, 64, 71, 160n68; use
of term, 20–21; the viral and, 94; vocabu-
lary, paucity of, 15. *See also specific forms,
such as search queries*
Guillén, Claudio, 154n11

Habermas, Jürgen, 25–26, 34, 35, 41, 65,
94–95, 154n7
Haraway, Donna, 69
Hayes, Sharon: BEACON compared to, 118;
*Everything Else Has Failed! Don't You
Think It's Time for Love*, 74; *I March in
the Parade of Liberty, but as Long as I Love
You I'm Not Free*, 40, 43, 46–53, 56–61,
72–74, 135–37, 156n19; *In the Near
Future*, 46, 74; "love addresses" (in gen-
eral), 43, 46, 74–75; *Revolutionary Love:
I Am Your Worst Fear, I Am Your Best Fan-
tasy*, 74
Hendricks, Geoffrey, 56
homeopathy, 76

I Love Alaska (Engelbert and Plug), 118
images: Debord's spectacle and, 4; person-
hood and, 105–8; populations of, 4, 31;
world overrun with, 30–31, 133
*I March in the Parade of Liberty, but as
Long as I Love You I'm Not Free* (Hayes),
40, 43, 46–53, 56–61, 72–74, 135–37,
156n19
indirection, communicative. *See* tonalities
and communicative indirection
individualism and individuality, 1, 22–23.
See also personhood
insiderness and outsiderness, 81, 96, 98,
99, 102–3
Internet: data collection and Internet ser-
vice commodities, 80; denial-of-service
(DoS) attacks, 63, 65, 159n61; email, 40,
100; as public sphere, 34–36, 41. *See also*
search queries and search engine subjec-
tivities; social media; trolls

In the Near Future (Hayes), 46, 74
intimacy: Gibson's *Pattern Recognition* and,
85; Hayes's *I March* and, 59; intimate
publics, 7, 25–26, 34, 82; the viral and
toxic intimacy, 93; without reciprocity,
42

Jackson, Shannon, 139n2
Jameson, Fredric: on conjunction, 17–18;
group form and, 26; "levels," 143n4;
metacommentary, 142n30; on naming
in postmodernism, 167n33; on politi-
cal unconscious of postmodernity, 7;
on postmodernism's collapse of culture
into economy, 175n25; on technology,
30, 147n1
Jorn, Asger, 129
Joselit, David, 4, 30–31, 140n7, 148n14,
152n37

Kant, Emmanuel, 91
Kaprow, Allan, 56
Kelty, Christopher, 29, 35–37, 151n26
Kluge, Alexander, 34
knowledge and personhood, 113–14
Krauss, Rosalind, 18–19, 143–44nn8–10
Kwon, Miwon, 168n43, 169n50

labor of production and of consumption,
in Gibson's *Pattern Recognition*, 87
Laclau, Ernesto, 155n17
Lambert-Beatty, Carrie, 53, 160n64
Lee, Pamela, 148n4, 174n23, 177n45,
178n55
Leiter, Brian, 67–68
Levmore, Saul, 67
life: conjunction of description and, 7,
141n12; ordinary, 24, 39, 142n27
literal, the, 147n34
liveness, 110, 111, 115, 117, 129
*Live Portrait of Tim Berners-Lee (An Early-
Warning System)* (Thomson & Craig-
head), 111
LOL, 99–101, 171n65
Lovink, Geert, 147n1

Lymbix, 100
Lyotard, Jean-François, 43, 45–46

Manning, Chelsea, 163n99
marketing: Free Software movement and, 35; in Gibson's *Pattern Recognition*, 83–88; "individual will" and, 39; traditional advertising vs. search engines, 119–20
"mass," 15–16
Massumi, Brian, 140n9, 143n2
media theory, 10–12, 18
mediation, definitions of, 11
Meier, Megan, 68
metacommentary, 142n30
Microsoft, 112
Miller, Chris, 159n54, 159n57
misogyny and trolls, 70
"mob," 15–16
modernism: antagonism and defamiliarization, 55–56, 128; capitalism as artificial life and, 178n57; formlessness, 15; group form and, 18, 22; mass market capitalism and, 3; search engines and, 129–30; self-reflexivity, faith in, 165n9
Moten, Fred, 27, 139n1
Mouffe, Chantal, 155n17
Moxley, Jennifer, 156n20
Museum Highlights (Fraser), 53–54
My Calling Card #1 (Piper), 54–55

naming and the unnamed, 92
Nancy, Jean-Luc, 167n31
National Security Agency, 163n89
Negt, Oskar, 34
neoliberalism: communicative capitalism and, 162n85; Foucault on, 31–32, 36–37, 80
neoliberal theory, 31–33, 149n19
net.art, 147n32
networks, meaning of, 5
Nickas, Robert, 92
Noland, Kenneth, 18
Nussbaum, Martha, 67

Olitski, Jules, 18
ordinary life: Berlant on, 142n27; data as parallel, 24; protocological affiliation and, 39
ordoliberals, 31
outsiderness and insiderness, 81, 96, 98, 99, 102–3
ownership, in Gonzalez-Torres, 95

parallelism: algorithmic logic and, 72; capitalism and, 178n57; data and ordinary life, 24; defined, 38–39; as form of relation, 76; group form and, 4, 10; personhood and, 132; populations and, 39; protocological affiliation and ordinary experience, 39; reciprocity, broken genres, and, 74–77; search queries and, 121, 130–33; Spinoza's concept of, 164n100; as structure, 4; tonelessness of networked spaces and, 102
parenthetical phrases, 92, 96, 98, 100–102
Pasquale, Frank, 68
Pattern Recognition (Gibson), 82–89, 103, 167n33, 175n25, 176n31
performance art: Acconci's *Seed Bed*, 54–55; antireciprocal trajectory of, 53; Fraser's *Museum Highlights*, 53–54; Goldberg on immediacy and, 52; Lambert-Beatty on Rainer and, 53; Piper's *My Calling Card #1*, 54–55; the spectacular and, 53–54. *See also* Hayes, Sharon
personhood: BEACON and, 122–23; civil rights conception of, 68–69, 71; Deleuze's "dividuation," 178n54; Gonzalez-Torres's figuration of, 94–95, 96; images and text as persons, 105–8; knowledge and, 113–14; liberal vs. algorithmic, 108; parallelism and, 132; pseudonymity and accountable personhood, 68; reciprocity ideal and, 42; search queries and, 111, 129; search queries and representational vs. algorithmic logic, 118–20, 123, 125–31; universal, ideal of, 68. *See also* individualism and individuality; subjectivity

Pinterest, 171n67
Piper, Adrian, 56; *My Calling Card #1*,
54–55
politics, hidden, 98
Pope.L, William, 56
populations: AIDS activism and logic of,
97; asymmetry of, 114; automaticity and
parallelism of, 39; automatic or proto-
cological affiliations and, 37–39; as
collectivizing forms, 6; confrontation
with publics, 71; as data accumulations,
38, 79–81; emoticons, LOL, and, 101;
Gibson's *Pattern Recognition* and building
of, 86, 98; of images, 4, 31; indirect suf-
fering and, 164n2; as interpassive sub-
ject, 149n17; life managed by, 82; mar-
keting subjects as back-formations of,
121; neoliberal theory and, 31–33; overlaid
upon publics, 32–33, 37; parallelism and,
4, 39; public spheres and, 36; represen-
tational vs. algorithmic logic and, 123;
search queries and, 129–30; sovereignty
rhetoric in, 164n2; togetherness and, 115;
the viral and, 94
postmodernism, 129–30, 156n21, 167n33,
175n25
PRISM, 163n89
protocol and protocological affiliations,
37–39, 152n37
protocological infrastructure, 140n10
pseudonymity, 68
publics: built up from minima of partici-
pation, 80; confrontation with popula-
tions, 71; counterpublics and, 80; criti-
cal (Habermas), 94–95; emails and, 40;
Hayes's *I March in the Parade of Liberty*
and, 40; intimate, 7, 25–26, 34, 82; never
knowing who else is there, 114–15; popu-
lations overlaid upon, 32–33, 37
public spheres: Habermas's theory of, 34,
41; Internet and, 34–36, 41; as mediated
relationality, 3; post-Habermasian litera-
ture on, 153n2; "recursive," 35–36; social
media and, 37; trolls and the pathological
public sphere, 63, 65–66
punctuation, "cultural logic" of, 101–2

queer theory, 7, 10–12

Rainer, Yvonne, 53
Rancière, Jacques, 144n14, 153n4
reciprocity and nonreciprocity. *See* broken
genres, reciprocity ideals, and nonreci-
procity
relational aesthetics: Bishop's criticism
of, 155n17; Gonzalez-Torres and, 96,
170n50; group form and, 21–22; Hayes
and, 52. *See also* Bourriaud, Nicolas
representation: group form, representa-
tional logics, and nonrepresentability,
26–27; "re-presentation," 3; represen-
tational vs. algorithmic logic in search
queries, 118–20, 123, 125–31
"reputation bankruptcy," 174n15
*Revolutionary Love: I Am Your Worst Fear,
I Am Your Best Fantasy* (Hayes), 74
Richmond, Scott, 165n9
Ruppert, Evelyn, 149n17

Scanlon, Joe, 91
Scheible, Jeff, 101–2
Schmidt, Eric, 168n44
Schwartz, Mattathias, 62
Scientology, Church of, 63
Scott, Joan W., 143n2, 165n11
search queries and search engine sub-
jectivities: as advertising, 119–20; de-
materialization in logic of, 125; Engel-
bert and Plug's *I Love Alaska* and Grey's
User 927, 118; images and text as per-
sons, 105–8; inability to interact, except
as users, 126; liveness and, 110, 111, 115,
117, 129; mode of "seeing," 118; parallel-
ism and, 121, 130–33; personhood and
representational vs. algorithmic logic,
118–20, 123, 125–31; search engine in-
dustry, 112–14; silent witness, 114–23;
simulated interpersonal relation, 172n7;
spatiality of, 158n46; Thomson & Craig-
head's BEACON, 109–10, 111, 114–18,
120–33, 172n3
Sedgwick, Eve, 8, 38, 141n17, 152n41
Seed Bed (Acconci), 54–55

self-consciousness in context of populations, 80
Seltzer, Mark, 63
seriality: BEACON and, 116, 127, 131–32, 172n3, 177n45; endlessness and, 131; Lee on, 177n45
Serpentine Gallery, 91
sexuality: absented in "you" of Hayes's *I March*, 60; Bersani and Dutoit on, 17; sex in public, 55
Shaviro, Steven, 69, 75, 91
Sierra, Kathy, 68
Situationists, 21, 129, 145n19
Snowden, Edward, 37, 163n99
sociality vs. reciprocity ideal, 42
social media: competition in, 45; democratic ideals and, 41–42; posting stories and photos, hope in, 59–60; public spheres and, 37. *See also* trolls
Solari di Udine, 124
Sontag, Susan, 30
sovereignty rhetoric in populations, 164n2
spectacle and the spectacular, 30, 53–54
spectatorship, 53–54. *See also* audience
Spector, Nancy, 167n35, 170n56
"Speech, Privacy, and the Internet: The University and Beyond" conference (University of Chicago Law School, 2010), 67–68
Spinoza, Baruch, 164n100
Storr, Robert, 90, 169n48
strong theory, 8
subjectivity: "audience-oriented," 154n7; BEACON and, 116; Bersani on, 24; Foucault on knowledge and, 173n13; Fried on object production and, 178n55; Gibson's *Pattern Recognition* and, 75; Gonzalez-Torres's candy works and, 89; group form and, 15, 20; Hayes's "love addresses" and, 74–75; nonreciprocity and, 43; parallelism and, 38; Ruppert's "interpassive subject," 149n17; tonelessness and, 102; trolls and, 42, 62, 64. *See also* personhood
suffragists, "voiceless speech" of, 60–61
Sunstein, Cass, 67, 161n74

technology: biopolitics of neoliberalism and, 36–37; blamed for broken genre, 153n3; deliteralizing accounts of, 29–31; different framings of significance of, 147n1; Foucault on neoliberalism and, 32; as icon, 29; image technologies, 30–31. *See also* data; Internet; search queries and search engine subjectivities
television, 110, 172n9
Thatcher, Margaret, 107
Thomson, Jon, 110. *See also* Thomson & Craighead
Thomson & Craighead: BEACON, 109–10, 111, 114–18, 120–33, 172n3; characterizations of, 110–11; *The First Person*, 111; *A Live Portrait of Tim Berners-Lee (An Early-Warning System)*, 111
Thrift, Nigel, 51
tonalities and communicative indirection: diacritics and emoticons, 81–82, 99–103, 171n65; Gibson's *Pattern Recognition* and attention, 82–89, 103; Gonzalez-Torres's candy works and imagined populations, 89–99, 103; populations as data entities and, 79–81; tonelessness of networked spaces, 102–3
ToneCheck software, 100
transgender and broken genre, 70
trolls: anonymity of, 62–63; Anonymous and the Yes Men, 63–65; definitions of, 62; democratic ideal and, 61–62; the differend and, 66, 70; group form and, 64, 71; law, civil rights conception of personhood, and, 67–69, 71; misogyny of, 70–71; public sphere and, 65–66; as technical feature of networks, 64, 160n68
Tumblr, 171n67
Turkle, Sherry, 153n3

"Untitled" (Placebo) (Gonzalez-Torres), 90–93
User 927 (Grey), 118

viral, the, 93–94, 168n42
virtuality, Massumi on, 140n9

visual studies, 29
"voiceless speech," 60–61

Walters, Lawrence, 121, 176n36
Wark, McKenzie, 128–29
Warner, Michael, 34, 37, 80
watermarks, in Gibson's *Pattern Recognition*, 88–89

weak theory, 8
winks, in Gonzalez-Torres, 96, 98, 103

Yes Men, 63–64, 160n64

Zittrain, Jonathan, 174n15
Žižek, Slavoj, 34, 176n36
Zuckerberg, Mark, 107